The Apotheosis of Democracy, 1908–1916

The American Arts Series/University of Delaware Press Books

Winner of the University of Delaware Press Award
for Best Manuscript in American Art

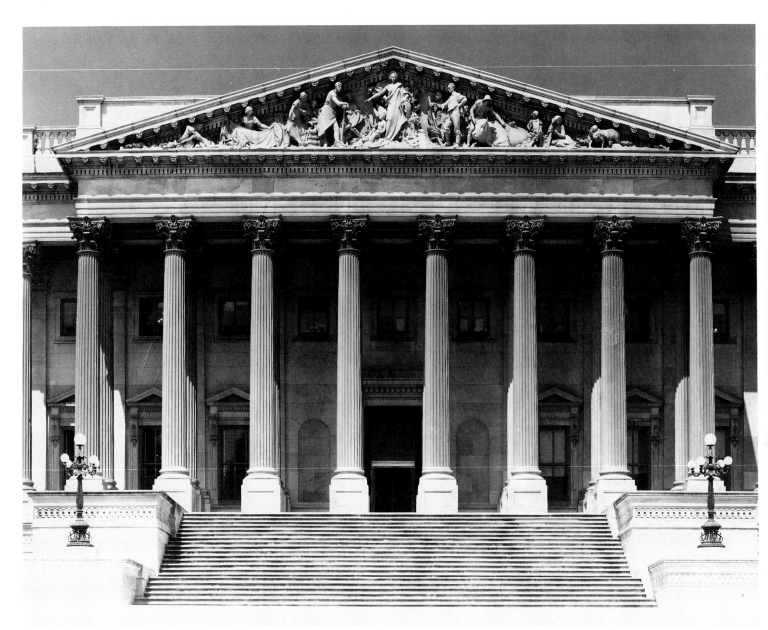

F. Paul Wayland Bartlett, The Apotheosis of Democracy,
*1908–16. Marble, Pediment for the House Wing of the United
States Capitol Building. Photograph: Architect of the Capitol.*

The Apotheosis of Democracy, 1908–1916

The Pediment for the House Wing of the United States Capitol

THOMAS P. SOMMA

DELAWARE

Newark: University of Delaware Press
London : Associated University Presses

Associated University Presses
440 Forsgate Drive
Cranbury, NJ 08512

Associated University Presses
25 Sicilian Avenue
London WC1A 2QH, England

Associated University Presses
P.O. Box 338, Port Credit
Mississauga, Ontario
Canada L5G 4L8

The paper used in this publication meets the requirements
of the American National Standard for Permanence of Paper
for Printed Library Materials Z39.48-1984.

Library of Congress Cataloging-in-Publication Data

Somma, Thomas P.
 The Apotheosis of democracy, 1908–1916 : the pediment for the House Wing of the United States Capitol / Thomas P. Somma.
 p. cm.—(The American arts series/University of Delaware Press Books)
 Includes bibliographical references and index.
 ISBN 0-87413-528-1 (alk. paper)
 1. Apotheosis of democracy (United States Capitol, Washington, D.C.) 2. Bartlett, Paul Wayland, 1865–1925—Criticism and interpretation. 3. United States Capitol (Washington, D.C.) 4. Relief (Sculpture), American—Washington (D.C.) 5. Pediments—Washington (D.C.) 6. Washington (D.C.)—Buildings, structures, etc. I. Title. II. Series.
NB237.B37A62 1995
730'.92—dc20 94-13350
 CIP

PRINTED IN THE UNITED STATES OF AMERICA

For Marie and Bonnie

Contents

List of Abbreviations

CHN	Charles Henry Niehaus	MCM	Montgomery C. Meigs
EC	Edward Clark	PWB	Paul Wayland Bartlett
EDP	Erastus Dow Palmer	R.A.C.	Records of the Architect of the Capitol
EW	Elliott Woods	SE/SB	Suzanne Earle Emmons/Suzanne Earle Emmons Bartlett
GB	Gutzon Borglum		
GP	Getulio Piccirilli	TC	Thomas Crawford
HD	Henry Dexter	TDJ	Thomas Dow Jones
HKB	Henry Kirke Brown	THB	Truman Howe Bartlett
JQAW	John Quincy Adams Ward	WRB	William Randolph Barbee
LT	Launt Thompson		

Acknowledgments

I AM GLAD TO HAVE THE OPPORTUNITY TO THANK SOME of the people, institutions, and organizations who have contributed to the research, preparation, and completion of this book.

I must first mention that the publication of this book is indebted to the ground-breaking research produced over the last decade or so by a growing list of scholars interested in nineteenth- and early twentieth-century American sculpture, especially Wayne Craven, David C. Huntington, Richard Guy Wilson, Lewis I. Sharp, Michael T. Richman, George Gurney, Michael Edward Shapiro, Kathryn Greenthal, Vivien Green Fryd, Lauretta Dimmick, and Michele H. Bogart. I am particularly grateful to Wayne Craven not only for his scholarship, but also for his unfailing enthusiasm and encouragement. Other scholars, friends, and colleagues whose ideas or advice inform the content of this book include Michael W. Panhorst, John Stephens Crawford, Damie Stillman, Roberta K. Tarbell, Pamela Scott, and Dennis R. Montagna.

Much of my research was accomplished under a United States Capitol Historical Fellowship, and I want to thank especially the Hon. George M. White, Architect of the Capitol, and the United States Capitol Historical Society, Clarence J. Brown, President, Frederic D. Schwengel, founder and late President, for their generous support. I would also like to acknowledge the following individuals and organizations for their considerable assistance: Office of the Architect of the Capitol, Barbara A. Wolanin, Pam Violante, John Hackett, Florian Thayn, and Linnaea Dix; United States Capitol Historical Society, Cornelius Heine, Rebecca Rogers, and Donald Kennon; Tudor Place Foundation, Inc., Eleanor C. Preston, Anne C. Webb, Osborne Phinizy Mackie, and Ross Watson; Library of Congress, Manuscripts Division, Reading Room, Mary Wolfskill, Mike Klein, Fred Bauman, Ernest Emrich, Jeff Flannery, Chuck Kelly, and Kathleen C. McDonough; Smithsonian Institution, Joan R. Stahl, Kimberly Cody, Rachel Allen, and Christine Hennessey; Library of Congress, Prints and Photographs Division, Elisabeth Parker, C. Ford Peatross, and Diane Tepfer; and the National Park Service, John C. Howland.

I wish to express my sincere appreciation to the Board of Editors of the University of Delaware Press, Jay L. Halio, Chair, for their encouragement of my studies and for their ongoing commitment to the history of American sculpture. My gratitude also goes to Julien Yoseloff, Director, Associated University Presses, and to members of his editorial staff, Michael Koy, Paul Rieder, and Rebecca L. Woolston, for their personal and professional involvement in the final stages of this book's completion.

Finally, I thank my wife, Marie Somma, for her endless patience, advice, and loving support—with these things all is possible.

Introduction

THE SCULPTURAL DECORATION FOR THE PEDIMENT OF the House wing of the United States Capitol represents one of the most prestigious and historically important federal commissions to be awarded in America during the opening decades of the twentieth century. For one thing, the installation of the marble figures in the long-vacant House pediment finally brought to completion a project of expansion and decoration of the Capitol Building that had begun in the early 1850s. As such, it offers interesting opportunities for exploring the early development of government-sponsored public sculpture in America. But the pediment, unveiled just eight months prior to America's entry into World War I, should also be appreciated within the more contemporary context of the American Renaissance, that episode in the cultural history of the nation generally recognized as beginning with the Centennial in 1876 and ending in 1917 with America's direct involvement in the war.

Much of the art associated with the American Renaissance sought to define contemporary America in terms of the historical past, and, essentially conservative in character, promoted existing political and economic conditions rather than meaningful social change. As one of the most visible public expressions of American Renaissance ideals, the statuary for the House pediment also reflected the convergence of political authority and the perceived need to instruct a general population undergoing dramatic ethnic and demographic changes.

Chapter 1 of this study examines the history of the House pediment from 1851, the year construction began on the new north and south wing buildings of the U.S. Capitol, to early 1908, when the Congressional committee charged with com-

pleting the pediment finally recommended the American expatriate sculptor Paul Wayland Bartlett (1865–1925) to design and execute the statuary. Throughout the second half of the nineteenth century numerous sculptors cast an ambitious eye on the undecorated pediment; and, wishing to associate themselves with the most prominent public building in America, many of these artists prepared elaborate sketch models and courted political patronage in the hopes of winning the elusive commission. This chapter recounts their efforts and disappointments and offers reasons for the government's long delay in appointing a sculptor for the project.

Chapter 2 gives a detailed chronological account of Paul Wayland Bartlett's commission to provide sculptural decoration for the House pediment, beginning with the circumstances surrounding Bartlett's selection in 1908 and concluding with the inauguration of the pediment in August 1916. This chapter focuses on the progressive development of Bartlett's imagery from the preliminary sketch models to the final marble statues, and on the complexity of Bartlett's contract with its two subsequent extensions and modification. Other aspects of the commission briefly considered include the selection of the type of marble to be used for the final statues and the pediment's installation and unveiling.

Chapter 3 provides an in-depth analysis of the design, style, iconography, and historical context of the statuary for the House pediment, noting its principal sources and precedents and studying its relationship to the aesthetic and cultural values of the period. Emphasis is placed on the fundamentally conservative economic values embodied in the pediment's theme and handling, the commission's historical position with re-

13

spect to the public expression in art of Americanist and nationalist sentiment, and the links between Bartlett's imagery and the social and political values of pre–World War I America. The chapter ends with an evaluation of the significance of the House pediment to the history of American architectural sculpture and to post–World War I treatments of themes dealing with the American worker.

The book concludes with a catalogue of the known models and casts of Bartlett's sketches and final figures for the House pediment, an appendix comprised of selected letters and documents related to the history of the commission, including Bartlett's original and modified contracts both of which are reprinted in full, and an extensive bibliography of primary and secondary sources.

The Apotheosis of Democracy, 1908–1916

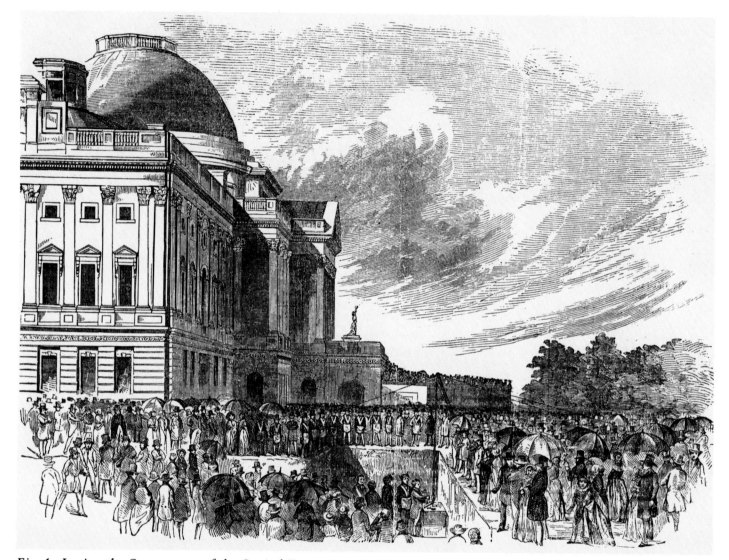

Fig. 1. Laying the Cornerstone of the Capitol Extension. From
Gleason's Pictorial Drawing Room Companion *1 (2 August*
1851): 216. Photograph: Architect of the Capitol.

1

Prelude to a Commission, 1851–1908

1850–1855: The Capitol Extension of 1851;
Hiram Powers and Thomas Crawford

ON 4 JULY 1851 PRESIDENT MILLARD FILLMORE, WITH appropriate civic and Masonic ceremony, laid the cornerstone for a major extension to the United States Capitol Building (fig. 1).[1] The event marked the beginning of a phase of Capitol expansion and decoration that would take more than a half-century to complete. The need for a Capitol extension had been brought on by the rapid growth of the legislative branch of the federal government during the preceding quarter-century. Indeed, by 1850, a mere twenty years after the completion of the Old Capitol Building by Charles Bulfinch (1763–1844),[2] the overcrowded conditions within the Houses of Congress had become so serious as to require immediate attention.

Consequently, on 30 September 1850 Congress had approved an act containing a provision for the enlargement of the Capitol, allocating $100,000 to be expended at the direction of Fillmore who was given final responsibility for the design and the selection of an architect.[3] Acting under this authority, Fillmore had appointed Thomas Ustick Walter (1804–87) as the architect of the Capitol Extension and, early in June 1851, had approved a general outline of Walter's plan that called for two wing buildings to be placed to the north and south of the Old Capitol but connected to it by corridors.[4]

On 23 March 1853 President Franklin Pierce, Fillmore's successor, issued an order directing that the jurisdiction over the Capitol Extension be transferred from the Department of the Interior to the War Department (the commissioner of public buildings and grounds retained control over the central portion of the building or the Old Capitol) and that the secretary of war, Jefferson Davis, designate a suitable officer to take charge. Pursuant to Pierce's order Davis appointed Captain Montgomery C. Meigs (1816–92), an army officer from Philadelphia, as superintendent of the Capitol Extension.[5] Under Pierce, Davis and Meigs were given full authority over the planning and construction of the extension.

Walter's original plans for the Capitol Extension did not show pediments over the eastern porticos of the north and south wings (fig. 2). Meigs, however, soon proposed a number of changes to Walter's designs including the introduction of a pediment over the east front of each wing (fig. 3).[6] These modifications were approved by Pierce on 27 June and 5 July 1853.[7] Meigs believed the pediments would not only improve the aesthetic presentation of the buildings, but also provide a valuable opportunity for American sculptors to display their developing skills.

In early July 1853, Meigs wrote to Edward Everett of Boston for his opinions regarding the American sculptors most capable of designing the Capitol pediments "in such a manner as to reflect honor upon themselves and our country."[8]

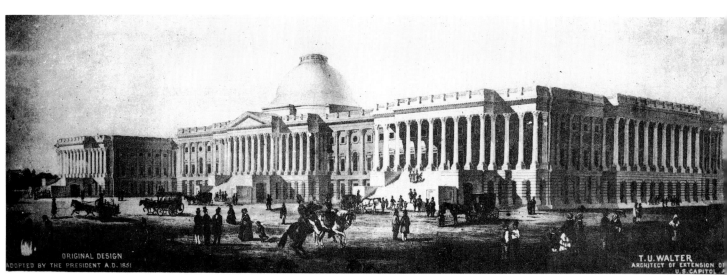

Fig. 2. Exterior Design of Capitol Extension Approved by President Fillmore in 1851. From Glenn Brown, History of the United States Capitol *(Washington, D.C.: U.S. Government Printing Office, 1900–1903), 2:plate 164. Photograph: Architect of the Capitol.*

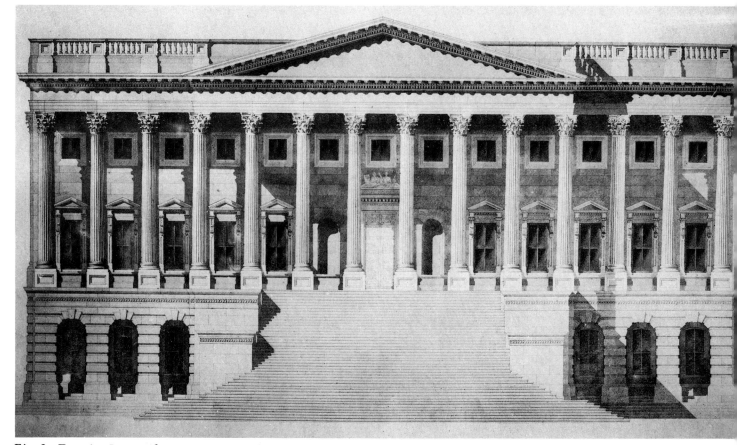

Fig. 3. Exterior Design for East Portico of the North and South Wings, 1853. From Glenn Brown, History of the United States Capitol *(Washington, D.C.: U. S. Government Printing Office, 1900–1903), 2:plate 182. Photograph: Architect of the Capitol.*

Hoping to get the best sculptural decoration possible for the new wing buildings yet aware of his own limited experience in the visual arts, Meigs was eager to rely on the advice of Everett, a respected connoisseur and amateur art critic whose taste in sculpture reflected the classical thought dominant in America since the early years of the Republic.[9] Responding quickly to Meigs's letter, Everett suggested two expatriate neoclassical sculptors, Hiram Powers (1805–73), whom he personally considered to be "the first living artist," and Thomas Crawford (1813?–57), as the most competent Americans to design and execute the proposed sculptural pediments for the Capitol.[10]

Following Everett's recommendation, Meigs wrote to Powers in Florence and Crawford in Rome, inviting each of them to submit a design for the enrichment of one of the pediments together with an estimate of cost. Referring to the highly symbolic "naked Washington" by Horatio Greenough (1800–1852), a seated portrait statue commissioned by Congress in 1832 and "unsparingly denounced by the less refined multitude," Meigs cautioned each sculptor to avoid "too refined and intricate allegorical representations" as "not altogether adapted to the taste of our people." Meigs concluded:

In our history of the struggle between civilized man and the savage, between the cultivated and the wild nature, are certainly to be found themes worthy of the artist and capable of appealing to the feelings of all classes.[11]

Crawford promptly accepted Meigs's proposal, informing the superintendent that he would begin work at once on a suitable design that was "intelligible to our entire population." Meigs encouraged the sculptor to prepare sketches as quickly as possible and to avoid any undue publicity regarding the commission until his designs were officially adopted. In this way Meigs hoped to mitigate congressional interference, reasserting to Crawford that control over the extension buildings "is expressly committed to the President by law, by him placed in the hands of the Secretary of War, under whose order I am in charge." By the end of October 1853, Crawford had submitted photographs of his designs to Meigs who found them "appropriate and intelligible."[12]

Taking a cue from Meigs's own written comments regarding possible themes, Crawford designed a pediment illustrating the progress of civilization on the North American continent from a primitive, savage state, represented by the extinction of the American Indian and the taming of the wilderness, to a more advanced condition of cultivation and material progress. It was a bold statement of the doctrine of manifest destiny, an idea central to American thought at mid-century (fig. 4). As completed, the pediment is dominated at center by a female personification of America. To America's left is a pioneer felling a tree and an Indian group representing the demise of the aboriginal races, while to her right there are a variety of figures that reflect the values of the new masters of the continent: the soldier (War), the merchant (Commerce), the schoolmaster (Education), and the mechanic (Industry).

On 30 November 1853, less than four months after Crawford was first contacted regarding the pediments of the Capitol Extension, Meigs notified the sculptor that his designs had been accepted by Secretary Davis and President Pierce.[13]

Unlike Thomas Crawford, Hiram Powers declined the offer to submit a design for one of the proposed pediments. In late September 1853, he wrote Meigs:

I thank you much for the frank and kind spirit in which you have written to me. But I have not the time to prepare designs for the decoration of the Capitol Buildings even if it were a desirable object with me to *propose* for a commission from the Government of my country.[14]

One may wonder why Powers flatly rejected Meigs's request. The captain suspected that the sculptor considered himself above the level of a mere competitor and was put off by the fact that his designs would be subject to the approval of public officials.[15] While this notion is plausible, there may have been another reason for the expatriate sculptor's refusal to accept Meigs's proposal.

By the summer of 1853 Powers had grown impatient over the continuing reluctance of the United States Government to purchase his allegorical statue of *America*, a figure Powers had been working on since early 1848 with the intention that a marble version should be housed one day in the Capitol Building in Washington. Beginning in 1850 Congress had made numerous attempts to commission the statue, but all had

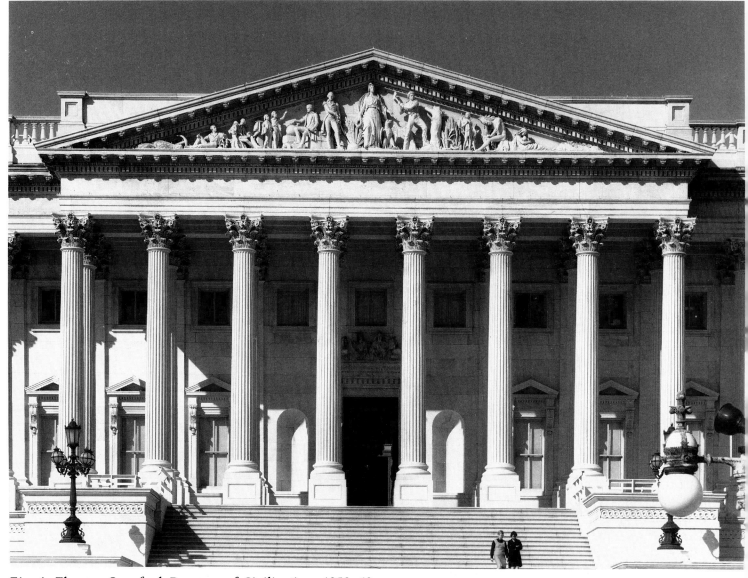

Fig. 4. Thomas Crawford, Progress of Civilization, *1853–63. Marble, Pediment for the Senate Wing of the United States Capitol Building. Photograph: Architect of the Capitol.*

failed. Thus, when Meigs's proposal regarding the Capitol pediments reached Powers, the sculptor was already in a disagreeable temper with respect to government patronage.[16] Powers was irritated further when he learned that Crawford had agreed to Meigs's request, the conditions of which Powers considered to be exploitive.[17]

Despite Powers's recalcitrance Captain Meigs and Secretary Davis seemed committed to the idea that the commission to decorate the second pediment should go to him, or, if he would not consent, then to another American sculptor of comparable skill and ability. In the summer of 1855 their resolve was put to the test when the

War Department received an offer from the French sculptor and history painter Antoine Etex (1808–88) to execute the second pediment of the Capitol Extension. As a sculptor Etex had enjoyed considerable international renown since the 1830s largely as a result of the two reliefs he had created for the Arc de Triomphe in Paris.[18]

Etex came to America in 1855 to determine the status of his large historical painting, *To the Glory of the United States*, a work that he had sent to the Crystal Palace Exhibition (1853) in New York City. By July of that year Etex had left New York for Washington where he hoped to convince the American government to purchase his painting.[19] In Washington he was entertained

at the White House by President Pierce who may have suggested that he inquire into the un-awarded House pediment. Unfortunately for Etex the response he received from those in charge of the extension left no doubt of the importance they had assigned to the national character of the commission:

This pediment has already been offered to an American Artist of high reputation among his Countrymen, and although his other engagements have caused him to decline it, his friends have lately been informed that the work still remains open to him should he be able to undertake it. Under these circumstances it is not considered proper to offer the Commission to another artist. I must add also that the field for Art in America has hitherto been so limited that it would perhaps be hardly generous to our young and struggling artists to give to a foreigner one of the first two Pediments ever decorated under the auspices of the Government. I acknowledge the truth that art is Cosmopolitan, yet the great works of Europe do not afford opportunity to our Artists, and the unfolding genius of our people can find no sphere in this Department of Art but that afforded by such works at home.[20]

Meanwhile, Meigs had offered another commission to Crawford in connection with the Capitol Extension: the reliefs for the bronze doors of the Senate entrance. Excited about Meigs's newest proposal, Crawford took advantage of a lull in his studio work in Rome to make a quick trip to Florence in order to study the famous bronze doors of the Baptistry by Lorenzo Ghiberti. While in Florence Crawford learned directly from Powers of his refusal to participate in the proposed work at the Capitol. Crawford tried to get Powers to reconsider and at one point even offered him the entire commission, but Powers remained adamant.[21]

Convinced of Powers's obstinacy regarding the matter, Crawford, upon his return to Rome, wrote Meigs offering his services for the second pediment. But Meigs was not ready to award both pediments to the same sculptor. He told Crawford that in lieu of Powers he would prefer to give the second pediment to some other deserving American sculptor, provided, of course, that he met the demands of the commission.[22]

Actually, Captain Meigs had not yet given up entirely on Hiram Powers. As late as the summer of 1855 Meigs could still report with guarded optimism to Jefferson Davis:

No other artist has been invited to prepare designs for this pediment, and I should be very much gratified now to receive from Mr. Powers an intimation that he was willing to put his talent at the disposal of his country for this purpose.[23]

In this hope Meigs had been encouraged by a number of Powers's friends and supporters, namely Samuel Yorke Atlea, S. G. Asher, and especially Edward Everett, all of whom had urged Meigs not to consider his negotiations with the sculptor closed until they had had a chance to persuade him to change his mind.[24] Nonetheless, by the autumn of 1855 the likelihood that Powers would ever reverse his decision seemed increasingly remote,[25] and, inasmuch as Crawford continued to make rapid progress in modeling his figures for the Senate pediment,[26] Meigs was growing more and more anxious to resolve the situation on the House side.

1855–1857: Henry Kirke Brown and Thomas Crawford

The first American sculptor officially to submit designs for the decoration of the House pediment of the Capitol Building was Henry Kirke Brown (1814–86) of Brooklyn. As a young sculptor Brown had received a thorough training in the classical tradition during a lengthy stay in Italy. However, unlike most American sculptors working in Italy during the 1840s and 1850s, Brown became convinced that only in America could a truly native tradition of sculpture take root and flourish.[27]

In 1846 Brown returned to America ready to dedicate his career to the pursuit of an American sculptural art based on American meanings. Despite Brown's commitment to furthering sculpture in his native country, however, he often continued to rely on motifs borrowed more or less directly from the classical past. But he did seek to loosen the grip of the antique on his work by adopting a more vigorous, naturalistic style, and, in his eagerness to establish the uniqueness of American sculpture, he turned to the kind of subject matter that would be recognizable as distinctly American.

Early in November 1855, Brown traveled to Washington in search of a government commission in connection with the decoration of the new Capitol wings. On a previous visit in May 1849, Brown had been severely critical of the statuary at the Capitol Building, particularly Luigi Persico's *Discovery Group*, 1837–44, and Horatio

Greenough's *George Washington*, 1832–41. What had distressed him was not so much the uninspired execution of these works but rather their essentially Italianate, neoclassical character.[28] Now, as he made his way to Washington in the hope of securing his own national commission, he was keenly aware of the opportunities such a commission would provide for representing American experience in a manner more in keeping with the will and spirit of the American people.

At the Capitol Brown presented himself to Meigs who treated him to a personal tour of the building and grounds. Meigs showed Brown the models that Crawford had recently completed for the Senate pediment representing the triumph of white civilization. At the time of Brown's visit to Washington Italian stonecutters already had begun the task of carving Crawford's figures in marble; the work was being carried out in statuary shops that had been erected on the Capitol grounds for this purpose.

The two men also discussed the various art commissions still to be awarded in connection with the new wings including "a pediment to match Crawford's, which Powers had refused."[29] Meigs told Brown that the commission was still open to Powers but that he doubted Powers would ever propose a design for it. When Brown asked if he could prepare a design for the pediment Meigs replied that he "could not invite him to submit one" but "that if any American sculptor presented a design of *pre-eminent* merit" he "thought it would be likely to be adopted."[30]

In his dealings with Brown the captain clearly hoped to avoid a public competition between two equally matched American artists, a preference he had followed since the beginning of his tenure as superintendent. From Meigs's point of view the private selection of a sculptor had several advantages. For one thing, it eliminated the public display of choosing the design of one artist over that of another, a situation many artists also found distasteful. Furthermore, by avoiding a public competition Meigs could maintain greater control over the final decision.

Brown had been impressed with the work he saw in progress at the Capitol, and he left Meigs's office excited about the possibilities of helping to decorate one of the grandest public buildings in America. Later that evening he wrote to his wife:

This morning . . . went to the Capitol of my country, and since then, that whole building has been revolving in my brain, with ten thousand other thoughts . . . more eternal than buildings.[31]

Brown returned to Brooklyn, and before three weeks had passed he informed the superintendent:

I have been making a design for the Pediment which I soon hope personally to submit to you. I do not think my subject will in any way conflict with those already adopted, it having only one connected thought for its object (viz., America). . . . I am not expecting favoritism, nor am I building too strong hopes upon what I know to be an uncertainty, but I do rely upon an impartial judgement which shall consider the merits of my designs.[32]

On 15 December 1855 Brown notified Meigs that his design for the second pediment was completed and that as soon as photographs were made he would see that they were forwarded to Washington.[33] In fact, to insure that his initial sketch model for the House pediment be judged as quickly as possible, Brown decided to deliver the photographs to Meigs personally. Arriving in the Capitol on the Monday before Christmas, Brown immediately called on the captain and presented him with the evidence of his past months' work. The photographs that have survived (fig. 5) reveal a pediment dominated at the center by the majestic figure of America, her arms outstretched in a broad gesture of welcome and protection, while to either side are arranged various figures representing the institutions and "material interests" of the country.

The most curious aspect of Brown's design is the depiction of the institution of slavery, which is represented by a single black man sitting on a bale of cotton (fig. 6). In mood and pose Brown's slave is comparable to Crawford's *Dying Indian Chief* (fig. 7) in the Senate pediment: not only are both figures derived from the same antique prototype, the *Torso Belvedere*, ca. 150 B.C., by Apollonios of Athens, but also they contemplate a similar fate—racial subjugation at the hands of the white man.[34] Still, one has to wonder why Brown, an outspoken abolitionist from New England, would want to include a southern slave in his design. Given Brown's strong opposition to slavery, his choice of imagery seems contradictory to say the least.

One explanation for the presence of the slave was Brown's belief that an artist was duty bound to create works that embodied the significant is-

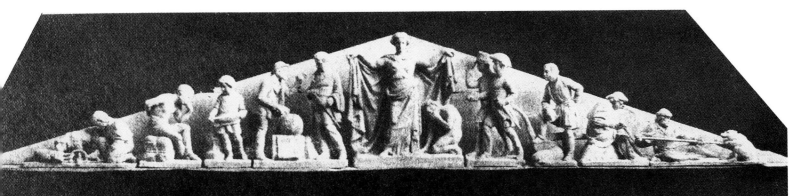

Fig. 5. Henry Kirke Brown, America, *first design for the House Pediment, 1855. No longer extant. Photograph: Henry Kirke Bush-Brown Papers, Manuscripts Division, Library of Congress, 3:832F.*

sues and emotional temper of his time. Brown's friend and fellow abolitionist, William Morris Davis, expressed these sentiments in a letter he wrote to the sculptor in May 1855:

What is the characteristic of the *present age* of *today?* Is not the battle waxing hot between Right and Wrong, Truth and Error, Liberty and Slavery. Are not circumstances of mighty power compelling men and nations to side with one or the other. . . . Can not some gifted mind embody the present in a work that will leave to the future a "sign of the times" that will plead for Truth, Liberty and Right. To short sighted man, the triumph of wrong seems imminent, yet it cannot be, the right must prevail. Yet it behooves every well wisher of his kind to lay his hand to the work according to the gift bestowed upon him.[35]

Brown himself wrote that he hoped his slave "might move and awaken a national feeling in regard to its importance." In other words, he thought a monument to slavery on America's most symbolic public building might shake the country out of its prevailing mood of compromise and force a resolution to the slavery question once and for all. Of course, regardless of any possible artistic merit, Brown's design, politically speaking, was inconceivable. Meigs politely recommended to Brown that he change his design before submitting it to Jefferson Davis. The sculptor reluctantly agreed but remarked that he felt as though he "had also kneeled to slavery."[36]

Some three years later Brown got a second opportunity to place before the public a bold sculptural statement regarding the issue of slavery. In the spring of 1859, well after his proposed models for the House pediment were completed, Brown accepted an offer to execute the statuary for the central pediment of the State Capitol Building then under construction in Columbia, South Carolina. As Wayne Craven has noted, this commission—like the House pediment before it—assumed a national as well as local importance:

There were those in the South who had long seen as inevitable the separation of the Union; when this occurred, many envisioned Columbia as becoming the capitol of the southern confederacy, which meant that the Columbia State House might well become, in effect, a national Capitol. This gave added prestige to the building and called for a special kind of imagery in the building's sculptural decoration.[37]

Brown's pediment for the South Carolina State House was never completed; the start of the Civil War forced the sculptor to suspend all work on the project in May 1861, and, eventually, the plaster models and any marble figures that Brown may have produced were destroyed by General Sherman in 1865 during his march to the sea.[38] However, several photographs included among the Henry Kirke Bush-Brown Papers at the Library of Congress in Washington show Brown's clay or plaster sketch models for the commission (figs. 8 and 9).

As the photographs indicate, three classically inspired female personifications occupied the middle portion of Brown's design; the central figure represented *South Carolina* while to her immediate right and left stood *Liberty* and *Justice* respectively.[39] But what is most striking about Brown's design, and what ties it to the sculptor's first sketch for the Capitol pediment in Washington, is that the two remaining sides

Fig. 7. Thomas Crawford, The Dying Indian Chief, Contemplating the Progress of Civilization, *1856. Marble, Courtesy of The New-York Historical Society, New York City.*

Fig. 6. Henry Kirke Brown, Negro Slave Sitting on a Bale of Cotton, *or* Thinking Negro, *detail from Brown's first design for the House Pediment, 1855. No longer extant. Photograph: Henry Kirke Bush-Brown Papers, Manuscripts Division, Library of Congress, 3:1355B.*

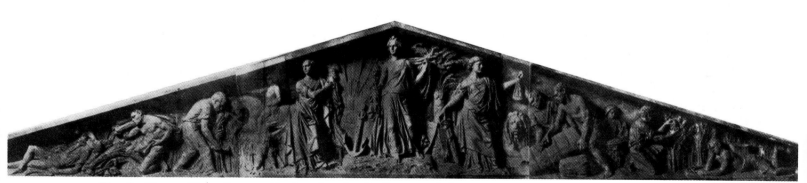

Fig. 8. Henry Kirke Brown, Design for the Pediment of the South Carolina Statehouse, *1859–61. No longer extant. Photograph: Henry Kirke Bush-Brown Papers, Manuscripts Division, Library of Congress, 5:1333+1.*

Fig. 9. Henry Kirke Brown, Sketch Models for the Central Figures of the Pediment for the South Carolina Statehouse, *1859–61. No longer extant. Photograph: Henry Kirke Bush-Brown Papers, Manuscripts Division, Library of Congress, 5:1368A.*

of the composition were dedicated to the institution of slavery (figs. 10 and 11). Here, Brown represented docile black men and women peacefully going about their various daily labors in the field while a benevolent plantation overseer (located just to the left of *Liberty*) supervised from horseback.

Although there is nothing even remotely negative or accusatory about Brown's imagery (this is explained by the fact that it was created specifically for southern patrons), in view of the sculptor's personal beliefs we must assume that he intended his new design to embody a motive similar to that of his earlier rejected sketch for the House pediment; that is, the condemnation of slavery on moral grounds. Surely, William Morris Davis's interpretation of the design for the South Carolina pediment was shared by Brown himself:

A mind educated in the belief that the laborer is worthy of his hire, while admiring the majesty and beauty of the central figures . . . might question whether Justice presiding over enforced and unrequited toil, should not naturally end in ragged, aimless, and improvident sloth: or that Liberty, wresting the harvest from the reaper's hook, should not naturally terminate in death-like stupor and exhaustion. Such a mind might question, whether the stooping slave bearing the rice sheaf, is not borne down by a burden greater than the grained straw? Whether the low-crouched form, the abject helplessness expressed in every feature, tell not a piteous tale of a crushed manhood and an outraged spirit within.[40]

While the complexity of Davis's interpretation might have satisfied the philosopher or the moralist, the fact remains that the ambiguity and political passivity of the design reflected the extent to which Brown had to imply or even disguise the true meaning of his imagery in order to complete the commission successfully. That Brown was willing to compromise his art in this way is perhaps more telling of the crisis in American values at the time than it is revealing of the sculptor's individual creative process. Still, it is ironic that the prevailing atmosphere of compromise regarding slavery that Brown found so reprehensible would become such a prominent feature of his own ill-fated pedimental design.

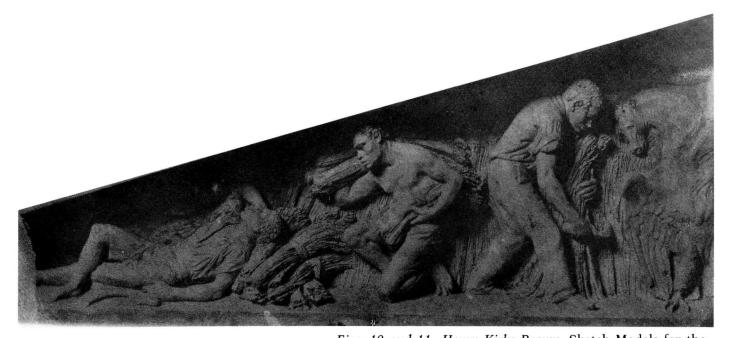

Figs. 10 and 11. Henry Kirke Brown, Sketch Models for the Side Figures of the Pediment for the South Carolina Statehouse, *1859–61. No longer extant. Photograph: Henry Kirke Bush-Brown Papers, Manuscripts Division, Library of Congress, 5:1369A, 5:1369B.*

After his meeting with Meigs in late December 1855, Brown immediately returned to Brooklyn and began working on a second design for the decoration of the House pediment. On 21 January 1856 he informed Meigs that he had omitted the objectionable part of his design and substituted a miner in its place.[41] A week later Brown wrote William Morris Davis that his new design was finished and that as soon as photographs were taken he would send them to Washington for another judgment. Brown confided to Davis that he was not discouraged by the failure of his first design, nor did he blame Captain Meigs for his objections to the slave; rather, he felt that Meigs "was acting under a restraint" and thought that the superintendent was simply taking the wisest course of action to secure the eventual success of his design.[42]

On 12 February 1856 Brown prepared a package containing photographs of his second design (fig 12). The following day he sent the package on to Washington with his founder, Joseph T. Ames, of Chicopee, Massachusetts, who had stopped in Brooklyn on his way to the Capitol.[43] The photographs were accompanied by a letter to Meigs in which Brown gave a detailed description of the new design:

You will see by it [the new design] that my country is no myth in my eyes and that I have had recourse to no unfamiliar symbols to express my idea of it, but have sought the America of today surrounded with the material interests which stimulate her children to action. America occupies the central position in the group extending her blessing and protection alike to all, not merely to her own citizens, but to the poor and distressed foreigner who kneels at her feet on the left. On her right are the anvil, wheel and hammer representative of the mechanic arts. The first standing figure to the left of America represents a citizen depositing his vote in the ballot box, a very distinguishing feature of our country and the symbol of equal rights. Next to him is the farmer cultivator of the soil, ingenuous and simple resting on his plow with the products of his labor at his feet. Next comes the fisherman seated upon his upturned boat mending his nets. Lastly upon that side is the brave and athletic hunter combating the wild animals. I have placed him upon the outskirt of civilization showing him to be hero of all border strife and hardship.

Upon the other extremity is the Indian trapper in whom I have desired to express that stillness and wariness peculiar to his race. Beside him are his dog, trap and the dead object of his pursuit. He stands for the interests of the fur trade.

Next to him I have introduced the miner, or gold seeker of California with his pick, shovel and pan. Next the American boy, frank and brave, with his little boat which he evidently intends to launch upon the first convenient sheet of water. He is the promise

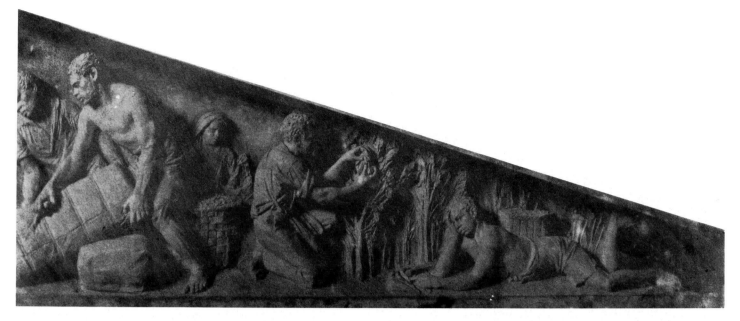

of commerce and navigation, the perpetual renewal of the hope of all. Next the old weather-beaten navigator and discoverer demonstrating with globe and maps the characteristics and resources of the countries he has found and exhibiting a specimen of mineral ore to the statesman, who stands attentively considering his propositions. . . .

In this specific idea of America I have represented my country as showing favoritism to no class, she holds out no prizes to any, but distributes equal blessing to all trades and professions.[44]

Brown ended his description with a passionate statement about the importance of creating an authentic American art based on specific American meanings without resorting to foreign conventions:

My feeling is that all art to become of any national importance or interest must grow out of the feelings and the habits of the people and that we have no need of the symbols or conventionalities of other nations to express ourselves. Our country has a rich and beautiful history to illustrate . . . and every American artist should endeavor to infuse into his works all the vitality and national policy in his power that when future generations shall look back upon his work they may see that he has expressed himself with truthfulness and honesty.[45]

In order to stress the "Americaness" of his design Brown turned for inspiration to the contemporary American scene, and, like the content in Crawford's north pediment, Brown's subject matter parallels certain themes common in American painting at the time. For example, Crawford's interest in the doctrine of manifest destiny relates his imagery to paintings such as Asher B. Durand's *The Progress of Civilization*, 1853, and George Caleb Bingham's *Fur Traders Descending the Missouri*, 1845. As far as Brown's figures are concerned, the citizen depositing a vote in a ballot box recalls Bingham's political scenes, such as *The County Election*, 1851–52. On the other hand, the miner panning for gold and

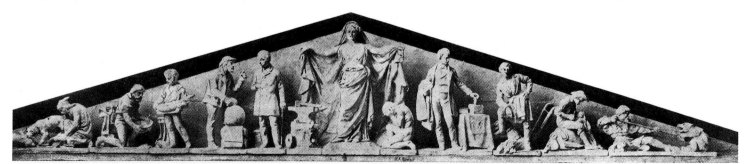

Fig. 12. Henry Kirke Brown, America, *second design for the House Pediment, 1856. No longer extant. Photograph: Henry Kirke Bush-Brown Papers, Manuscripts Division, Library of Congress. 3:832G.*

the explorer showing a piece of ore to a states-
man allude to westward expansion and the com-
mercial destiny of America, themes that were
often evoked in contemporary history painting.[46]

One of the figures in Brown's design, the
farmer resting on his plow, may have been in-
spired by a painting already at the Capitol—*The
Calling of Putnam from the Plow to the Revolution*
(fig. 13; see color section) by the Italian artist
Constantino Brumidi (1805–80). Brumidi had
studied modeling with Thorwaldsen and Canova
and painting with Baron Camuccini before emi-
grating to America following the French occupa-
tion of Rome in 1849. He became an American
citizen in 1854. The following year Meigs hired
him to provide mural decorations for the Capi-
tol, a project that engaged the artist for more
than twenty-five years.[47]

*The Calling of Putnam from the Plow to the
Revolution* is part of a fresco cycle begun by
Brumidi in the spring of 1855 to decorate the
Committee Room on Agriculture, which is today
a meeting room for the House Committee on Ap-
propriations. *The Calling of Putnam* occupies a
lunette on the west wall of the room while a par-
allel story from Ancient Roman history, *The Call-
ing of Cincinnatus from the Plow* (fig. 14; see color
section), is on the opposite wall. The two frescoes
are among the first works of art completed for
the new wings.[48] Brown probably viewed them
in early November 1855, when he first came to
Washington to see Meigs. On the morning of his
arrival at the Capitol Brown had passed several
hours with Brumidi, who, Brown later wrote,
was painting a fresco in one of the rooms of the
Capitol. Less than a month earlier, Meigs had
reported to Jefferson Davis that Brumidi was
working on a fresco in "one of the rooms of the
basement of the South wing," almost certainly
the Committee Room on Agriculture.[49]

The Calling of Putnam illustrates a famous epi-
sode in the life of Israel Putnam, one of the he-
roes of the American Revolution. According to
historical accounts, Putnam received news of the
Battle of Lexington while he and his son were
plowing in the fields. Following in the footsteps
of his Roman counterpart, Cincinnatus, who left
his farm to fight for Rome, Putnam immediately
mounted a horse and rode to Boston to offer his
services in defense of his country. Brumidi's
fresco shows the decisive moment in the drama
as Putnam turns from his work, the reins of the
plow horses still in his left hand, to receive word
of the battle from the man on horseback to his
right.[50]

Certain resemblances between Brumidi's im-
age of Putnam and the farmer from Brown's de-
signs suggest that the fresco may have informed
Brown's handling of this portion of the pedi-
ment. Not only do both figures assume a similar
pose with one leg raised and resting on a rock,
but also in each case a plow is prominently dis-
played in the immediate background. Further-
more, the proximity of the farmer to the soldiers
in Brown's original design suggests the sculp-
tor's intention to link the figure with the Revolu-
tion. In any case, associating his farmer with a
famous American hero, and one already depicted
within the walls of the Capitol, could only en-
hance the national identity of Brown's pediment

*Fig. 15. Citizens Bank of Washington, D.C. Bank Note, 1854.
Photograph: Krause Publications/James A. Haxby.*

and improve its chances for acceptance. Besides, such associations made good artistic sense especially in view of Brown's search for distinctly American types.

In his determination to Americanize his pediment Brown may have sought further inspiration among the pages of popular literature or the work produced in connection with the business of bank note engraving. Artists such as Felix O. C. Darley (1822–88) and John Casilear (1811–93)—as well as many others of lesser reputation associated with the numerous engraving firms active during the period—produced literally hundreds of illustrations rooted in the everyday particulars of common American experience. Stylistically unpretentious and full of descriptive detail, the engraved images on bank notes would have been an especially rich source for this kind of iconography (see fig. 15). In fact, not long after Brown's designs were finally rejected a writer for *The Crayon* challenged those in charge of the Capitol Extension for employing foreign artists (like Brumidi), arguing that American designers of bank note engravings would "choose more appropriate subjects, and treat them better, than those accepted and painted on the walls of this building."[51] That Brown profited from a familiarity with bank notes in preparing his sketches for the House pediment is suggested by the fact that in his second design he placed at America's right hand an anvil, hammer, and wheel, accessories commonly found on contemporary bank notes.[52]

On 20 March 1856, more than a month after Brown had sent the photographs of his new design to Washington, Captain Meigs forwarded one of the photographs accompanied by its description to Jefferson Davis with the recommendation that Brown's design be rejected. Six days later Davis wrote his response on the cover of Meigs's letter: "Capt[ain] Meigs will answer Mr. Brown's letter declining his proposition in terms the most acceptable to this artist."[53] Needless to say, after nearly four months of concentrated effort during which time he completed the sketch models for enough sculpture to fill two pediments, Brown was bitterly disappointed over losing the commission. He wrote a friend:

I rec[eive]d the stamp of fate upon my bald head the other day. H. K. B. is not to figure nor highfallute in the Cap[i]t[o]l of his country. No, my young fellow you have not poetry enough. You have chosen your subjects from low life—your genius is too groveling.[54]

Despite the fact that Brown's designs were rejected and his models were never executed in stone, his work with respect to the House pediment—and the South Carolina State House—is significant for it represents one of the earliest attempts in American sculpture to produce native figural types grounded in realism and essentially free of foreign influence. For this reason, Brown deserves to be appreciated as one of the first native sculptors to have shed the stylistic conventions of neoclassicism in favor of American authenticity.

Interestingly enough, Brown's progress in this regard probably contributed to the failure of his sketches to meet with the approval of those in charge of the Capitol Extension. Stripped of the veneer of classicism that characterizes Craw-

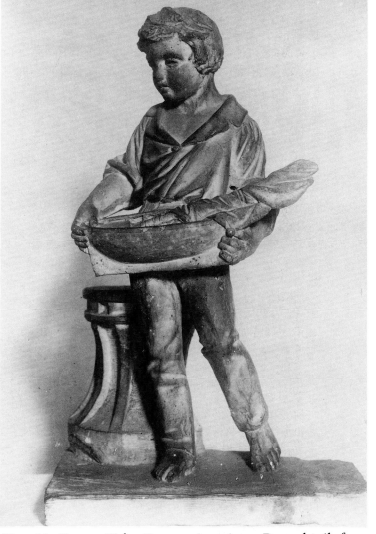

Fig. 16. Henry Kirke Brown, American Boy, *detail from Brown's second design for the House Pediment, 1856. Plaster cast, no longer extant. Photograph: Henry Kirke Bush-Brown Papers, Manuscripts Division, Library of Congress, 3:382H.*

ford's pediment, Brown's designs may have seemed stylistically out-of-step with their intended architectural setting; or, perhaps, Meigs felt they simply lacked the proper sense of grandeur for so prominent a public building, a suspicion that the sculptor himself seemed to share. In any event, one thing is certain: no longer conceived in terms of the classical tradition with its allusions to republican virtue, the meaning of Brown's designs seems reduced to mere anecdote and sentimentality (fig. 16). Brown's inability to imbue his figures with the level of symbolism required of such a commission is not surprising. Not until much later in the century would American artists eventually learn, through the example of French sculpture, how to create convincing monumental imagery without the need to rely on aesthetic formulas derived from the antique.[55]

Brown's failure to win the commission to decorate the House pediment apparently convinced Meigs that no other American sculptor could match Thomas Crawford's skill or imagination in handling such a complex assignment. Consequently, on 2 May 1856, less than five weeks after Brown's design was rejected, Meigs wrote Crawford asking him to prepare a design for the second pediment of the Capitol Extension.[56] Crawford was in Paris preparing to leave for America when he received Meigs's letter, which had been forwarded to him there from Rome. Crawford waited until he reached New York in late July before sending his reply to Meigs. "I shall give the subject my most serious attention," he assured the superintendent, "and though I cannot promise to offer a design immediately yet you may rely upon having the best I can give before the end of Dec[ember] next."[57]

Crawford had returned to the United States to visit family and friends and to seek new commissions. He arrived in Washington at the beginning of August to discuss with Meigs the status of several current projects associated with the decoration of the new extension buildings. Besides the Senate pediment, Crawford had received commissions from Meigs to design the bronze doors of both the Senate and House wings, two allegorical figures of *Justice* and *History* to go above the east entranceway of the Senate, and a figure representing *Armed Freedom* to surmount the Capitol dome. During his stay in Washington, Crawford also tried to finalize plans for the second pediment. He was unable to do so, however,

for Meigs's authority over the construction of public buildings was then under serious challenge by the Congress.

Only a few months earlier, Representative Edward Ball of Ohio had spoken in Congress against the management of the Capitol Extension by the War Department, reserving special criticism for Meigs's handling of the sculptural decorations for the new wings:

Are gentlemen aware that this Government has become an extensive manufacturer of statuary? It is even so. Just around the corner may be found two shops filled with Italian and German sculptors busily engaged in manufacturing statuary to be placed in the east pediment of the two wings [only the Senate wing]. This too is with no authority of law that I can find unless under the general authority to construct the two wings to the main building. . . . The statuary in question does not seem designed to commemorate any historical events or personages connected with this country. It seems to be a mere amateur collection and therefore deserves no place in the national Capitol. The graven images have the likeness to nothing in the Heaven above or the earth beneath.[58]

By the time Crawford arrived in Washington in mid-summer 1856, a bill that could unseat Meigs as superintendent of the Capitol Extension had already passed the House. Under the circumstances, Meigs was in no position to order additional work and Crawford left Washington without a firm commitment regarding the second pediment. Soon after his departure, however, Crawford was relieved to learn that the move against Meigs had been defeated in the Senate and that the captain, fully vindicated, was once again firmly in charge of the extension buildings. The next day Crawford confided to his wife:

You will be glad to hear that an attempt to turn out Capt[ain] Meigs, which succeeded in the [House of] Representatives, was quashed in the Senate. This is important for me, as I think it insures the second pediment; for had he been displaced, someone without taste would have succeeded him and . . . the arts might go a-begging, I fancy.[59]

As Crawford prepared to return to Europe, he remained hopeful that the commission to decorate the House pediment would eventually come to him.[60] Unfortunately, and tragically, Crawford's impending illness and subsequent death the following year from a brain tumor would prevent him from ever actually producing any work in connection with the commission. Already during his final days in America the sculp-

tor had developed pain and a marked swelling in his left eye, the first signs of his fatal condition. By that November the illness had progressed to the point where Crawford's ability to work in the studio was severely hampered.[61]

In mid-January 1857, Crawford left Rome for Paris seeking expert medical treatment for his worsening condition; his wife, who had remained in America since the previous summer, soon joined him there. The following May they went to London in search of further medical advice but nothing could be done to prevent the sculptor's inevitable decline.[62] In late August James Clinton Hooker, a banker from Rome and a friend of the Crawfords, notified Meigs: "Within the past few weeks all hopes of Mr. Crawford's ever being able to resume his labors have passed away, and the duration of his life is quite uncertain." Referring to the House pediment, Hooker explained:

The other works which you had spoken to him about, a pediment, if I remember correctly what he told me, of course cannot be executed as there are no models or designs. He has been blind for more than three months.[63]

Crawford died in London on 10 October 1857, leaving behind numerous unfinished projects including those begun for the Capitol,[64] and at least one potential commission—the House pediment—still going "a-begging."

1857–1858: Erastus Dow Palmer

Early in 1857 another American artist took a sudden interest in the commission to provide sculptural decoration for the House pediment—Erastus Dow Palmer (1817–1904) of New York. Palmer originally worked as a carpenter in Utica, New York, until about 1846 when without any formal training he began cutting cameo portraits of his family and friends. Over the next few years Palmer gradually abandoned carpentry to concentrate on his career as a sculptor, and in 1849 he moved his family from Utica to Albany where he hoped to receive more lucrative commissions from the state.[65] Because Palmer was self-taught and never studied abroad—he did not even visit Italy until late in life—the character of his art is in some respects more genuinely American than that of Henry Kirke Brown. Nevertheless, Palmer's style is marked by the same idealization of natural form that typifies

the work of American sculptors who were more directly influenced by Italianate neoclassicism.

Palmer began work on a design for the statuary of the House pediment in late February or March 1857. Apparently, he was never officially invited to do so. Existing records suggest, rather, that his involvement in the project was stimulated originally by his friends and supporters who, with or without Palmer's knowledge, contacted Meigs on the sculptor's behalf.[66] A number of them, including Edwin B. Morgan of Aurora, New York, one of the sculptor's closest friends, and Hamilton Fish, the former governor of New York, had taken a great deal of satisfaction in Palmer's growing reputation as an artist particularly following his success in a recent one-man exhibition in New York City. Aware of the potential for federal patronage in regard to the new buildings in Washington and desirous of a local artist receiving national recognition, Palmer's supporters naturally were anxious to see the sculptor apply his burgeoning talent to a more ambitious project. Meigs, once contacted about the commission, probably agreed to consider Palmer's design as long as it was clearly understood that it in no way secured him the commission.

Regardless of the expectations, or lack of them, under which Palmer labored, by early April 1857, he had completed an initial sketch for the pediment. He chose as his theme the arrival of the Pilgrims in America. On 10 April 1857 Hamilton Fish wrote Meigs that a photograph of Palmer's design would soon be forwarded to him in Washington and that it deserved the superintendent's close attention. Three days later Edwin B. Morgan also wrote to Meigs in support of Palmer's design.[67]

In his letter Morgan enclosed an article that had appeared in the *Albany Evening Journal* on 10 April 1857. The article gave a lengthy and detailed description of Palmer's composition:

The design represents the Landing of the Pilgrims at Plymouth, or, more strictly speaking, it represents a scene supposed to occur just subsequent to the debarkation. A group of them have gathered round their pastor in various devotional attitudes, while he is standing with uplifted hands, in the act of returning thanks for their safe passage through the perils of the voyage, and imploring Divine aid and guidance in the trials to come.... The central figure is that of the venerable Elder BREWSTER. He is dressed in the simple Puritan garb, while a long cloak hungs [sic] loosely from his shoulders. He stands with his face

turned towards Heaven, and his arms outstretched in devotion. Next to him kneels ROSE STANDISH—her hands clasped and her upturned face glowing with a woman's trust and religious fervor. In strong contrast, by her side, stands Captain MILES STANDISH, with his head reverently bent, but his body erect, rigid and soldierly, and his arms folded on his breast. Just behind him sits upon a chest a more youthful soldier. He leans partially on his gun, his hands resting on the muzzle, while his eyes and his thoughts wander from the religious exercise before him toward the forest around, and the adventure that lurks there. A mother holding upon her knees a babe born on shipboard during the voyage, divides her attention between the pastor and her child. On the right of the central figure kneels a man habited like Standish, and next [to] him an athletic, sturdy Puritan is leaning on the axe that is to hew out a home for him in the wilderness. Behind him are a young girl and two children, and behind them sits Mr. CLIFTON upon a fragment of rock, his head bowed over the open Bible that rests upon his knees, to whose assurances of a still watchful Providence he clings, on this new and untried shore. The savage winter character of the surrounding scene is evinced by the rocks and leafless trees in the background. Behind one of the latter crouches an Indian, listening, and silencing by the motion of his hand the dog that crouches beside him. Behind the rocks upon the left of the group two wolves, half in surprise, half in fear, peer cautiously out. In the distance the mast of the "Mayflower" is seen against the sky.[68]

Soon after receiving the photograph of Palmer's sketch for the House pediment, Meigs replied to the sculptor, sending him a lengthy critique of the design, which the superintendent had found unsatisfactory particularly in terms of grouping and composition. Meigs felt that the space of the pediment was "not enough filled up" and he challenged Palmer's arrangement of figures as "rather too symmetrical." He also criticized the sculptor for "putting the weaker members of the subject in the most dangerous situations," an error in judgment that seemed to the captain to be "casting some stain upon the diligence and prudence of our forefathers," and he questioned the inclusion of a dog with one of the Indians, arguing that "few of the domestic animals were found here by the early settlers. If the dog was here, he is the only one." Finally, Meigs strongly recommended to Palmer that after proper study he should prepare models in the round of his design at least several feet in length overall, the expense of which in time and money he would be willing to cover as long as the cost was reasonable.[69]

A photograph in the collection of the Office of the Architect of the Capitol shows Palmer's final models set into their architectural frame (fig. 17). A comparison between the photograph and the description of Palmer's original design in Meigs's letter and in the Albany Evening Journal reveals that, following the superintendent's advice, Palmer did make several changes. For example, the "mother holding upon her knees a babe born on shipboard," a group originally placed near one of the corners of the pediment, was moved to a "less dangerous situation" just to the left of the central figure, while the kneeling man assumed her vacated position. In addition, Palmer eliminated various components of the initial design including some of the landscape elements, one of the two wolves, and the dog that originally accompanied his Indian master; and, he decided to add a second Indian, which he placed in the extreme right-hand corner of the pediment.

In April 1858 (one year later), The Crayon reported that an exhibition for the benefit of the poor then open in Albany included among other things Palmer's models for the east pediment of the Capitol in Washington. "These figures," the notice explains, "represent the most important among the pilgrim passengers of the Mayflower, and are intended by the artist to symbolize various qualities and virtues." The notice lists the figures with their corresponding virtues, and the arrangement appears to be consistent with the photograph in the Office of the Architect of the Capitol:

Brewster stands alone as the central figure, and he typifies *Hope*; on either side are Rose Standish and Mrs. White and child, who are intended respectively for *Faith* and *Charity*, and on either side of them, adapted to the inclination of the pediment cornice, appear Bradford as *Enterprise*, Standish as *Defense*, Priscilla Mullen and boy as *Purity*, John Alden as *Adventure*, Robinson as *Reverence*, Little Girl as *Investigation*, Carver as *Meekness*, and a crouching Indian and a wolf at the extreme ends as *Danger*.[70]

Yet another description of Palmer's design appeared much later in an article by Frederick G. Mather entitled "History of a Pediment," which was published in the Philadelphia Evening Herald on 11 October 1889. Mather's account differs with the 1858 notice in The Crayon only in the qualities that it assigns to various figures and corresponds in every detail with the Washington photograph. Thus, it almost certainly describes Palmer's models and their placement within the

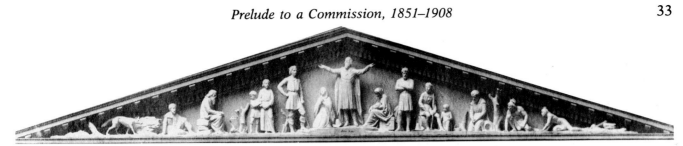

Fig. 17. *Erastus Dow Palmer,* The Landing of the Pilgrims, *design for the House Pediment, 1857. Clay, Albany Institute of History and Art. Photograph: Architect of the Capitol.*

pediment according to the sculptor's final intentions. As seen in the photograph, the figures from left to right are identified by Mather as follows: a wolf; a Pilgrim (Fatigue); Elder Robinson (Fidelity); a child, and Priscilla Mullen (Purity); Governor Bradford (Enterprise); Rose Standish (Hope); Elder Brewster (Faith); Mrs. White (Charity), with her child, Peregrine; Miles Standish (Self-Defence); John Alden (Adventure), and a child; Governor Carver (Meekness); a crouching Indian (Danger); a creeping Indian (Danger).[71]

A major weakness in Palmer's design for the House pediment was the sectional nature of his theme. Recognizing the regional limitations of Palmer's imagery, Joseph Willson, a sculptor from New York City, wrote to Meigs in May 1857, criticizing the design on the grounds that it lacked the proper national significance:

The pediments are the crowning capstones of the Capitol, which is the representative of all our institutions—of the whole country; and designs for those should be as vast and comprehensive, not taking an *incident* of history, but something more general.[72]

Willson then offered to submit a design of his own with a much broader appeal:

Now Crawford's design, it strikes me, is eminently appropriate for the place it is designated for, embracing as it does the rise and progress of civilization . . . but yet it does not nor could not cover all the ground. . . . The arts and sciences; learning, has not a sufficient place there, and is capable of being treated in a grand manner; it strikes me that that is the field for treating the remaining pediment.[73]

In view of the symbolic overtones of the commission, Willson's observations certainly seem valid. Moreover, Palmer proposed his sectional theme at a time of growing political uncertainties when anything that threatened the delicate balance between northern and southern interests was sure to be avoided by those in the federal government committed to maintaining the integrity of the Union. Ultimately, the distinctly northern flavor of Palmer's design was probably enough justification for its rejection regardless of whether or not it satisfied the aesthetic demands of the commission.[74]

One aspect of Palmer's imagery that deserves further attention is his depiction of the American Indian. As already noted, Palmer included two native Americans in his final pedimental design, a Creeping Indian and a Crouching Indian, or *Ambush Chief* (fig. 18), as the plaster cast of the work is entitled.[75] Palmer's Indians symbolized the savagery of the American wilderness that the Pilgrims had to confront and overcome in order to survive in their new home. The Indians also provided an effective contrast to the religious devotion displayed by the Pilgrims. As such, they lack the sense of impending doom that renders Crawford's Indians from the Senate pediment harmless and, essentially, pitiable.

Although Palmer's Indians seem to pose no immediate threat to life or limb, their presence within the composition recalls a well-established tradition in American art and literature of representing the violent confrontation between pious Christian and pagan savage as a metaphor for spiritual enlightenment and salvation. Such confrontations often stressed the exceptional religious faith and the supposed moral superiority derived therefrom of a white female captive threatened with a horrible fate at the hands of her Indian captors. Prominent examples include John Vanderlyn's *The Death of Jane McCrae*, 1804; Thomas Cole's *Landscape Scene from "The Last of the Mohicans,"* 1827, based on James Fenimore Cooper's *The Last of the Mohicans*, published in 1826; and Horatio Greenough's *Rescue Group*, 1836–50, which was assembled in front of the east façade of the Capitol by Robert Mills in 1853. Palmer's own *White Captive*, begun in

Fig. 18. Erastus Dow Palmer, Ambush Chief, *detail from Palmer's design for the House Pediment, 1857. Plaster cast, Albany Institute of History and Art. Photograph: Architect of the Capitol.*

November 1857, and eventually purchased by Hamilton Fish for his New York residence, is also related to this tradition.[76]

Palmer forwarded photographs of his completed models to Meigs in June or early July 1857.[77] The superintendent's personal thoughts regarding the relative merits of Palmer's final proposal are not known, but in view of his remarks regarding the sculptor's initial design they probably were not particularly favorable. At this moment, however, a bigger problem faced the captain than whom to select to decorate the House pediment—his job was once again in jeopardy.

In March 1857, James Buchanan became the fifteenth president of the United States.[78] Buchanan, a conservative, prosouthern Democrat from Pennsylvania, had defeated the more glamorous Republican candidate, John C. Fremont, largely on the basis of his ability to draw support from both northern and southern states. In so doing, Buchanan's election avoided for a short time longer the unsettling prospect of a sectional candidate gaining the presidency. But it also prolonged the uneasy atmosphere of political conciliation in Washington despite deteriorating relations between opposing sectional forces in the country at large. Upon taking office, one of Buchanan's immediate concerns was the incor-

poration of widely disparate factions within his administration—the preservation of the Union probably depended on it—and he chose the members of his cabinet accordingly. Needing a strong representative from the upper South, Buchanan named John B. Floyd, a former governor of Virginia, as his secretary of war.

Many members of Congress had long challenged the authority of the War Department and Meigs, in particular, to supervise the construction and decoration of public buildings, preferring to see such responsibilities removed to the Department of the Interior where they had belonged originally. Also, from the beginning of Meigs's tenure as superintendent of the Capitol Extension he had found himself in constant conflict with the architect of the Capitol, Thomas U. Walter, regarding priority over the planning and construction of the new wings. Both ongoing disputes centered around a fundamental conflict between military and civilian authority in the federal government, but as long as Pierce was president and Davis was secretary of war Meigs's position was always upheld.[79] However, with the election of Buchanan and his subsequent appointment of Floyd, a civilian, as secretary of war, Meigs soon realized he could no longer rely on the political support he had enjoyed under his former supervisors.

For one thing, Floyd was an ambitious politician who realized the patronage possibilities connected with the construction of the new wings of the Capitol and was not above using the privilege of his position to further his own ends. Buchanan, on the other hand, was a cautious, indecisive man, who had little regard for Meigs personally or professionally and was more than willing to defer to the judgment of his secretary of war in matters related to the extension buildings.[80] Under these circumstances, even if Meigs had reacted enthusiastically to Palmer's final proposed design he would have been hard pressed to pursue its official approval.

On 11 July 1857 Meigs sent the photographs of Palmer's design for the House pediment to Secretary Floyd. The package included the sculptor's original sketch and fourteen ambrotypes of the final models as well as Meigs's correspondence with the sculptor and letters of support from several of Palmer's friends. Meigs informed the secretary that "Mr. Palmer bears a high reputation as a sculptor" and that "many persons of taste give him the first place among

sculptors living in this country." But he stopped short of recommending that Palmer's design be adopted.[81]

By this time it was clear to Palmer's supporters back home that the fate of the commission rested in the hands of the secretary of war and the president. Thus, after a consideration of the sculptor's design was not soon forthcoming, a group of Palmer's friends led by Thomas W. Olcott petitioned Floyd and Buchanan once again in the hope of forcing a favorable decision. In late August 1857, Olcott wrote Meigs with four letters of endorsement for Palmer and asked him to deliver them to President Buchanan. Meigs forwarded the letters to Floyd who sent them on to the president, but Buchanan simply referred them back to the War Department without making a decision.[82]

There the matter stood until early November when, at a meeting of Buchanan's cabinet, it was decided rather contentiously that it was impossible to contract for statuary to adorn the House pediment unless it could be shown that the existing appropriation bill specifically authorized such a purchase.[83] Palmer, however, was unwilling to wait any longer and he immediately wrote Meigs asking to be reimbursed for his time and effort in connection with the commission. Pursuant to Palmer's request, on 17 November 1857 Meigs signed an order authorizing the payment of one thousand dollars to the sculptor "for design [and] model for Pediment of U.S. Capitol Extension."[84]

Palmer and his friends suspected, apparently with good reason, that the northern character of his theme had grated on Floyd's southern sympathies and that this had prevented the acceptance of the sculptor's models.[85] Addressing himself to this particular point, another of Palmer's friends in Albany, G. W. Sewell, contacted Meigs in early February 1858, in one final effort to champion the abandoned design:

To obviate any difficulty in the way of the adoption of Mr. Palmer's design, has this occured to you—Take out the figures in the central pediment, and replace them by Crawford's. Put Palmer's in the *North* one, and the landing at Jamestown in the *South*, to be designed, say by [Edward Sheffield] Bartholomew [1822–58] or [Randolph] Rogers [1825–92], you have then the story of both the Cavalier and the Puritan, and as the result and compliment of both, the central design, typical of the grand consummation of the perils and labors of the *whole* . . . you have then one story and a good one. If you can bring this about, I shall

consider the "Union" safe, can't you do it? Is not this a fair *compromise?*[86]

Sewell's suggestion, while imaginative, was quite impractical. Yet one is struck by the directness of his remarks and the concern they indicate regarding the future of the Union. Unfortunately, in formulating his designs for the House pediment, Palmer, like Brown before him, was unable to invoke such nationalistic sentiments without becoming embroiled in the sectional rivalries that moved the country inevitably toward civil war. Ultimately, the exercise of bad artistic judgment and the vicissitudes of pre-Civil War politics had conspired once again to frustrate the hopes of a sculptor seeking the commission to decorate the second pediment of the Capitol Extension.

1857–1861: Thomas Dow Jones, Henry Dexter, and William Randolph Barbee; The U.S. Art Commission

Erastus Dow Palmer was the last American sculptor before the Civil War to mount a sustained effort aimed at winning the commission to decorate the House pediment. Nevertheless, before the outbreak of armed hostilities in April 1861, three other native-born sculptors, Thomas Dow Jones (1811–91), Henry Dexter (1806–76), and William Randolph Barbee (1818–68), all expressed a serious interest in the commission, and at least two of them—Dexter and Barbee—produced models for the pediment. Both Jones and Dexter hailed from the North; thus, in view of the southern bias within the War Department, their efforts regarding the Capitol pediment were more or less doomed from the start. Barbee, on the other hand, was a Virginian, and, while never awarded the commission officially, he probably had President Buchanan's personal endorsement for the job. Indeed, if not for the intervention of the Civil War, Barbee may well have succeeded in executing the statuary for the empty House pediment.

Thomas Dow Jones was originally from Cincinnati, Ohio, where he worked as a stonecutter before turning to portrait sculpture in the early 1840s. His numerous portrait busts and medallions exhibit the dry naturalism characteristic of the more provincial type of marble sculpture produced in America during the decades surrounding the Civil War; such work lacks the ro-

manticizing and idealizing dimensions of the European-inspired neoclassical sculpture of Powers and Crawford.[87] Among Jones's more noteworthy portrait busts are those of Lewis Cass and General Winfield Scott, both of which were modeled in the late 1840s before Jones left the Cincinnati area for the East Coast where he hoped his talents would attract more ambitious projects.

In late October 1857, Jones was in Lexington, Kentucky, lobbying for one of his designs—now lost—for a proposed monument to Henry Clay. While in Lexington he learned of the unclaimed commission to decorate the House pediment and immediately wrote Lewis Cass, President Buchanan's secretary of state, regarding the possibility of being assigned the work. As an example of his ability as a designer, Jones enclosed a tracing of his proposed Clay monument. He asked Cass to forward the tracing to Meigs, which the secretary did soon after the receipt of the sculptor's letter.[88]

Upon his return to Cincinnati, Jones followed up his original inquiry by sending photographs of his design for the Clay monument to Cass and Meigs. In his letter to Meigs, Jones included a brief description:

Your practiced eye will at once see the nature of the design—the first, or base section, is designed [to] represent the Sylvan age of Kentucky, the 2d section, the Pioneer age of Kentucky—the 3d section the Civic age . . . and on each of the four angles of the monument, supporting the pedestal or platform of the statesman [Clay], Liberty, Justice, Peace, and Plenty—as it were, illustrating the history of Mr. Clay and Kentucky at the same time. If my style of designing is worthy of your consideration, I would be most happy to design, and model the uncommissioned pediment of the Capitol buildings.[89]

For personal testimonials Jones referred Meigs to Vice-President John C. Breckinridge, of whom he had recently completed a portrait bust, as well as to Secretary Cass and General Winfield Scott. All was to no avail, however. The fate of the commission, as evidenced by the outcome of Erastus Dow Palmer's efforts, was no longer in the hands of the captain. Even if Meigs had been impressed with Jones's talent, which he most likely was not, he could take little or no action in the matter.

Henry Dexter of Boston was, like Jones, primarily a portraitist. Initially apprenticed to a blacksmith, Dexter began painting portraits in the mid-1830s and modeled his first bust soon thereafter. By the early 1840s he had become the leading portrait sculptor in the Boston area, eventually going on to produce more than 180 busts over the next thirty years.[90]

In October 1858, Dexter traveled to Washington in search of federal commissions so that he "might with others share the liberality of our government's patronage in encouraging native talent." After learning that one of the pediments was "still open for competition," Dexter sought out Meigs and, following a brief meeting with the superintendent, quickly returned to Cambridgeport, Massachusetts, to begin work on a preliminary model. On 4 November 1858 Dexter informed Meigs that he had commenced models for the pediment in clay. "They are subjects relating to America," he explained, "Ideal, rather than descriptive of any particular sense; beginning at a period prior to Crawford[']s and closing with a prophetic future."[91] Meigs promptly responded to Dexter's letter, and, while it is unknown exactly what the superintendent told him, he clearly did not discourage the sculptor in his pursuit of the coveted assignment.

In mid-January 1859, Dexter wrote Meigs that his nearly completed models would be ready to forward to Washington in a matter of days.[92] But Dexter apparently had second thoughts about sending his models to Washington without more of a commitment on the part of the government. Instead, he decided to make another trip to the Capitol and present Meigs personally with a photograph of his design. Due to an illness, however, the superintendent was unable to see Dexter and, leaving the photograph behind, the sculptor returned home.[93]

A photograph of Dexter's sketch model (fig. 19) is in the Henry Dexter Collection of The Society for the Preservation of New England Antiquities in Boston. Dexter's own written description of the design also exists. He had chosen as his central theme "The Settlement of America":

In the first place, as one pediment is adopted [Crawford's], and is suggestive of the present and the future, I have chosen an earlier period in our Country's history, and have treated it in the manner of an Epic. The subject is this: that in the settlement of this country by Europeans it was approached by water and in a boat: the country was a Wilderness with wild beasts: its inhabitants were the savage red Men: in the establishment of the family relations commenced the *Nation*: superhuman power saves them from being destroyed by the Indian warrior: unity of Mother

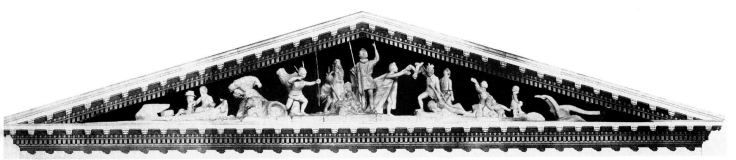

Fig. 19. Henry Dexter, The Settlement of America, *design for the House Pediment, 1858–59. No longer extant. Photograph: Henry Dexter Collection, Courtesy of the Society for the Preservation of New England Antiquities.*

and Brothers was strength: the pinion of Mechanics was united to the segment of power: and peace and prosperity possessed the land. No particular person or action is represented, but such as will apply to many. There is but one Alegorical [*sic*] or Mythological figure; and I do not see how a story could be told requiring less explanation.[94]

Given the extremely poor quality of Dexter's model and the many similarities between his theme and that of Crawford's, it is unlikely Meigs would have responded favorably to this latest design for the House pediment. Nonetheless, Dexter quickly grew impatient for a decision, and he wrote Meigs to express his concern that the superintendent was apparently unable to exercise proper control over the commission.[95] But Meigs's authority over the extension buildings was not what it had once been. In fact, by early 1859, as political tensions worsened within Buchanan's administration and the animosity between Meigs and Floyd grew more bitter, it was no longer clear just who, if anyone, was authorized on behalf of the government to accept decorative designs for the new federal buildings. Given the limited options open to them, sculptors such as Jones and Dexter had little recourse but to press their applications through Meigs in the hope that the superintendent still retained some influence in such matters.

Just how ambiguous the situation had become is best seen in the case of the Virginia sculptor, William Randolph Barbee. As a young man Barbee had pursued a career in law, being admitted to the bar in 1843. In time, however, an adolescent interest in carving grew progressively stronger, and by the early 1850s Barbee had moved his family from Luray, Virginia, to Florence, Italy, where he began to study sculpture in earnest. In 1857 or early 1858 Barbee returned to America with his two principal works in hand, *Coquette* and *The Fisher Girl*. In execution and sentiment both marble statues reflect the unmistakable influence of Hiram Powers.[96]

By early 1859 Barbee was in Washington. In fact, by this date he was occupying two basement rooms in the House wing of the Capitol Building that had been assigned to him as a studio. Apparently, Barbee had not received authorization to use the rooms through Meigs but through the influence of the Speaker of the House of Representatives, James L. Orr, an earlier patron of the sculptor.[97] Why was Barbee at the Capitol? It is impossible to know for certain. However, according to the sculptor's son, Herbert Barbee, "the rooms were presented to him by Pres[ident] Buchanan to induce him to locate to Washington. It was believed then he would make the south pediment of the Capitol."[98]

One possible motive for Barbee's unofficial appointment as "sculptor-in-residence" at the Capitol may have been to circumvent the authority of the Washington Art Commission, which Congress had established in June 1858, to examine all potential decorations intended for the Capitol. But whatever influence or motivation brought Barbee to Washington sectional rivalries almost certainly figured in the decision. It would not be unreasonable to assume, for example, that by the late 1850s there were those around the president who felt strongly that the commission to decorate the second pediment should be reserved for a southern sculptor.[99] After all, little if any of the decorative art ordered for the Capitol up to that point had been devoted to distinctly southern themes or values. Furthermore, all of the previously submitted designs for the House pediment had come from

northern artists, some with self-proclaimed political agendas. Surely Barbee's appearance at the Capitol in 1859 could have been the result of an equally partisan attempt to place the commission safely in the hands of an artist from the South.

Available evidence strongly suggests that Barbee not only proposed a design for the House pediment, but also produced several advanced models before his work at the Capitol was interrupted by the outbreak of the Civil War. In early June 1859, James B. Eads, a friend of the sculptor, wrote Barbee, "I was greatly interested in the account which you gave me of your new work for the other Pediment in the U.S. Capitol. It strikes me as being excellent work."[100] Fourteen years later, in 1873, James Dabney McCabe, in a book entitled *Behind the Scenes in Washington*, made another reference to Barbee's work in connection with the commission. "The southern pediment has not been filled," McCabe explained, "but a design is stated to have been selected and to represent the discovery of America by Columbus. The sculptor is W[illia]m R[andolph] Barbee."[101] In 1927 the existence of Barbee's design for the Capitol pediment was confirmed by his son;[102] but presently this design is either unlocated or destroyed and there are still more questions than answers concerning Barbee's tenure at the Capitol.

The unsuccessful attempts by Jones, Dexter, and Barbee to win the commission to decorate the House pediment underscore the difficulty American artists had in securing federal commissions during the years leading up to the Civil War. Artists seeking such commissions often found themselves at a loss when it came to pursuing their prospects with the government. Meigs's power over these matters had been compromised by his conflict with Floyd and by the general perception that he preferred foreign to native-born artists, a charge not altogether fair to the captain. An artist did have one reasonable alternative to Meigs: he could petition the members of the Joint Committee on the Library, who, besides attending to the Library of Congress, assumed supervisory control over works of art procured for the Capitol. But the Joint Committee on the Library also had come under attack for employing foreigners in the decoration of the Capitol.[103]

To address these problems a group of mostly local artists had founded in November 1856 the Washington Art Association. Under the leadership of Dr. Horatio Stone, a physician turned sculptor, the group aggressively pursued the interests of American artists in trying to obtain commissions with the federal government. Their continued protests eventually convinced Congress to curtail all expenditures for decorative purposes in connection with the Capitol Extension and to establish an art commission to oversee the selection of works of art for the Capitol.[104]

In March 1858, the Association had sponsored a national convention of American artists in Washington to draw attention to the problem of federal patronage of the arts and to bring pressure on Congress to improve its methods for awarding artistic commissions. The convention was the first of its kind in America and it attracted noted artists from around the country including Rembrandt Peale (1778–1860) of Philadelphia, Henry Kirke Brown and Asher B. Durand (1796–1886) of New York, William H. Rinehart (1825–74) of Baltimore, and Albert Bierstadt (1830–1902) of Boston.

As a group, the artists attending the convention approved a memorandum to Congress requesting that an Art Commission composed of American artists be established to oversee the distribution of federal appropriations for artistic purposes.[105] Despite strong sentiments in both the Senate and the House against using any of the money appropriated for the construction of the extension buildings for decoration, on 12 June 1858 Congress approved an act authorizing the establishment of the proposed commission. The act directed the president to appoint three distinguished American artists as members of the commission and stipulated that all designs accepted by them would be subject to the final approval of the Joint Committee on the Library.[106] After a delay of nearly a year, President Buchanan finally appointed the commission on 18 May 1859, selecting as its three members James R. Lambdin (1807–89), John F. Kensett (1816–72), and Henry Kirke Brown.[107]

Superintendent Meigs responded negatively to the establishment of the Art commission. He felt sure that the involvement of artists in the selection process would only delay completing the decoration of the new Capitol buildings, and he understood that the failure of Congress to define the commission's functions or to give it sufficient authority would render its pronouncements unenforceable and largely ineffective. Later that

summer, in a letter to Randolph Rogers, Meigs confided that "with the commission of artists, and various other obstructions," he did not know when, if ever in his lifetime, projects such as the frieze in the Capitol Rotunda or the statuary for the House pediment would be completed.[108]

Less than four months later, on 2 November 1859, Meigs was removed from his position as superintendent of the Capitol Extension. The ongoing feud between him and Floyd had erupted finally over a dispute between the captain and Thomas U. Walter regarding control of the plans for the boilers at the new U.S. Post Office; Floyd used the controversy as a pretext for getting rid of Meigs. Although Meigs did retain control over the construction of the Washington Aqueduct, Captain William B. Franklin replaced him as the superintendent in charge of the Capitol, the Capitol dome, and the Post Office. Thus ended, for all intents and purposes, Captain Meigs's association with the history of the House pediment.[109]

Soon after Meigs's dismissal his opinions regarding the efficacy of the new Art Commission were confirmed. Following their appointment, Lambdin, Kensett, and Brown had assumed their responsibilities as art commissioners without delay (Brown temporarily set aside his work at the Statehouse in Columbia), and in late February 1860, they submitted their initial report to Congress.

The report began with a careful assessment of the art already commissioned for and currently adorning the Capitol Building. Following this, the commissioners gave their recommendations for the future course of decorative work at the Capitol, focusing on specific portions of the building such as individual rooms, halls, and stairways. Regarding the two pediments of the Capitol Extension, they wrote the following:

It having been determined to fill the pediments of the eastern porticos with statues, and the statues for one of them having already been executed here in marble, under the direction of the former superintendent, it would be proper to recommend an appropriation for the remaining pediment at any time; but as the progress of the building does not render it important at present, it is deemed advisable to defer it to another year. In connexion with this subject, however, the commissioners feel constrained to add that had it not have been decided to fill these pediments with statues they would have recommended alto-relievi for that purpose. Statues must always convey an idea of detachment, as something superadded; while alto-

relievi form a part of the building, and consequently admit of a treatment more in harmony with it.[110]

The commissioners concluded their report with estimates of the appropriations needed to implement their foregoing recommendations; the total amount came to $166,900![111] The House and Senate reacted to the Art Commission's cost estimates with shock and disbelief. For a Congress already reluctant to spend Capitol Extension funds on artistic embellishment, the level of appropriations called for by the commissioners was out of the question and probably even somewhat embarrassing. Consequently, by the end of that June, both houses had passed bills abolishing the Art Commission and "limiting the appropriation for the completion of the Capitol to the work necessary to complete the building, excluding painting and sculpture."[112]

The abrupt elimination of the Art Commission so soon after its inception was consistent with the century-long disinclination of Congress to expend federal monies for artistic purposes. But more than this, it also reflected the heightened fiscal conservatism that possessed Washington during the years just prior to the Civil War. In such an atmosphere the embellishment of government buildings was viewed by many as a luxury at best, and at worst, as a misappropriation of public funds. With Meigs temporarily banished to Florida and the Joint Committee on the Library prevented by law from authorizing expenditures for Capitol decorations, the demise of the Art Commission removed the last official avenue for completing projects such as the sculptural decoration of the House pediment. Not until well after the conclusion of the Civil War would Americans turn their attention once again to the empty triangular space above the House portico of the U.S. Capitol Building.

1861–1872: Theophilus Fisk Mills and Launt Thompson

With the coming of war in April 1861, all phases of construction at the Capitol were necessarily interrupted. On 15 May 1861 Captain Meigs, who had just been reinstated as superintendent of the Capitol, issued an order suspending all work on the Capitol Extension and the new dome. "The Government has no money to spend except in self-defence," Meigs cau-

tioned, "and all good citizens will cheerfully submit to their necessary share of sacrifices imposed upon them by the Government assailed by widespread conspiracy and rebellion."[113]

Over the next twelve months little was done on the construction or decoration of the extension buildings. Then, on 16 April 1862, Congress ordered the transfer of the superintendency of the Capitol Extension and the erection of the dome from the War Department back to the Department of the Interior, under whose supervision the work had commenced originally.[114] Almost immediately work on the Capitol resumed with Thomas U. Walter placed in charge as both architect and superintendent of the Capitol Extension.[115]

During the remainder of the war the various projects that had been interrupted were, under Walter's guidance, slowly but steadily brought to completion. By November 1862, the principal framework of the new dome had been erected and the bronze cast of Crawford's *Freedom*, which was intended to surmount the dome, had been completed by the American sculptor Clark Mills (1815–83). The exterior of the dome was finally completed in November 1863, and Crawford's statue was in place one month later.[116] Crawford's marble figures for the Senate pediment also had been placed into position by this time.

Walter continued to supervise the completion of the Capitol Extension until 26 May 1865 when, dissatisfied with limitations on his jurisdiction, he resigned from all duties related to the supervision of the Capitol. Apparently, the underlying reason for Walter's resignation was the fact that control of the older portions of the building had remained in the hands of the commissioner of Public Buildings and Grounds and that such a division of authority had, in Walter's view, compromised his position as architect of the Capitol. The question of full authority over the Capitol Building was not to be settled until 15 August 1876 when, by an act of Congress, the responsibilities of the commissioner of Public Buildings and Grounds as related to the Capitol were duly and wholly transferred to the architect of the Capitol. On 30 August 1865 Edward Clark was appointed as Walter's successor.[117]

During the years immediately following the war, a federal government burdened with the task of reunifying the country was hardly in a frame of mind to consider seriously a commission to decorate one of the pediments of the Capitol Building. Nevertheless, by December 1869, the commission had generated enough new interest in Congress that a Joint Resolution was offered in the House to appropriate funds "for a group of statuary for the south wing of the Capitol." The full resolution read as follows:

Resolved by the Senate and House of Representatives of the United States of America in Congress assembled, That the sum of one hundred and thirty thousand dollars be, and the same is hereby, appropriated, out of any money in the Treasury not otherwise appropriated, to enable the Secretary of the Interior to contract with [Theophilus] Fisk Mills, sculptor, for the execution of a group of statuary, in marble, for the south wing of the Capitol, in order to complete said building by the year eighteen hundred and seventy-five: *Provided,* That said group of statuary shall be placed upon the pediment of the south wing as a match-piece to the "Progress of Civilization" now upon the pediment of the north wing, and shall embody the great feature of emancipation and fix in imperishable form the "Act" whereby four millions of bondmen were made free.

Length of group sixty-five feet; centre figure, ten feet high, estimated cost, ten thousand dollars; eleven figures, nine feet high, estimated cost, ninety-nine thousand dollars; three figures, four feet high, estimated cost, twelve thousand dollars; one figure, five feet high, estimated cost, five thousand dollars; placing group on pediment, estimated cost, four thousand dollars; total cost, one hundred and thirty thousand dollars.[118]

The nature of the resolution is curious on several accounts. First of all, it designates a specific theme, emancipation, as well as a specific sculptor, Theophilus Fisk Mills (born ca. 1842), the son and assistant of Clark Mills. Secondly, it gives a detailed estimate of costs based on the height and number of figures making up the total pedimental design. Based on these facts it is most likely that the congressional move was the result of a lobbying effort on the part of the sculptor named in the resolution—young Mills—and that the particulars of the resolution were based on Mills's specific proposals. This also would explain the incredible sum of $130,000 that the resolution estimated to be the cost of executing and installing the figures, an amount nearly double that eventually paid for the successful completion of the same commission some fifty years later.

Following its introduction, the Joint Resolution to contract for the completion of the House pediment was referred to the Committee on Pub-

lic Buildings and Grounds for consideration. It is not known if Mills ever submitted a sketch model upon which the government officials could pass judgment.

Meanwhile, as Mills awaited congressional action, another American sculptor, Launt Thompson (1833–94) of New York, expressed an interest in the vacant pediment. As an assistant to Erastus Dow Palmer from 1854 to 1858 Thompson had witnessed first-hand Palmer's unsuccessful attempt to win the elusive commission.[119] Now, in early 1870, recently returned to New York from two years in Rome, Thompson was eager to obtain a major federal commission of his own. Probably aware of the recent resolution in Congress he lost no time in inquiring after the undecorated pediment.

In late January or early February 1870, one of Thompson's friends, Captain F. C. Adams of Washington, contacted Edward Clark on the sculptor's behalf to learn if the government was accepting designs for the statuary of the House pediment. Clark replied that as yet no direct action had been taken on the subject but that he had no doubt the Committee on Public Buildings and Grounds would "be happy to receive designs for that purpose." Speaking for himself Clark added, "I should be glad to have a design from Mr. Thompson, and will, with pleasure, submit it to the Committee."[120]

Learning of Clark's response Thompson quickly set about preparing a design for the pediment. He chose as his central theme "Peace and Abundance." The subject, popular in American art during the decades following the Civil War, symbolized the enduring prosperity of the nation as a result of the preservation of the Union. By early April 1870, a description—now lost—of Thompson's design had been forwarded to Clark via Captain Adams.

At this point Clark wrote to Thompson directly at his rooms in the Studio Building on Tenth Street, New York, regarding his proposed pedimental design:

Capt[ain] Adams has favored me with your description for a group for the South Pediment of the Capitol. I freely say that I like your design—Peace and Abundance—better than any that has been offered. It would do well to make a sketch or small model, to submit to the Committee. This could be done at your convenience, as I do not believe Congress will take any action on the subject this session. The right time, in my judgment, to press this will be early next session.[121]

Clark's judgment on pending congressional action was based on the recent decision by the Committee on Public Buildings and Grounds to delay a consideration of the design submitted by Fisk Mills.

One week later, Thompson responded to Clark's letter:

I am very glad to learn that the idea strikes you favorably, [and] I will go out [and] make a sketch in relief similar in size to those in your office. Relief is less satisfactory [and] complete than [in] the round, but it may serve the purpose.[122]

Thompson's remarks are provocative for they imply that he had visited Clark's office at the Capitol and, while there, had seen several sketch models for the House pediment previously submitted by other sculptors. Presumably, such models would have been executed by either Thomas Dow Jones, Henry Dexter, William Randolph Barbee, or Fisk Mills, since all evidence indicates that the models prepared by Henry Kirke Brown and Erastus Dow Palmer were never taken to Washington.

In spite of his statement to the contrary, Thompson apparently never produced a sketch model of his design for the House pediment. Had he done so, he might have enjoyed the best chances of any sculptor since Thomas Crawford of actually winning the commission. Not only was the architect of the Capitol Extension, Edward Clark, enthusiastic about the sculptor's design and willing to represent Thompson's case before Congress, but also the optimistic character of the theme would have appealed to those in the government intent on healing sectional wounds and moving the nation in a positive direction. As it happened, no further action was taken by Congress regarding either Thompson's or Mills's attempts to obtain the commission. Despite the Joint Resolution of 1869 there simply was not enough general interest or congressional support during the immediate post-Civil War period to justify committing public funds to the sculptural decoration of the House pediment.

1900–1908: The 1905 Report on the Extension and Completion of the Capitol Building; Gutzon Borglum and Charles Henry Niehaus

Official disinterest in the commission had continued throughout the final decades of the nineteenth century. However, as the country entered

a new century, a noticeable shift in the attitude of the federal government regarding the role of art in a democratic society helped prepare the way for a new surge of interest in projects like the long-delayed decoration for the House pediment. One of the main reasons for this new openness toward federally sponsored art commissions was the attention to national art policies that characterized the administrations of President Theodore Roosevelt (1901–09).[123] Roosevelt seemed to realize more than any of his predecessors—with the exception perhaps of Washington and Jefferson—that art could be a powerful tool for shaping national policy and for giving voice and direction to the fundamental convictions and restless energies of the American people. America's emergence during these years as a major economic and political player on the world stage further fueled the use of art—especially public art—to define in both contemporary and historical terms the unique character of the national identity.

Another factor that helped to revive interest specifically in the commission to decorate the House pediment was the publication of Glenn Brown's *History of the United States Capitol* (1900–1903). Brown's book exerted a powerful influence on Congress and the public alike, and did much to popularize the early history of the Capitol Building and the federal city. Among other things the work contributed to the establishment in 1901 of the Senate Park Commission, which, under the leadership of Senator James McMillan, formulated a comprehensive plan for the development of Washington based on models from America's past, especially the original plan of the city by Pierre-Charles L'Enfant (1754–1825).[124]

But the single, most important development regarding the House pediment and the factor that led more or less directly to the completion of the long-standing sculptural commission was Congress's decision to extend the east front of the Capitol Building in accordance with Thomas U. Walter's original plans. In November 1864, Walter, then architect of the Capitol Extension, had reported to Congress the need for the central east front of the building to be extended further east to coincide with the line of the new wings. According to Walter, the extension would correct the visual defect that had resulted from the placement of the new larger dome—designed in proportion to the greatly expanded building—

onto the foundations and walls of the original smaller dome; it also would provide increased accommodations within the building which Walter assumed to be a congressional imperative.[125]

In 1901, Edward Clark, the current architect of the Capitol, after conducting his own careful studies, had recommended that Walter's plans for the extension and completion of the Capitol Building be implemented. Subsequently, on 28 April 1904 Congress established by civil act a Joint Commission to inquire into the plans for the extension and to suggest any modifications to Walter's plans, which in its view were either necessary or advantageous. The act also stipulated that if and when Congress appropriated the funds for such work, the superintendent of the Capitol Building and Grounds, Elliott Woods, would assume the responsibility under the direction of the commission to contract for and supervise the work.[126]

The Joint Commission, which was composed of three members each from the Senate and House, met and organized on 30 April 1904. Senator George P. Wetmore of Rhode Island was elected chairman and the New York architectural firm of Carrère and Hastings was selected to advise the commission. Besides the main question at hand, the extension of the central east front of the Capitol Building, Carrère and Hastings were instructed to consider and report on several related problems including the placement of statuary in the vacant House pediment.[127]

On 19 February 1905 Carrère and Hastings made their final report to the Joint Commission. They recommended moving the entire central front of the Capitol forward twelve feet ten inches in order "to bring the main wall of the building at the center under the extreme projection of the Dome, and give the Dome the apparent support which it should have."[128] The architects estimated that the total cost for the extension would be $800,000. They also submitted an estimate for the cost of placing a sculptural group in the east pediment of the House wing—$55,000. This sum included "the sculptor's honorarium for the model, supplying of the necessary marble, erected in place, and the execution of the carving from the artist's model."[129] Subsequent to the report the Joint Commission recommended that Congress adopt the architects' suggestions regarding the extension. The commission further recommended that Congress

approve "placing a sculptural group in the House pediment to correspond in character, size, and finish with the sculptural work now existing in the pediment of the Senate Wing."[130]

The first sculptor in the twentieth century to approach the problem of decorating the House pediment of the U.S. Capitol Building was Charles Henry Niehaus (1855–1935) of New York. Essentially a portrait sculptor, Niehaus came to prominence during the last quarter of the nineteenth century, a period when most American sculptors turned to France for instruction and inspiration. Niehaus, however, had trained at the Royal Academy in Munich. Thus, his style reflects the more rigid academic formulas of German neoclassicism as opposed to the less restrained variety of classicism typical of the French Beaux-Arts tradition.[131]

Some time before his death in January 1902, Edward Clark had asked Niehaus to prepare pedimental designs for possible use on the National Capitol. About two years later, in March 1904, Elliott Woods, superintendent of the Capitol Building and Grounds, sent Niehaus drawings of the pediment of the House wing undoubtedly to aid the sculptor in creating his designs. By no later than December 1904, Niehaus was busy preparing sketches for statuary to adorn not only the House pediment, but also, apparently at Woods's request, the soon-to-be-broadened pediment of the central building.[132]

Meanwhile, Woods had begun corresponding with a second American sculptor from New York, Gutzon Borglum (1867–1941). Early in his career Borglum had studied sculpture in Paris where he absorbed the vigorous modeling and pulsating forms characteristic of the more progressive developments in late nineteenth-century French sculpture.[133] During the fall months of 1904 Woods received several letters testifying to Borglum's expertise as an artist, particularly his strength regarding monumental decorative work. Those writing to Woods on Borglum's be-

half included the state architect of New York, G. L. Heins, and the French sculptor and Borglum's former teacher, Auguste Rodin (1840–1917).[134]

In mid-January 1905, Borglum wrote Woods to notify him that he would be in Washington the following week with "a very rich and complete model" for the pediment of the House wing. Upon his arrival in Washington, however, Borglum found that Woods was ill and unable to see him. The sculptor then decided to set up his pedimental model in Woods's offices at the Capitol and left word that upon his return to New York he would write the superintendent a full report on his proposal including an estimate of costs.[135]

After reaching New York Borglum sent Woods a small photograph and diagram of his model for the pediment of the House wing together with a detailed description of the design (fig. 20):

The whole idea is representative of the building of a nation, and to illustrate that in its application to our country, I have placed in the center the figure of Columbia, offering protection to the varied nationalities that form the nation. I should in the development of this central idea, give the faces of the five figures gathered directly about and under her marked national characteristics.

To the spectator's right as he faces the design, I next show a group of three—architect, sculptor, and assistant—in the act of preparing a cap of a column for the building in the background, in the course of erection. This building for the purpose of the idea is naturally the Capitol of the country, and in the finished work it will be carefully developed so as to explain its relationship to the design. Next to the right is the figure of a mechanic, which I should use to represent the mechanical arts, and next to it, the figure placing a plow, represents agriculture. On the left I show the other wing of the Capitol in its completed state: the first figure will be representative of Law signifying order; then close to it Literature or History, and, grouped below, a female figure which I shall probably develop into the Goddess of the Fine Arts—this trio symbolizing the higher development of civilization. The next figure to the left is a male figure symbolizing transportation. To the left, further on, the last figure

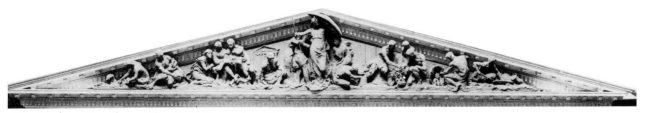

Fig. 20. *Gutzon Borglum,* The Building of a Nation, *design for the House Pediment, 1904–5. No longer extant. Photograph: Architect of the Capitol.*

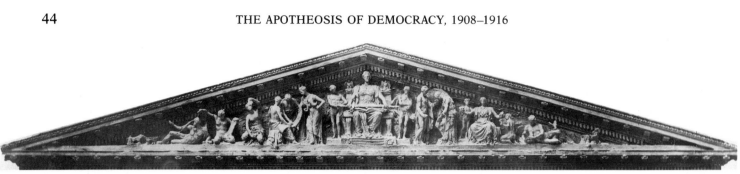

Fig. 21. Charles Henry Niehaus, The Law, *design for the House Pediment, 1904–5. No longer extant. Photograph: Architect of the Capitol.*

on this side of the pediment shows Ceres, Goddess of Grain, gathering the harvest. The proportion of the figures in this pediment in relation to the architecture, has been very carefully considered, both separately as masses and collectively as groups. The figures have been placed in the pediment so that they can be read from the steps of the Capitol, that is, they will not be lost in the recess in which they are built.[136]

Borglum estimated that the execution and installation of his figures would take three to three-and-a-half years to complete at a total cost of $104,000, nearly double the cost reported to the Joint commission by Carrère and Hastings, a factor that probably prevented Borglum's design from ever receiving serious consideration.[137]

The same week that Borglum's report arrived in Elliott Woods's office Charles Niehaus had notified the superintendent that his pedimental models had been completed and that once they were cast in plaster they would be ready for delivery. Niehaus's models were shipped to Washington about two weeks later.[138]

Niehaus prepared three separate designs: *The Law* (fig. 21), for the House pediment; and, for the pediment of the central portico of the building, *The Mother Republic* (fig. 22) and *Liberty*, or *The Flight of the Eagle*. The sculptor provided Woods with written descriptions of all three designs. His description of *The Law* reads as follows:

In this composition, the figure of the Law seated, is represented as resting a sword on an open book. On one side is a youth binding facets, "Strength in Unity," and beside him, "Counsel" is represented by three figures studying and discussing a parchment, which one of the number is holding. "Truth" holds a leaf so that the dewdrop on it may catch and reflect the light, and in her hand is a circle of stars, to suggest Heaven's clearness as well. At the extreme left "Tradition" is lifting the cloak of Antiquity who in turn is grasping the old and rude implements of torture, formerly used.

To the left of the Law "Arbitration" is represented by two figures engaged in breaking a sword: "Justice" balances the burdens or rewards of two children who have appealed to her, and at the extreme end "Mercy" is loosening her doves. This composition has technically taken advantage of the fact that while Law is single in its purpose, it must recognize two opposing sides, and the figures are in double groups. This also affords an opportunity for depth and color in the succession of groups.

Eagles are shown as surmounting the cornice above the pediment.[139]

Over the next few years Congress took little action with respect to the Joint Commission's recommendations, especially regarding the sculptural decoration of the House pediment. Eventually, as months, then years, passed with no congressional action forthcoming, Borglum lost interest in the project. Niehaus, however, continued to press for the coveted assignment with the apparent encouragement of Woods who seemed to be genuinely impressed with the sculptor's designs for the Capitol pediments.

Still, by the end of 1907 and with no progress in sight, Niehaus's patience was wearing thin, and he wrote Woods to complain about congressional inaction regarding the commission:

The fact that the pediment of the Senate wing was appropriately treated by the sculptor's art years ago, thus giving that side of the pile a finished appearance, affords a very marked contrast with, and strongly emphasizes the barrenness of the other pediment of the House of Representatives. . . . The air of incompleteness which this barren pediment gives to that portion of the House of Representatives has been for years a general topic of adverse criticism among the mass of observers, and is so entirely out of harmony with the development of the grand National Capital laid out nearly one hundred and twenty years ago by Washington and L'Enfant as to be a constant source of regret. Do you not believe sufficient interest may be infused in quarters sufficiently influential to remedy the matter?[140]

Niehaus's arguments obviously were meant to

Fig. 22. Charles Henry Niehaus, The Mother Republic, *design for the Central Pediment of the United States Capitol Building, 1904–5. No longer extant. Photograph: Architect of the Capitol.*

pressure Woods and those in Congress with authority over the Capitol Extension to move the project ahead.

At this point Woods himself was growing impatient with Congress's inability to appropriate the funds necessary to contract for a sculptor. So, in response to Niehaus's most recent communication the superintendent quickly wrote that he would take up the matter once again with Congress, but that he needed an estimate of the cost of the work "as a basis for an appropriation." In mid-December 1907, Niehaus notified Woods that his sketch for the House pediment was composed of about fifteen figures all exceeding life-size, and that for the sum of $110,000 he would "prepare the necessary models, furnish the marble and other requisite materials and undertake the entire execution of the work."[141]

Unfortunately for Niehaus, his long-held desire to decorate one of the pediments of the National Capitol would never materialize. Again, as in Borglum's case, a major problem was his initial estimate for the cost of the project. Early in March 1908, Representative Samuel W. McCall of Massachusetts, a member of the Joint Committee on the Library, contacted Woods regarding the amount of money necessary for the sculptural decoration of the House pediment.[142] Referring to the 1905 Report of the Joint Commission, Woods notified McCall that the cost of the statuary had been set at $55,000. "This would seem to settle the question of the amount stated in your bill," Woods concluded, "and that the $75,000 would be ample for all contingencies."[143] The bill to which Woods referred was an act McCall would soon introduce in Congress for completing the pediment of the House wing of the Capitol. The act, approved on 16 April 1908, read as follows:

Be it enacted by the Senate and House of Representatives of America in Congress assembled, That the expenditure of seventy-five thousand dollars, or so much thereof as may be necessary, be, and the same is hereby, authorized for the purpose of completing the pediment of the House wing of the Capitol by placing suitable statuary thereon, said expenditure to be made under the direction of the Speaker of the House, the Joint Committee on the Library, and the Superintendent of the Capitol.[144]

Soon after corresponding with McCall in early March regarding a suitable appropriation for the completion of the House pediment, Woods wrote Niehaus to ask him if he would consider doing the work for $75,000, a sum considerably lower than the sculptor's original estimate. On 9 March 1908 Niehaus replied:

I have expended so much time on the compositions . . . and the work has so long appealed to my ambition that the money consideration has become secondary, and in the event of being commissioned to do the work for $75,000.00 I would gladly accept it.[145]

Two days later Woods notified Niehaus that he would transmit photographs of the sculptor's proposal for the House pediment with descriptions attached to Congressman McCall for his personal judgment. But McCall was not particularly pleased with Niehaus's sketch for the House pediment, finding it crowded and probably somewhat unintelligible.

When Niehaus learned of the congressman's initial response to his sketch he nervously wrote Woods:

Of course, as you are aware, the sketch model is simply a suggestion of the composition, grouping and lines. In making the "Serious" or "Study" model—which will be upon a very much larger scale—desired or suggested modifications of any feature of the pediment may easily be made, so that upon its completion, all the details being satisfactorily determined, it will show accurately just what the pediment will be. I would like to write to Mr. McCall and explain this but refrain until advised as to the wisdom of so doing.[146]

Niehaus also firmly opposed the use of more than one sculptor on the pediment, an idea that both

McCall and Woods were seriously considering. Niehaus cited the New York Appellate Courthouse, 1896–1900, and the pediment for the New York Stock Exchange, 1901–4, as recent examples of the poor results generally obtained when two or more sculptors were employed on the same project. "With the execution of the work entrusted to one man," Niehaus explained, "much nervous wear and tear is eliminated, responsibility is fixed, and satisfactory results may be guaranteed."[147]

On 7 May 1908 the commission to complete the House pediment that had been created by McCall's act met in the room of the Senate Committee on the Library for the purpose of organization. Representative Joseph G. Cannon, speaker of the House, was chosen as chairman, and a committee of three—McCall, Senator Wetmore, and Woods—was appointed to consider the question of a sculptor.[148] Senator Wetmore immediately contacted Carrère and Hastings in New York for their advice.[149] Four days later the two architects responded:

The three men who first suggest themselves to us are Messrs. Herbert Adams, Daniel C. French, and Karl Bitter. Any one of these men, we believe, would give absolute satisfaction, as they are artists of rare ability. We would also suggest Mr. Charles H. Niehaus, who has shown himself very capable in this direction. He has, in fact, made several studies of pediments, models of which we believe could be seen in the Capitol Building today. They are extremely interesting,

and we feel that he, also, would show himself very capable if he were entrusted with the work.[150]

None of the sculptors mentioned in the architects' letter would ever be offered the commission to decorate the House pediment, not even Niehaus, despite his long-standing association with the project and the support of the superintendent of the Capitol. Of the three men—Woods, Wetmore, and McCall—appointed to recommend a sculptor, McCall was the most influential, and by May 1908, he already had definite ideas about who should receive the work.

On 25 May 1908 Niehaus sent Elliott Woods a bronze cast—presently unlocated—of a sketch detail from one of his pedimental models for the Capitol. Niehaus called the piece "The Nymph of Opportunity" and described it as one of several figures from the models that had "elicited marked admiration" from visitors to his studio over the past few years. "It is modelled with equal care on all sides," he declared, "and, if agreeable to you, may form an attractive ornament for your office until such time as I may claim it."[151] Mr. Niehaus may have claimed his "Nymph" far sooner than he had anticipated, for the next day, at a meeting of the commission for the completion of the pediment of the House wing of the U.S. Capitol, the committee appointed to consider the question of a sculptor recommended the selection of Paul Wayland Bartlett (1865–1925) of Paris and New York.[152]

*Fig. 23. John Quincy Adams Ward and Paul Wayland Bartlett,
ca. 1905. Photograph: The National Sculpture Society.*

2

The Commission, 1908–1916

The Selection of Paul Wayland Bartlett and His
Original Contract

IN LATE FEBRUARY 1908, REPRESENTATIVE CHARLES R. Thomas, a member of the Joint Committee on the Library, wrote John Quincy Adams Ward (1830–1910) at his studio in New York City to ask the sculptor if he would consider undertaking the proposed project to decorate the House pediment. On 8 March 1908 Ward responded:

It was very good of you to think of me in connection with the proposed sculpture in the pediment of the House wing of the Capitol. It is a subject that I have often thought of during the past twenty five years— a grand opportunity for any sculptor—affording a scope of treatment that other work seldom bring and I should be very sorry to see it fall into the hands of anyone who would treat it in a perfunctory manner. But, it is too late for me to undertake such a commission for by the time the work now in my studio is completed I shall need a rest.[1]

Throughout his long and distinguished career, Ward had, indeed, often thought of the vacant House pediment; in fact, some fifty years earlier he had entertained rather specific intentions regarding the unclaimed commission.[2] But now, in 1908, seventy-eight years old and plagued by increasingly poor health, Ward was no longer in any condition to assume the arduous task of designing, modeling, and erecting an entire pediment of sculpture. Instead he had a recommendation for Representative Thomas:

I have been thinking seriously on the subject of the proper sculptor for this work—one who would bring to it the enthusiasm of vigorous age, the advantages of good training and the intelligence to select a proper theme for the work and give a wholesome tone to the adornments of the Capitol. The one name that comes to me is that of Paul W. Bartlett. Mr. Bartlett is unusually well equipped for such a work having assisted, or colaborated [sic], with me on an important pediment here in the city—New York Stock Exchange Building. I have had some talk with him since receiving your letter. He is very enthusiastic over the whole idea and takes what I conceive to be the proper view of the design for such a work.[3]

Ward's remarks probably conveyed as much personal sentiment as professional opinion regarding the abilities of the younger sculptor, for the two artists had, over the last ten years or so, developed a genuine respect and affection for one another (see fig. 23). Nonetheless, the recommendation of so prestigious a figure in American art as Ward would have carried considerable weight with Thomas and the other congressmen assigned the task of selecting a sculptor for the House pediment, and Bartlett's collaboration with Ward on the statuary for the New York Stock Exchange (fig. 24), 1901–4, the most prominent pedimental commission in America since Crawford's pediment for the Senate wing

Fig. 24. John Quincy Adams Ward and Paul Wayland Bartlett,
Integrity Protecting the Works of Man, *1901–4. Pediment,
New York Stock Exchange. From Russell Sturgis, "Façade of the
New York Stock Exchange,"* Architectural Record *16 (November 1904): 477, fig. 5.*

of the Capitol, would have been particularly convincing.[4]

Bartlett soon received a second and even more compelling professional endorsement. In late May 1908, Senator George P. Wetmore, one of the members of the commission to complete the House pediment, wrote the National Sculpture Society (NSS) requesting the names of ten sculptors deemed by the society most competent to execute the Capitol pediment. Less than a week earlier, Bartlett, himself, had traveled to Washington from New York City, where he had been working since early December 1907, for a meeting with members of the commission—presumably Woods, Wetmore, and McCall. It was at this meeting, or soon thereafter, that the committee members decided to contact the NSS regarding the selection of a sculptor to decorate the pediment.

On 25 May 1908 the council and the sculptor members of the NSS held special meetings in the rooms of the society at 215 West Fifty-Seventh Street to consider Wetmore's request. The council decided that the ten sculptors should be elected in open meeting and formulated a plan for voting that was offered to the sculptor members in the form of the following resolution:

That the professional members of the Society shall elect three sculptors present, who shall be considered as recommended to Congress. The three sculptors thus selected shall nominate seven or more names to be balloted on by the professional members of the Society at large. Those Candidates having the highest number of votes on the ballots shall be elected.[5]

Upon adoption of the resolution the professional membership—thirty-four sculptors were in attendance—elected Paul Bartlett, Hermon A. MacNeil (1866–1947), and Karl Bitter (1867–1915) as the three sculptors among those present who were most competent to execute the pro-

posed work. Bartlett, MacNeil, and Bitter, in turn, offered fifteen names in nomination for the remaining seven positions. After a second balloting the following seven sculptors were elected to complete the list of ten: A. A. Weinman (1870–1952), Charles Henry Niehaus, Attilio Piccirilli (1868–1945), Isidore Konti (1862–1938), Herbert Adams (1858–1945), Richard E. Brooks (1865–1919), and Albert Jaegers (1868–1925). The secretary of the society immediately forwarded the names to Senator Wetmore in Washington.[6]

Evidently, Wetmore and McCall were more than satisfied with the society's recommendation for on the following day at a meeting of the full commission to complete the House pediment, the committee appointed to consider a sculptor recommended Paul Wayland Bartlett for the job. Wetmore then offered the following resolution, which was unanimously agreed to:

RESOLVED, That Hon. Samuel W. McCall and Mr. Elliott Woods, are hereby authorized on behalf of the Commission, and in its name, to enter into a contract with Paul Wayland Bartlett, sculptor, for the execution and installation of a marble sculptured group for the ornamentation of the pediment of the House wing of the Capitol, the same to be in harmony with the architecture of the Capitol building, on designs to be approved by the Commission.[7]

On the motion of Senator Wetmore it was then

ORDERED, That all expenses by the Commission shall be disbursed by and through the Department of the Interior as other appropriations for the Capitol building are disbursed, and on vouchers approved by the Superintendent of the Capitol Building and Grounds.[8]

The next day Congress approved an "act making appropriations for Sundry Civil Expenses of the Government for the fiscal year ending June thirtieth, nineteen hundred and nine." It contained the following provision:

Toward procuring statuary for the pediment of the House wing of the Capitol, to be expended as provided by law, including not exceeding five thousand dollars for procuring a suitable design, fifteen thousand dollars.[9]

Thus, by the end of May 1908, the commission had chosen a sculptor and Congress had appropriated the funds needed to begin the project.

Bartlett's selection as the sculptor for the statuary of the House pediment although sudden was by no means fortuitous; it came in the wake of a series of successful public monuments that

he had designed over the previous decade and a half. As early as 1892 the young expatriate sculptor had begun to turn from his earlier preoccupation with ethnological studies and animal sculpture to pursue more ambitious monumental commissions;[10] and, in his search for such commissions he had begun to visit America more regularly, dividing his time between Boston, where his father Truman Howe Bartlett (1835–1923) operated a school of sculpture,[11] and New York and Washington, where he courted colleagues and potential patrons in the hope of cultivating a social and professional standing in his native country.

In 1895–96 he figured significantly in a controversial national competition for a sculptor to design and erect in Washington an equestrian monument to General William Tecumseh Sherman. The Sherman Monument Committee made up of members of the Society of the Army of the Tennessee had requested from the National Sculpture Society a panel of sculptors and architects to judge the artistic merit of the design models to be submitted.[12] The art jury, composed of among others Ward, Augustus Saint-Gaudens (1848–1907), and Daniel Chester French, chose Bartlett's design as the best; but the Monument Committee ignored the jury's decision and instead awarded the commission to the Danish-born sculptor Carl Rohl-Smith (1848–1900), whose submission the art jury had ranked only tenth in the competition. The local and national outrage over the affair brought an unusual amount of attention to the commission and a large measure of public support and professional favor to Bartlett.[13]

One year prior to the Sherman competition Bartlett had received his first major public commission when he was chosen to execute three figures for the Main Reading Room of the Library of Congress in Washington: *Law,* one of the eight plaster female personifications to surmount the main piers of the room; and *Columbus* and *Michelangelo,* two of the sixteen bronze historical portraits to be set upon the balustrades of the gallery. Bartlett modeled all three figures in Paris but sent both *Columbus* and *Michelangelo* to New York to be cast in bronze by the Henry-Bonnard Bronze Company in 1897 and 1898, respectively.[14] *Michelangelo* (fig. 25), the last statue to be completed for the room and a work hailed by most contemporary critics as a

Fig. 26. Paul Wayland Bartlett, Equestrian Statue of Lafayette, *reduced replica of the second version, modeled, 1900–1907. Bronze, The Corcoran Gallery of Art, Gift of Mrs. Armistead Peter III, 1958.*

Fig. 25. Paul Wayland Bartlett, Michelangelo, *modeled, 1894–97; cast, 1898. Bronze, Main Reading Room, Library of Congress, Washington, D.C. From Charles V. Wheeler, "Bartlett (1865–1925),"* The American Magazine of Art *16 (November 1925): 577.*

genuine American masterpiece, was finally placed into position on Christmas Day 1898.

Within a year of the installation of *Michelangelo* in the Library of Congress Bartlett had contracted for four more major public monuments. One, *The Genius of Man,* a temporary group designed for the main fountain of the Court of Fountains at the 1901 Pan-American Exposition in Buffalo, celebrated human achievement. The other three—an equestrian statue of General George B. McClellan for *The Smith Memorial,*

1898–1912, in Philadelphia's Fairmount Park, a commission Bartlett never completed;[15] a *General Joseph Warren,* 1898–1904, for Roxbury, Massachusetts; and an *Equestrian Statue of Lafayette* (fig. 26), 1898–1908, for the Louvre in Paris— were all intended to memorialize military heroes from America's past. The *Equestrian Statue of Lafayette,* a gift to the French nation on behalf of the American people, would become the centerpiece of Bartlett's career.

The immediate purpose of the *Lafayette Monument* was to mark the celebration of United States Day at the 1900 Universal Exposition in Paris. On a more symbolic level, however, the monument reaffirmed the political and cultural

bonds that had united the two sister republics for more than a century. As such, the commission embodied a metaphorical significance not unlike Frederic-Auguste Bartholdi's *Liberty Enlightening the World* unveiled in New York Harbor only twelve years earlier. Bartlett's first version of *Lafayette* in plaster was unveiled in Paris on 4 July 1900. It took the sculptor nearly eight more years, however, to complete a bronze version of the statue which, after many delays and revisions, was finally hoisted into position in the gardens of the Louvre in late June 1908.[16]

By the early twentieth century, then, Bartlett had firmly established his credentials as a monument maker of the first rank. With such international recognition came the opportunity to undertake a number of prestigious commissions involving the sculptural decoration of public architecture. The most prominent of these commissions included the collaborative effort with Ward on the pediment for the New York Stock Exchange, a sculptural program for the north front of the Connecticut State House in Hartford, 1904–9,[17] six attic figures for the Fifth Avenue façade of the New York Public Library (figs. 27 and 28), 1909–15,[18] and the House pediment.

Bartlett returned to Paris from New York in late June 1908, to supervise the erection of his *Lafayette* in the gardens of the Louvre. Anxious to begin work on a sketch for the commission in Washington, however, he wrote Woods from France asking for detailed photographs of the pediment. Harry A. Vale, secretary to the commission, quickly sent the sculptor "three large photographs of the Senate and House pediments with dimensions indicated." In mid-August Bartlett wrote his father in Boston, "I have been making some sketches for my pediment, but I do not intend to make any final model until I have nosed about American a little for some characteristic touches." By early September 1908, he had returned to America, and later that month he confided to his father that the preliminary sketches for the pediment had been completed. "I don't take a historical view of it at all," he explained confidently, "and as a work I do not consider it in any way an undertaking like an equestrian statue. It is child's play in comparison."[19]

Over the next few months Bartlett did little if any work on his sketch models for the House pediment. Instead, he spent most of his time in New York City working closely with Ward in an effort to complete their equestrian statues for *The Smith Memorial.* Although their contracts had been annulled by the Memorial Committee in May 1906, they had continued to work on the commissions in the belief that once the statues were completed their contracts would be reinstated. During the final months of 1908 the health of the older sculptor was deteriorating, and he was in the process of giving up his studio. For these reasons Bartlett spent the larger portion of his time working on the horse for Ward's *Hancock* rather than on his own group.[20] Besides, Bartlett apparently preferred to delay finishing the *McClellan* until he could occupy his own new studio in Washington; there he could complete the large equestrian statue under more suitable conditions.

Before leaving France the previous September, Bartlett already had begun preparations to build the large Washington studio in order to facilitate the final phases of his work in connection with the House pediment (see fig. 29; see color section). He chose a location just north of Union Station and about one block from the railroad tracks. The superb location would allow easy transport of large plaster models, marble, and other bulk materials to and from the studio and was only minutes from the Capitol Building. While Bartlett was kept busy in New York, many of the preliminary details regarding the construction of the studio were handled by his close friend and future wife, Suzanne Earle Emmons, of Washington.

Back in New York Bartlett continued to struggle with the demands of the Smith Memorial commissions but took time whenever possible to work on his sketches for the House pediment. Toward the end of November he decided to take a short break from his work in New York to go to Washington to check the progress of the studio. On the return train to New York he ran into Congressman McCall. Later, the sculptor wrote Suzanne about the unexpected meeting:

If I had wanted to help on my affairs in Washington most effectually I could not have done better than to take the 9 o'clock train yesterday. I deposited my overcoat . . . and my new travelling bag near my seat, and quietly walked into the smoking room just as the train was moving, and who do you suppose was there and greeted me with a friendly wink? Representative McCall, chairman of the Pediment Committee. . . . I had a chance to tell him all about my plans, studio, pediment and everything, and he was very much more than pleased. . . . Said he was sorry he had not

Figs. 27 and 28. Paul Wayland Bartlett, Philosophy, Romance, Religion, Poetry, Drama, *and* History, *modeled, 1909–14; carved, 1914–15. Marble, Attic of Main Façade, New York Public Library. Photographs: Michele H. Bogart.*

asked for more money, spoke of doing away with the other pediment. . . . and we left very good friends.[21]

Bartlett's story of his encounter with McCall is notable for two reasons. First, it reveals how easily the sculptor could interact with politicians and businessmen on a personal as well as professional level, a trait that surely helps account for the great success he had throughout his career in garnering key public commissions. Second, it indicates that at this stage of the plans for completing the Capitol Building, McCall was considering "doing away with" Crawford's statuary for the Senate pediment and replacing it with an entirely new program.

Throughout December 1908, and into the new year, Bartlett continued to work on Ward's horse as well as his own sketches for the House pediment. By this time he was also preparing sketches for the six attic figures for the New York Public Library. Finally, by mid-January 1909, Bartlett had finished with Ward's *Hancock* and could concentrate on his own projects. He wrote Suzanne in Washington:

Today I have been working on my own things, at last! and making sketches for the Public Library and hav-

ing models come. . . . Tomorrow morning I have a model for the Pediment, now things are going to fly along.[22]

With his business in New York concluded Bartlett headed for Washington, arriving there on 13 February 1909. That same day he met with Elliott Woods to deliver his sketch models and to discuss the provisions of his contract, which had yet to be signed.[23] Three days later the members of the commission met in the Office of the Speaker of the House. Bartlett was not present at the meeting. Secretary Vale read the form of the contract between the sculptor and the commission; it was duly approved with only minor revisions and ordered to be executed. The commission then viewed Bartlett's sketch models and agreed to the following resolution offered by Representative Charles Thomas:

RESOLVED, That the plaster sketch model of the marble sculptured group for the ornamentation of the pediment of the House wing of the Capitol, submitted to the Commission this day by Mr. Paul Wayland Bartlett, is approved.[24]

Upon the acceptance of Bartlett's designs the formal contract was signed by all parties and dated

16 February 1909.[25]

The contract stipulated that Bartlett's statuary had to be modeled in accordance with the accepted sketches, made of the best material available, and conceived in harmony with the architecture of the Capitol Building. This final provision meant that the style of Bartlett's figures had to blend with the delicate classicism of the House portico and yet be bold enough to match the monumentality of the site. The contract further stipulated that the sculptor had to erect the statuary at his own expense, and that the pediment was to be complete and in place within three years from the date of the signing of the contract, a surprisingly short period of time given the scope of the commission and Bartlett's reputation for failing to meet project deadlines. Elliott Woods was named as the administrative officer of the contract, and any claim by Bartlett for a modification of the contract would have to be made to, and accepted by, him.

According to the contract, upon the completion and erection of the sculpture Bartlett would receive the sum of $74,000 in full payment for materials furnished, services rendered, and labor performed. This meant that Bartlett was to receive no funds whatsoever until his sculptures were complete and in place within the pediment.

Such a system of payment was decided upon at the request of Bartlett himself who, according to Woods, had "insisted he did not want any money until he finished the work." Woods, on the other hand, favored a method of partial payments for work completed as a much more suitable plan for a commission of this length and complexity.[26] Several years hence, when it came time to transfer his models into marble, the sculptor would petition Woods for a modification of the contract to allow for partial payments. Bartlett's initial insistence on one final payment was characteristic of his tendency to let enthusiasm for a new project overwhelm more pragmatic considerations of time, money, and labor. This aspect of Bartlett's professional behavior combined with his workmanlike approach to the execution of a commission contributed to his inability to complete projects on time.

Although the contract had been duly signed, to become official it had to be approved by the Department of the Interior on whose authority the appropriated funds to pay for the pediment would be disbursed. Despite the fact that the contract called for a single payment to be made only after the work was completed and accepted, the Interior Department required that Bartlett execute a bond in the sum of $4,400 before they would approve his contract. Bartlett quickly no-

tified his New York attorney, Edwin Baldwin, about the new stipulation. Baldwin, in turn, contacted the Department of the Interior, inquiring as to the specific conditions of the bond that now had to accompany Bartlett's contract.

The Interior Department informed Baldwin that the bond required two individual sureties with Bartlett as principal.[27] When Bartlett returned to America from France in May 1909, it was decided that Baldwin and another New Yorker, Samuel C. Van Dusen, would act as sureties on the sculptor's bond; Baldwin eventually remitted the specified bond to the Interior Department on 8 June 1909.[28] One week later, Bartlett, then in New York, wrote Woods to acknowledge receipt of his copy of the approved contract. The final legislative obstacle to the completion of the House pediment had been removed. Now all that remained was for Bartlett to prepare the plaster models and to supervise the carving and installation of the final marbles within the pediment. It would take only seven more years.

Early Work on the Pediment and the First Extension of Bartlett's Contract

Two photographs in the Library of Congress show plaster casts of Bartlett's preliminary sketch models for the House pediment (figs. 30 and 31). They were modeled in late 1908 or early 1909 and most likely represent the sketches approved by the commission to complete the pediment on 16 February 1909. Both models reflect the basic theme and general organization of the finished pediment, that is, a central female personification flanked by two large figural groups representing, to the viewer's right, the labors of agriculture, and to the viewer's left, the labors of industry. The only significant difference between the two casts is the treatment of the central figure—in one sketch she brandishes a sword and a tablet, while in the other she rides a quadriga—which suggests that Bartlett had not yet decided upon her specific identity. Both personifications, however, are Athena-like in character and are most consistent with traditional images of Democracy, or America, Triumphant.

In its initial stages the general scheme of Bartlett's design benefitted from the input of the commission to complete the pediment, especially Wetmore and McCall. Speaking at the unveiling in August 1916, Bartlett recalled his first negotiations with the two congressmen:

When we came to discuss the subject or theme to be represented on the pediment, I was told that there was a vague feeling in the committee that the subject should be taken from the history of the United States. We came, however, to the conclusion that the theme

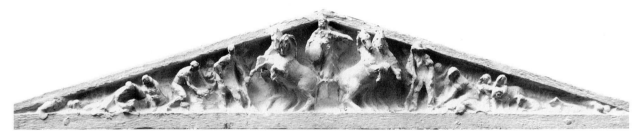

Fig. 30. Paul Wayland Bartlett, Preliminary Sketch Model for the Apotheosis of Democracy, *1908–9. Plaster, no longer extant. Photograph: Prints and Photographs Division, Library of Congress.*

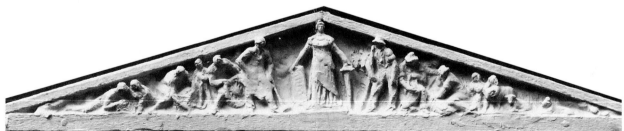

Fig. 31. Paul Wayland Bartlett, Preliminary Sketch Model for the Apotheosis of Democracy, *1908–9. Plaster, no longer extant. Photograph: Prints and Photographs Division, Library of Congress.*

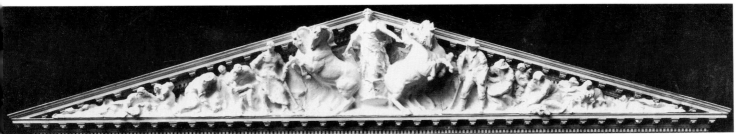

Fig. 32. Paul Wayland Bartlett, Advanced Sketch Model for the Apotheosis of Democracy, *1909–10. Plaster, no longer extant. Photograph: Prints and Photographs Division, Library of Congress.*

should be of the present rather than of the past. We thought because the House represents in its largest sense the people, that the people—the life and labors of the people—should be portrayed on this building, this temple of democracy. Hence this conception.[29]

Obviously, the members of the commission believed, as Captain Meigs had over fifty years earlier, that the proper decoration for a legislative building should be familiar and intelligible to the general population. This explains, at least in part, why the pedimental models by Gutzon Borglum and Charles Henry Niehaus had been rejected by McCall and the other members of the committee; they were simply too allegorical and too lacking in native imagery to be comprehensible to the American public in any meaningful way. In contrast, Bartlett's designs drew their inspiration more or less from the contemporary American scene. In this respect, they were more akin to Ward's design for the Stock Exchange pediment or to the mid-nineteenth-century pedimental designs of Thomas Crawford and especially Henry Kirke Brown.

By early summer 1909, Bartlett had gone to Paris where he spent the next few months in his studio at 16, rue de Commandeur working on his figures for the New York Public Library. In December, he returned to America with a full-size model of one of the figures, *Philosophy,* and during the first months of 1910 he continued to focus the major part of his efforts on the New York commission.[30] Still, during this period Bartlett did find the time to prepare several advanced sketch models for the House pediment. A third photograph in the Library of Congress shows an enlarged plaster cast of one of these models with the quadriga-type central portion (fig. 32). Enlarged plaster casts of two additional advanced models without the quadriga appear in a photograph of the interior of Bartlett's

Washington studio taken about 1910 and located in the Office of the Architect of the Capitol (fig. 33); the cast prominently displayed in the foreground was Bartlett's most advanced sketch model to date.[31]

In July 1910, an illustration of this model accompanied an article on Bartlett's pediment written by William Walton and published by *Scribner's Magazine.* Bartlett had cooperated with Walton during the preparation of the article, supplying him with photographs and even making corrections to his text. Thus, it is safe to conclude that Walton's description of the model had the sculptor's full approval.[32]

Walton identifies the central figure in the design as a representation not of Democracy but of Peace and describes her "more as a goddess, or a symbol, than as a living and merely human personification." She is the only purely allegorical figure in the composition. On her left arm she carries a circular buckler and in her right hand she holds extended an olive branch. Behind the goddess and slightly to the left Bartlett has placed her altar, "the curling smoke from which rises and mingles with her garments." In the final design, Bartlett will replace the single figure of Peace with a central group, *Peace Protecting Genius.* Turning his attention to the figures comprising the rest of the model, Walton defines those to the left of Peace as representing Hunting and Agriculture, and those to her right, the Manufactures and Navigation. In limiting himself to the depiction of the labors of everyday Americans, Walton explains, Bartlett "had in mind the more purely democratic character of the representative assembly that sits below, their more direct relations with the people."[33]

The first figure to the left of Peace is an aboriginal hunter carrying a slain deer. Walton describes this figure as "a forerunner of the

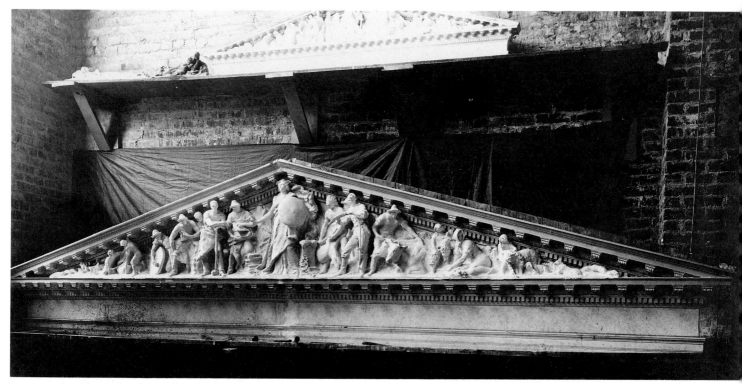

Fig. 33. Paul Wayland Bartlett, Two Advanced Sketch Models for the Apotheosis of Democracy, *1909–10. Plaster, foreground model, no longer extant; background model, Tudor Place, Washington, D.C., Temporary Loan. Photograph: Architect of the Capitol.*

development of the country," and, as such, it recalls Crawford's depictions of Indians in the Senate pediment. As Bartlett refined his design he would replace this hunter with a youth, a figure more suggestive of the present and future than the past. Next comes the mower, or reaper, with his scythe, "the symbol of completion, of gathering in, the harvest." This side of the model is completed by two groups of figures that, taken together, depict "the labor of the fields," a husbandman with cattle, and a woman and her children harvesting the field.[34] All these figures appear with only minor revisions in the finished pediment.

To the right of Peace stands a printer who, according to Walton, represents "one of the most important of all the manufactures which she [the figure of Peace] protects, that of books." Next is a metal-worker leaning on his hammer—a figure that corresponds in stance and position to the mower from the opposite side of the composition—followed by a founder who pours liquid metal into a mould while an assistant looks on from the background. Behind them a second foundry-worker is shown rolling forward a car

wheel. Bartlett eventually replaces this figure with a woman measuring cloth, or a weaver, no doubt intending that she balance the woman harvester from the left side of the design. Completing the right side is a group of two youths fastening a mast to a small boat. This group, representing Navigation,[35] recalls the *American Boy* from Henry Kirke Brown's models for the House pediment. In his final design Bartlett would reduce the group to a single fisherboy who, with his small vessel safely pulled ashore, is shown hauling in his catch from the sea.

Bartlett terminated each end of the model with a breaking wave, a device borrowed directly from the Stock Exchange pediment. The waves indicate, as the sculptor himself later explained at the unveiling, "that all this humanity, all its power and energy, are comprised between the shores of two great oceans—the Atlantic and the Pacific."[36]

Walton and the editors of *Scribner's Magazine* were impressed with Bartlett's design model for the House pediment. Walton, in fact, refers to the work as no less than "the United States equivalent, in this century, of the Panathenaic proces-

sion in the fifth, B.C.," adding with obvious approbation that "the sculptor declines to consider his commission as any less inspiring than his Grecian predecessor's."[37] These were courageous remarks considering the fact that Bartlett's project had yet to progress beyond the stage of a sketch model. Nonetheless, they indicate the general level of expectation that had come to surround the commission.

In late spring or early summer 1910, Bartlett returned again to Europe, and in early July he was able to write to Woods that he was hard at work on the pediment. For the next year and a half Bartlett split his time more or less between the House pediment and the remaining attic figures for the New York Public Library. Apparently, the first portion of the pediment to draw Bartlett's individual attention was the central figure of Peace, which he was busy modeling by at least February 1911. Later that summer he had shifted his focus to the northern half of the composition, that is, the figures representing "the labors of agriculture."[38]

Finally, in late October 1911, the first clay model of a figure from the pediment was complete and ready for the moulder; it was *Child Wrestling with a Ram*, a small piece from the northern corner of the pediment and one of three separate pieces that would comprise the large group, *Mother and Children Harvesting the Field* (fig. 34). The work was cast in plaster on 23 October 1911.[39]

Working from the northern end of the pediment toward the center, Bartlett now turned his attention to the reclining *Mother* and the *Boy Carrying Grapes*, the two remaining figures from the harvesting group. Bartlett had a lot of trouble modeling these pieces, especially *Boy Carrying Grapes*, the human model for which was a young child and very difficult to manage. Nevertheless, by mid-December 1911, Bartlett had given the final retouches to the clay model. Finishing *Boy Carrying Grapes* released Bartlett to concentrate on the *Mother*, which he expected to complete by the end of the month.[40] Bartlett would then begin modeling the last pieces from that side of the composition, two farmer groups entitled *The Husbandman* and *The Reaper and His Attendant*.

The sculptor recently had revised these groups as well as the central figure and possibly various other portions of the design. A revised sketch model of the central and southern portions of the pediment dates from about this time (fig. 35). In the new version a young genius, torch in hand, huddles at the side of Peace who extends her right hand over him in a gesture of protection. Also, the foundryman with a car wheel now has

Fig. 34. Paul Wayland Bartlett, Child Wrestling with a Ram, Mother, *and* Boy Carrying Grapes, *1909–11. Plaster, no longer extant. Photograph: Architect of the Capitol.*

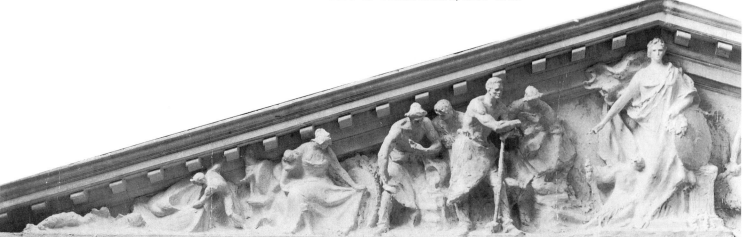

Fig. 35. *Paul Wayland Bartlett*, Revised Sketch Model for the Central and Southern Portions of the Apotheosis of Democracy, *1911. Plaster, no longer extant. Photograph: Architect of the Capitol.*

been replaced by the woman measuring cloth. On 8 December 1911 Bartlett wrote Suzanne regarding the recent changes in his design:

I have revised the other side of the Pediment . . . and I have got something very much better, particularly the middle figure. I have got "Peace protecting genius" . . . and the big piece with the farmers is definitely improved so I will have soon an interesting collection of photos to send to the people at the Capitol.[41]

Bartlett now decided to stay in Paris until the central and northern portions of the pediment were modeled and cast in plaster; then he would take the finished models to America where stone carvers could begin the process of translating them into marble.

The year ended with a flourish for Bartlett: on 30 December 1911 he was elected a corresponding member of the Institut de France, and less than two weeks later he would be elected to the Royal Academy of Belgium. These honors reflected the sculptor's growing international reputation since the erection of his *Lafayette* in Paris several years earlier. The new year also brought the completion of the third clay model for the House pediment, the *Mother* from *Mother and Children Harvesting the Field*. Feeling understandably triumphant at the moment, Bartlett marked the occasion by writing to Woods in Washington with a progress report of his work on the pediment:

At last I can give you some decent news of the Pediment! Yesterday, I finished one section [*Mother and Children Harvesting the Field*]. It is now in the hands

of the moulder and photos will be forwarded to you as soon as they can be made. I have another section well advanced [the two farmer groups] which I hope to have finished by the end of February. The other sections are under way. I, therefore, expect to be able to return to Washington in March with one half of the big model all finished ready to show to the committee. I would like them to erect in place a section of the plaster model, and if satisfactory, begin the marble work.[42]

Bartlett then introduced the topic of an extension to his contract, which had stipulated that the project be completed within a three-year period ending on 16 February 1912, less than seven weeks away. He told Woods he would need at least two more years to finish the modeling and another for the marble work to be done if it were begun in the spring. Bartlett concluded his letter with the news that the commission was beginning to attract attention in France. In so doing, he could not resist giving himself a pat on the back:

All the old French sculptors are very interested in the Pediment, as it is very different from anything they have here, and none of this magnitude has been executed for a very long time. It is largely to the Pediment and to the Lafayette that I owe my election, last Saturday, to the Institute of France.[43]

Within weeks the plaster casts of the *Mother* and *Boy Carrying Grapes* were completed, and Bartlett sent rolls of photographs to Woods and Senator Wetmore. He was particularly concerned that Woods have some photographs at once to show that real progress had been made on the pediment. Apparently, the sculptor was

apprehensive over Woods's willingness to approve an extension to the original contract. But there was no need to question Woods's cooperation, for the superintendent was interested only in obtaining sculpture of the best quality for the pediment.

On 3 February 1912 Woods wrote Bartlett that it would take some time before the sculptor's request for an extension could be taken up by the commission. Actually, it would take several months before the extension was finally approved. Meanwhile, as time passed with no official word from Washington, Bartlett became increasingly discouraged over what he perceived to be a lack of understanding on the part of the commission. To make matters worse, at that moment Bartlett was having financial difficulties and was beginning to regret his past decision to reject a system of partial payments for work completed.[44]

Finally, in late July 1912, Woods made a formal recommendation to Champ Clark, current Speaker of the House and, by consequence, the new chairman of the commission for completing the House pediment, that Bartlett's request for an extension to his contract be accepted. Subsequently, a form of approval granting an extension of two years from 16 February 1912 "or so much thereof as may be necessary" was signed by all available committee members and dated 25 July 1912. That same day, the secretary for the commission notified Bartlett in Paris that his contract had been extended.[45]

Further Work on the Pediment and the Second Extension and Modification of Bartlett's Contract

During the early months of 1912, as Bartlett waited for news from Washington on the extension of his contract, the sculptor worked diligently on the two remaining agrarian groups from the northern half of the pediment, *The Reaper and His Attendant* and *The Husbandman*. Progress was slow. The main problem was Bartlett's workload: his willingness to take on new projects with little thought to previous commitments forced him to spread his efforts among several major commissions concurrently.[46] Nevertheless, by late April, *The Husbandman* was ready to be cast in plaster (fig. 36).

Two months earlier Bartlett had decided to revise this group by eliminating one of the oxen.[47] This gave the design a greater formal clarity, which Bartlett believed was crucial to the success of the pediment, a work that would be viewed only at some distance. It also produced a more effective balance between the sculptural and the merely pictorial. Furthermore, the white mass created by the large head and prostrate body of the single ox would, in the final design, serve to separate the more deeply cut figures to either side, thereby adding a measure of rhythm and variety to the composition (the large cloth held by *The Weaver* on the opposite side of the pediment would perform a similar role). Thematically, the reduction of the group to one farmer and one animal emphasized the physical and psychological bonds that link the two, a feature of the group to which Bartlett clearly was attracted. The dominant mass of the powerful animal in conjunction with the subtle but insistent gestures of the husbandman establish the guiding presence of human control without disturbing the sense of cooperation inherent in the coordination of man and beast. This ability to merge the spirit of a piece with its formal properties characterizes Bartlett's best work.

With little hope of finishing the northern portion of the pediment anytime soon, Bartlett gave up the idea of going to America that spring. Instead, he took solace in the fact that Suzanne would be sailing to Europe to spend the summer with him in Paris and decided to bear down on his work in the hope of returning to Washington with the completed models for half of the pediment some time later that winter. Still struggling financially, Bartlett briefly considered mortgaging the Washington studio but decided against it, realizing that it might hamper his ability to finish the pediment. He did, however, persuade the American sculptor Bessie Potter Vonnoh (1872–1955) to sell the studio she co-owned with him in New York City.[48]

Throughout the summer of 1912 Bartlett divided his studio time between two works—his figure of *Poetry* for the New York Public Library and *The Reaper*, the final group from "the labors of agriculture." Despite Suzanne's presence the continuing demands of several major commissions often forced Bartlett into periods of isolation by which he hoped to avoid the distractions of everyday life. Characteristically, Bartlett accepted this self-imposed regimen as necessary to the successful conduct of his profession. Nonetheless, it was a condition about which he often complained.[49]

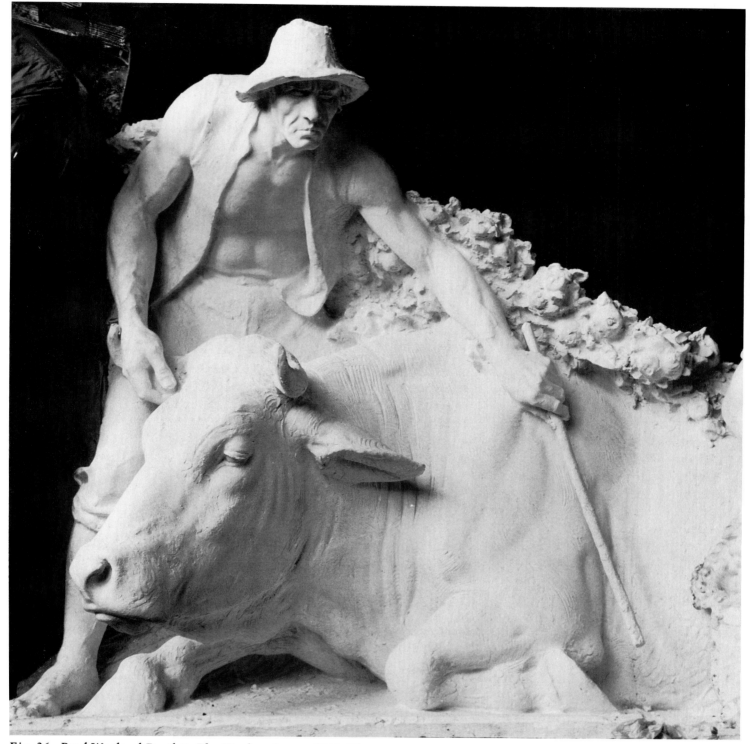

Fig. 36. Paul Wayland Bartlett, The Husbandman, *1912. Plaster, no longer extant. From William Walton, "Recent Work by Paul W. Bartlett,"* Scribner's Magazine *54 (October 1913): 527.*

In September 1912, Bartlett decided to lay aside his work on the pediment for the next few months and concentrate on his figures for New York. Then, as the new year approached other distractions delayed still further his return to the Washington commission. Sorely in need of an income, Bartlett decided to take advantage of his growing popularity as an instructor and signed on a large number of students for private lessons. He also spent a great deal of time that winter preparing a lecture on American sculpture and the French influence, which he first de-

livered in Paris on 22 January 1913. The speech was widely publicized both in France and America, and during subsequent weeks he was asked to repeat it several times before various organizations including the Académie Colarossi.[50]

In early February 1913, Bartlett was ready to resume work on the model for *The Reaper*. As he struggled to complete the group, he also made plans for his return to Washington. In mid-March he had new plaster casts made of the *Mother* and the *Child Wrestling with a Ram* and began the process of carefully packing all the models for shipment to America. Actually, the sculptor had more than artistic matters on his mind, for the recent death in Washington of Suzanne's husband, Dr. Samuel Franklin Emmons, finally had made it possible for her and Bartlett to marry.

Back in Paris, however, the sculptor suffered another financial setback, one that threatened his departure for the United States. A letter arrived from Thomas Hastings, the supervising architect of the New York Public Library, stating that Bartlett could not receive any further payments for his work on the library figures until he was owed at least $5,000—the State of New York would no longer issue checks for less than that amount. Bartlett recently had shipped to New York two casts of *Drama*, and the casts for *Poetry* would soon be ready. Still, by the sculptor's own calculation his bill would not top the required mark until both of these figures were enlarged in America and placed on the library to gauge their scale. "That settles my having any money for a long time," Bartlett wrote Suzanne. "I have a little, just enough to pay rent and moulders. . . . I do not know what I am going to do. I have some boxes packed ready to send to Washington—but I can't afford it."[51]

Fortunately, a situation soon presented itself that promised to alleviate some of Bartlett's financial distress. He was invited to deliver his lecture on American sculpture and the French influence at The Glasgow School of Fine Arts, in Glasgow, Scotland, and, if successfully received, he most likely would be offered a part-time position at the school as professor of sculpture. Bartlett immediately packed the remaining plaster casts that were ready, arranged for their shipment to New York, and bought his ticket for Scotland. He planned to spend four or five days in Glasgow, time enough to consider any propo-

sition the school might make, and then sail for America, arriving in New York around the end of April. "The thought of seeing you again for good cheers me up more than I can say," he wrote Suzanne, "and if I succeed in Glasgow as I expect I am going to make my American clients stand up in a line!"[52]

Bartlett's trip to Glasgow was a complete success, and, just as he had anticipated, on 10 April 1913 the school appointed him director of sculpture.[53] Within weeks he was back in the United States. Then, on the 29th of April, he and Suzanne were married in Washington. Over the next few weeks, Bartlett unpacked the plaster casts of his pedimental figures and had them set up in his Washington studio. Soon he wrote his father in Boston that many people, including Mrs. Woodrow Wilson, had come to the studio to see the models and that everyone was enthusiastic.[54]

Bartlett stayed in America for only a short time, returning to Europe with Suzanne in late May. Several weeks earlier, the Art Commission in New York had rejected the designs for three of his library figures—*History*, *Drama*, and *Poetry*—and this probably forced Bartlett back to his Paris studio to revise the original models.[55] In any case, the sculptor definitely planned to return to Washington in the winter. "My academic honors open the doors of the Embassies [in Washington]," he wrote his father, "and Lady Bartlett is so well-known here that if I am willing to stay here in the winter for a few months once in a while, I can have great power."[56]

In October 1913, *Scribner's Magazine* published a follow-up article by William Walton on the current status of Bartlett's pediment. Illustrating the article were photographs of all the models that had been completed up to that point—*Child Wrestling with a Ram*, the *Mother*, *Boy Carrying Grapes*, and *The Husbandman*. In his article Walton notes that Bartlett had removed the aboriginal hunter from the design in order to create greater freedom of action for the remaining figures but fails to mention the head of a youth that appears behind the reaper in the completed pediment. Curiously, Walton also states that Bartlett was considering changing the identity of the central figure from Peace to that of Democracy, suggesting that, even at this late stage, the sculptor was still undecided regarding the unifying theme of his design.[57]

In late December 1913, Bartlett was in Paris

putting the finishing touches on his models for *Peace Protecting Genius* and *The Reaper and His Attendant*. He was also preparing once again to leave for the United States to begin the next phase of his work on the House pediment. On the last day of the year he sent Elliott Woods another progress report:

At last I have finished or nearly finished my central group "Peace Protecting Genius" for the Pediment, and I was able last week to send you two rolls of photos . . . showing the complete composition of the Pediment. All the figures finished are on their way to Washington, and the others are all in clay *large size*, and well advanced. I am beginning to see my way clear, and I think now that I can get all the models finished in another year. I am leaving Paris the 7th of Jan[uary] and expect to arrive in Washington somewhere about the 15th.[58]

On 23 January 1914 Bartlett finally arrived in Washington where he would complete the remaining models for the pediment and begin the preparations for the carving of the marble figures. Upon his arrival he immediately wrote Woods to request that his contract be extended once again, this time for "three years from the termination of the last extension," and that in view of the tremendous cost of the marble, "the contract be so modified as to provide for partial payments during the progress of the work."[59] The next day Woods forwarded Bartlett's letter to Champ Clark with his personal recommendation that the sculptor's request be approved. "It appears to me," the superintendent explained,

that this extension, for the purpose of giving to the country a better work of art than would be possible if the work were hurriedly done, is a matter in which the Government will be the gainer, rather than the loser.[60]

Following an unexplained delay of several months, Woods's recommendation was accepted. The form of approval was duly signed by the members of the commission and dated 10 April 1914.[61]

After receiving permission in writing from Edwin Baldwin and Samuel C. Van Dusen, the two sureties on Bartlett's bond, Woods had a modified contract drawn up, which he and Bartlett signed on May 12th. Part 4 of the modified contract stipulated "that the time for completion of the original contract is hereby extended to February 16, 1917." It also stipulated the following method of partial payments:

At such periods of time as may be deemed just and proper, the said Superintendent [Woods] will cause an estimate to be made as to the value of the work actually done and put in place at the date of the estimate. Thereupon the Superintendent will issue a payment voucher equivalent to 90 per cent of the amount of the estimate. Such method of approximate partial payments will be continued during the progress of the work and until the completion thereof, after which the payment of the retained 10 per cent will be made in the discretion of the Superintendent.[62]

The day after the modified contract was signed Woods sent a copy to the Department of the Interior. Two days later the assistant secretary of the Interior acknowledged the receipt of the contract, stating that it had "been examined and found to conform to the legal requirements in such cases and to have been properly executed."[63]

More Work on the Pediment and the Selection of Marble

On 19 May 1914 Bartlett received his first payment for work done in connection with the sculptural decoration of the House pediment. The amount due the sculptor was estimated to be $15,000. In accordance with the terms of the modified contract, 10 percent was subtracted from that amount leaving a total first payment of $13,500.[64] At this moment the sculptor's spirits must have been high, for besides his improving financial outlook, the Art Commission in New York had just approved his revised figures for *History, Drama,* and *Poetry*.[65]

Meanwhile, the plaster cast of *Peace Protecting Genius* that was shipped from Paris on the 25th of April had finally arrived in New York, preceded by the cast of *The Reaper and His Attendant*. The other previously completed models were already at Bartlett's studio in Washington. Bartlett had *Peace Protecting Genius* and *The Reaper* enlarged in New York, and at least two sets of plaster casts were made of each group. This work most likely was done at the New York studios of the Piccirilli Brothers, well-known Italian stone-cutters with whom Bartlett had worked closely for some years. Bartlett soon would hire them to cut his marble figures for both the New York Public Library and the National Capitol.[66]

Bartlett was anxious to have the enlarged plaster casts of *Peace Protecting Genius* and *The*

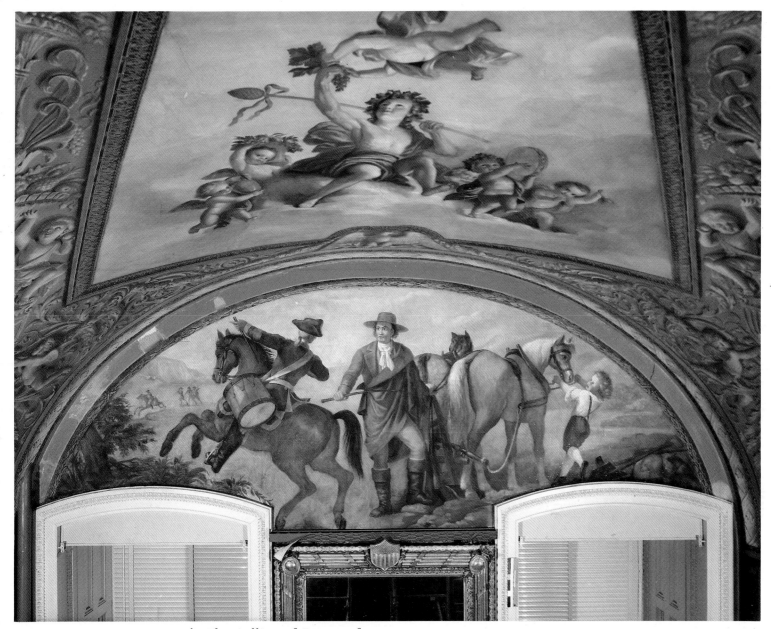

Fig. 13. Constantino Brumidi, The Calling of Putnam from the Plow to the Revolution, *1855–56. Fresco painting, West Wall, Room H-144, House Committee on Appropriations, House Wing, United States Capitol Building. Photograph: Architect of the Capitol.*

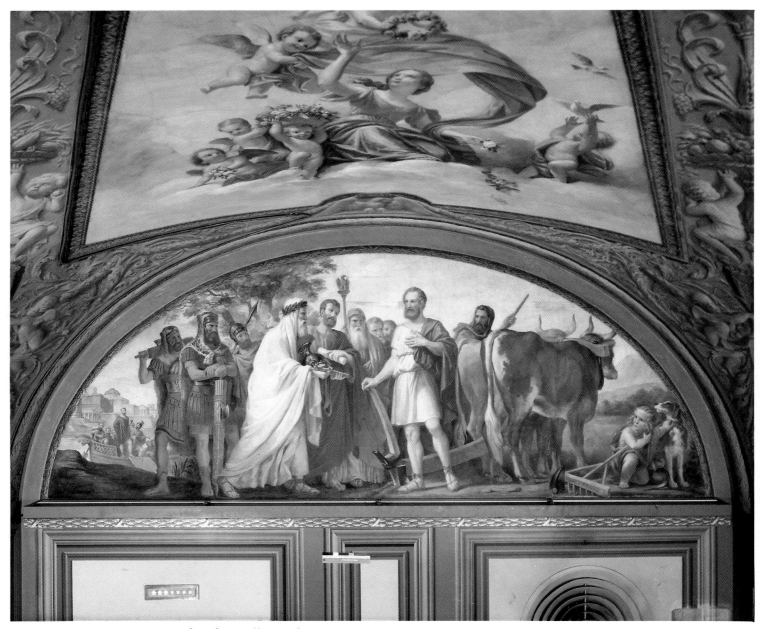

Fig. 14. Constantino Brumidi, The Calling of Cincinnatus from the Plow, *1855–56. Fresco painting, East Wall, Room H-144, House Committee on Appropriations, House Wing, United States Capitol Building. Photograph: Architect of the Capitol.*

Fig. 66. Jules Dalou, The Peasant, *1897–99. Bronze, garden of the Ny Carlsberg Glyptotek, Copenhagen. Photograph: NCG/ Ole Haupt.*

Fig. 29. Paul Wayland Bartlett in his Garden at 237 Randolph Place, N.E., Washington, D.C. (the studio is directly behind him), ca. 1910–15. Photograph: Tudor Place, Washington, D.C.

Fig. 69. Elihu Vedder, Minerva, *1897. Mosaic, Library of Congress, Washington, D.C. Photograph: Anne Day.*

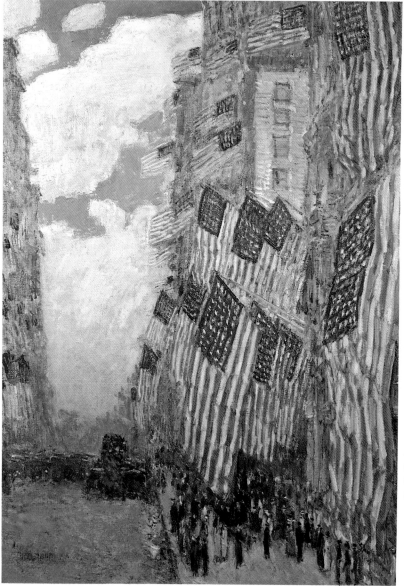

Fig. 73. Childe Hassam, The Fourth of July, 1916 (The Greatest Display of the American Flag Ever Seen in New York, Climax of the Preparedness Parade in May, 1916), *1916. Oil on canvas, Berry-Hill Galleries, New York, New York.*

Fig. 82. Paul Wayland Bartlett, Head of Peace *(detail of* Peace Protecting Genius, *central group from* The Apotheosis of Democracy; *head and partial bust), modeled, 1909–13; this cast, 1927. Bronze, James Monroe Museum and Memorial Library, Fredericksburg, Virginia, Gift of Mrs. Armistead Peter III, 1958.*

Fig. 83. Paul Wayland Bartlett, Head of Genius *(detail of* Peace Protecting Genius, *central group from* The Apotheosis of Democracy; *head, partial bust, and portion of a wing), modeled, 1911–13; this cast, ca. 1913–16? Plaster, Tudor Place, Washington, D.C.*

Figs. 84 and 85. *Paul Wayland Bartlett,* Mother and Children Harvesting the Field *(from* The Powers of Labor: Agriculture, *northern portion of* The Apotheosis of Democracy*), modeled, 1909–11. Bronze, The Columbia Museum of Art, Columbia, South Carolina, Gift of Mrs. Armistead Peter III. Photographs: Alt-Lee, Inc.*

Fig. 86. Paul Wayland Bartlett, Boy Carrying Grapes *(detail of* The Powers of Labor: Agriculture, *northern portion of* The Apotheosis of Democracy), *modeled, 1908–11. Bronze, Tudor Place, Washington, D.C.*

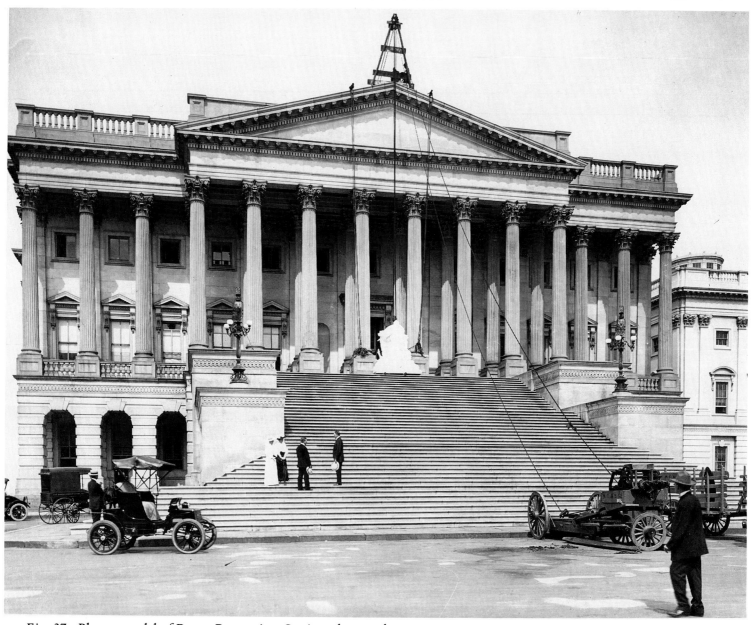

Fig. 37. Plaster model of Peace Protecting Genius *about to be hoisted into position within the House Pediment, 15 July 1914. Photograph: Architect of the Capitol.*

Reaper completed and sent to Washington; especially the casts of *Peace Protecting Genius,* one of which the sculptor intended to place on the building in order to check its scale and depth in relation to the pediment. The trial placement would give the sculptor a chance to measure how effectively he had been able to pull his figures up and out of their limiting triangular frame—the depth of the ledge was a mere three feet—so as to provide the most satisfying viewpoints from the ground. For Bartlett this was an essential point because he felt that if his figures were not easily accessible to viewers on the ground some

sixty feet below then his pediment would not be completely successful.

On 11 July 1914 the enlarged plaster casts of *Peace Protecting Genius* and *The Reaper and His Attendant* were shipped from New York to Washington. Four days later Bartlett supervised the trial placement of the central group within the House pediment. A photograph in the Office of the Architect of the Capitol documents the event (fig. 37). On the basement level directly in front of the east entrance to the House wing sits the plaster cast of *Peace Protecting Genius.* The equipment needed to hoist the model up to its

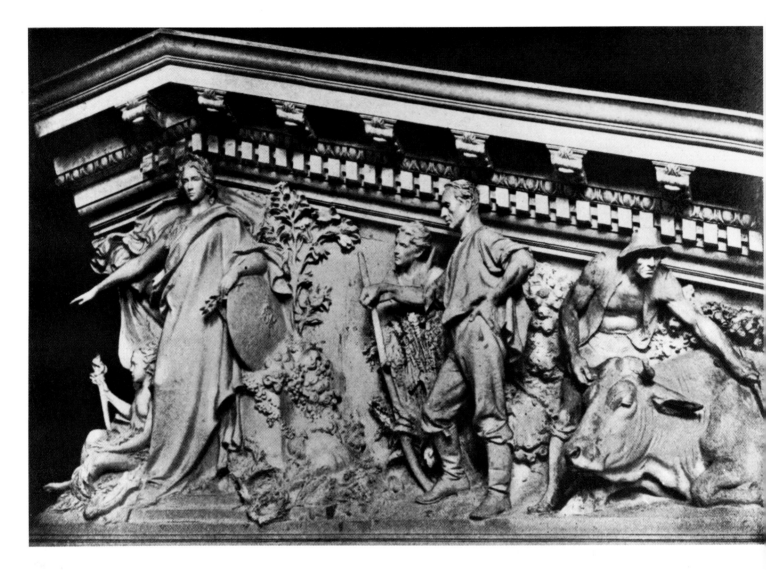

Figs. 38 and 39. Paul Wayland Bartlett, Peace Protecting Ge-
nius, The Reaper and His Attendant, The Husbandman, *and*
Mother and Children Harvesting the Field, *1914. Plaster, no
longer extant. From "Paul Bartlett's New Sculpture for the Capi-
tol,"* Vanity Fair *3 (November 1914): 32.*

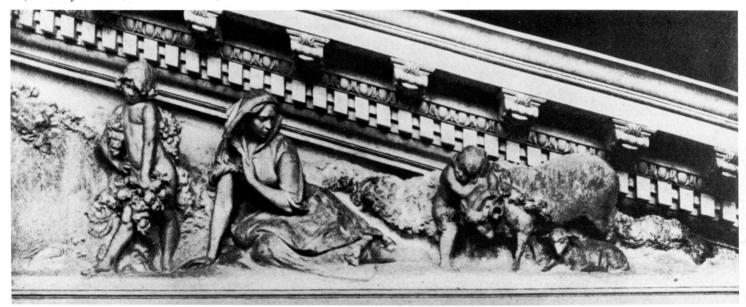

position can be seen surmounting the portico and at street level to the far right. On the steps leading to the House entrance stand Superintendent Woods (looking left) and Bartlett (looking right) with their wives.[67]

Back in his studio Bartlett put on view the plaster models for *Peace Protecting Genius* and *The Powers of Labor: Agriculture*.[68] In November 1914, two illustrations published in *Vanity Fair* showed the sculptor's models as they had been displayed in his studio the previous summer (figs. 38 and 39).[69] The casts appear within a carefully constructed plaster replica of the House pediment complete with modillions and dentil cornice. A scale replica of the architectural setting made it possible for Bartlett to evaluate each figure in terms of its ultimate position within the pediment and to adjust the stance and gestures of each successive figure to those already completed.

The photographs in *Vanity Fair* also reveal the incredible amount of pictorial detail in various levels of sculptural relief that Bartlett invested in the open areas behind and between his figures. The careful arrangement of such detail helped to unify the groups within a single continuous space, a sensation reinforced by the apparent freedom of Bartlett's figures—themselves carved essentially in high relief—to move and interact with one another despite the constraints of the architectural site. Thus, Bartlett avoided creating the impression of a series of single statues each isolated within its own private context, an unfortunate characteristic of Crawford's Senate pediment and of earlier, rejected designs for the House pediment. It is this more fluid handling of the composition—impressionistic versus neoclassic—that provides the clearest distinction between Bartlett's pedimental sculpture and that of his predecessors.

After exhibiting his models to Congress and the public, Bartlett wanted to return to France to finish the rest of the pediment in his Paris studio. But the outbreak of war in Europe forced the sculptor to change his plans and he decided to stay in America.[70] Bartlett spent the final months of 1914 in Washington working to complete the figures for the southern half of the pediment, that is, the figures representing *The Powers of Labor: Industry*. These models were well advanced in clay as early as December 1913, but only now could Bartlett turn his attention to the final phases of their modeling.

As was the case with the northern half of the pediment, Bartlett began at the extreme corner of the composition and worked his way toward the center. By late September 1914, the little *Fisherboy*, or *Boy With a Boat*, was in plaster;[71] by the end of the year, *The Weaver*, or *Woman Measuring Cloth*, also had been completed. In January 1915, *Art & Archaeology* published a photograph showing both casts set in place within the model replica of the pediment (fig. 40). The illustration appeared in an article written by Mitchell Carroll, the director of The Octogon, in Washington.[72]

Fig. 40. Paul Wayland Bartlett, Fisherboy *and* Woman Measuring Cloth, *1914. Plaster, no longer extant. Photograph: Architect of the Capitol.*

Carroll's discussion of the pediment is noteworthy because it represents the earliest attempt to place Bartlett's figures in some kind of art historical context. Carroll states, for example, that in theme and arrangement the pediment's central group, *Peace Protecting Genius*, compares favorably with the early fourth-century B.C. Greek statue, *Eirene and Ploutos* (fig. 68), by Kephisodotos the elder. He offers the additional suggestion that Bartlett's decision to conclude the pediment at each end with a wave symbolizing the Atlantic and Pacific Oceans, is reminiscent of the river gods, Ilissus and Cephissus, who fill the corners of the west pediment of the Parthenon. Following a more popular train of thought, Carroll points out that the facial features of *The Reaper* "bear a striking resemblance to Abraham Lincoln, who fulfills, more than anyone else, the ideal of the genius of the country," a common refrain echoed in most descriptions of the House pediment thereafter.[73]

While Bartlett continued to work on the remaining figures for the southern portion of the pediment, he also took steps to begin the delicate process of carving in marble the models already completed. Bartlett chose the Piccirilli Brothers to do the marble work in connection with the pediment commission, and, on 2 January 1915 four large boxes containing Bartlett's final plaster models of *Peace Protecting Genius* and *The Powers of Labor: Agriculture* arrived at the Piccirilli studios in New York City.[74]

Bartlett's work on the pediment now had progressed to the point where it was time for Congress to appropriate the remaining portion of the original sum of $75,000 that they had approved on 16 April 1908 to be applied toward the purchase of statuary for the House pediment. An initial sum of $15,000 had been appropriated on 27 May 1908, but these funds were applied to the partial payment of $13,500 made to Bartlett on 9 May 1914. Another appropriation was necessary if Bartlett were to receive further partial payments for work completed on the project.

On 5 January 1915 Elliott Woods wrote to Champ Clark, chairman of the commission to complete the pediment, to request that the necessary appropriation receive Congress's immediate attention:

The work under said contract having progressed to such an extent, that it is the belief and purpose of the sculptor Mr. Bartlett, to complete the contract by the erection and installation of the completed sculptured decorations of said Pediment during the month of November 1915, I respectfully suggest that such action may be taken as will secure during the present session of Congress of an appropriation of sixty thousand dollars, the sum required to complete the work as authorized and to pay the balance due on contract, and further, that the appropriation be made in such a manner as to be immediately available.[75]

Despite Woods's insistence, however, Congress did not act quickly. In fact, Bartlett would not receive a second payment in connection with the commission until the following August. Congress's consistent inability to act in a timely manner regarding financial matters must have infuriated the sculptor, who was already struggling under the pressure of trying to bring two major commissions to a successful conclusion.[76]

While Bartlett pondered the fate of his next partial payment, the question of what type of marble to use for the pediment had to be settled. With this in mind, in late March Woods sent a small sample of marble from the quarries of the Georgia Marble Company, in Tate, Georgia, to the Bureau of Standards at the Department of Commerce in Washington, for analysis. The sample was supplied by Bartlett, whose attic figures for the library in New York were presently being carved by the Piccirillis out of marble from the same quarry. In his accompanying letter to the Bureau of Standards Woods asked that the sample marble be tested and that a report be submitted on its comparative qualities and suitability with respect to the climate of the area.[77]

One week later, the acting director of the Bureau of Standards sent Woods the test results, which were less than satisfactory:

You are advised that this Bureau has made comparative tests of several white marbles from various parts of the country, including the Tate marble. . . . These tests indicate that the Tate marble is not as durable under exposure as the other four [East Dorset Vermont, Colorado-Yule, Amicola, and Alabama], that it has a lower transverse strength and is more susceptible to staining than the others. The marble that shows up best in the three tests is the Alabama marble and the next best is the East Dorset, Vermont, marble. The fact that these last two marbles are fine grained and nearly pure white would seem to recommend them especially for sculptural purposes.[78]

The report convinced Woods that it was in the best interests of the government to pursue the possibility of using Alabama or Vermont marble rather than Georgia marble for the sculptural decorations of the pediment. But when Bartlett

informed the Piccirillis of Woods's intentions, Getulio Piccirilli nervously wrote back:

I have just returned from out of town and found your letter which has quite upset me—the marble I have ordered for your pediment is here already and I cannot see what use it would be to me if refused for your pediment. My experience with this marble [Georgia] is of the very best. I have carved as you know, the pediment of the [New York] Stock Exchange[,] also the Court House statuary at New Haven[, Connecticut,] and [a] good many other pieces of sculpture and I can positively state that it is the best and strongest marble on the market.[79]

Bartlett was inclined to follow the advice of his Italian stonecutters; Woods was not. Despite Getulio Piccirilli's endorsement of Georgia marble, the superintendent continued to investigate Alabama marble with the idea that it was best suited to the requirements of the commission. However, neither Alabama nor Vermont marble was readily available, leaving Woods little option but to let the Italians begin carving Bartlett's figures in Georgia marble or suffer another substantial delay in the completion of the com- mission.[80] On May 1st Getulio again wrote Bart- lett, "The boy with the grapes has been started and I have no doubt that the marble will prove satisfactory." The Italian then added somewhat sarcastically:

It would be very much better if the *Scientists* dedi- cated their time to writing books and allow people that have the experience and knowledge of the differ- ent materials to use their jugment [*sic*] regarding such important matters.[81]

Final Work on the Pediment and Its Installation and Unveiling

As the Piccirillis began the task of carving in marble Bartlett's completed models, the sculp- tor was hard at work in his Washington studio modeling the remaining figures for the southern portion of the pediment. The model for *The Founder and His Assistant* (fig. 41) was probably in plaster by late April or May 1915, leaving only *The Ironworker and Printer* still to be finished.

Fig. 41. Paul Wayland Bartlett, Woman Measuring Cloth, The Founder and His Assistant, The Ironworker and Printer, *and* Peace Protecting Genius, *1914–15. Plaster, no longer extant. Photograph: Architect of the Capitol.*

The sculptor had asked John Albert Martin, an electrician employed at the Capitol, to pose for these last two figures, and he was reporting to Bartlett's studio on a regular basis by early April.[82]

In mid-May Bartlett left for San Francisco to serve on the International Jury of Awards at the Panama-Pacific International Exposition. "That will delay my work a bit," he wrote his father, "but it is interesting and worth-while to go."[83] Upon his return from San Francisco in early June, Bartlett resumed his work on the remaining pieces of the pediment, finally completing *The Ironworker and Printer* in late August (fig. 41). It was immediately cast in plaster at the Washington studio under Bartlett's supervision. Several weeks later Bartlett wrote his father that the pediment was "all in plaster," and except for "a few more retouches" would soon be done. The working plaster models of *The Founder and His Assistant* and *The Ironworker and Printer* were shipped from Washington to New York in late October 1915.[84]

Earlier that summer the Piccirillis had completed the marble version of *Boy Carrying Grapes* and Bartlett had gone to New York to inspect the statue.[85] Then, in mid-September, the Italians shipped the marble to Washington where it was set up in the garden outside Bartlett's studio (fig. 42).[86] Apparently, Woods had been waiting to make an official decision on the use of Georgia marble until he could evaluate the results of the Piccirillis' initial carving.[87] In any case, the little marble passed inspection and by the end of October 1915, the Piccirillis had begun carving the remaining figures. It would take them about eight months to carve the entire pediment.

The fall months of 1915 were particularly busy for Bartlett. The Piccirillis recently had completed the attic figures for the New York Public Library, and the sculptor made numerous trips to the Italians' studio to put the final touches on the marbles himself. The winter was no less hectic. Between 23 December 1915 and 18 January 1916 Bartlett's six attic figures were hoisted into place on the main façade of the new library, and the sculptor was in New York to preside over the entire installation. The event generated a lot of interest both on the streets of New York and in the national press, and Bartlett enjoyed assuming for the moment the public role of the celebrated artiste.[88] With the completion of his New York commission, however, public

Fig. 42. Paul Wayland Bartlett, Boy Carrying Grapes, *modele 1909–11; carved in marble, 1915. Photograph: Architect of th Capitol.*

and professional attention soon shifted to Bartlett's long-awaited House pediment.

In early February 1916, Rodman Wanamaker, the Philadelphia businessman and a friend and associate of Bartlett for more than a decade, wrote the sculptor regarding the soon-to-be-erected pediment. Wanamaker, who earlier in the century had enlisted Bartlett's cooperation in the formation of the American Art Association in Paris, praised the sculptor's recent work for the Capitol in the warmest terms and offered him his assistance in making its message more accessible to the general public.[89] Later that month a newspaper article entitled "Bartlett's Latest Work a Triumph of American Art" appeared in *The Philadelphia Evening Telegraph.* The article announced—incorrectly—that Bartlett's sculptural group for the National Capitol would be unveiled that May. The author of the article also went on to say that the unveiling was

looked for with considerable interest by artists, architects and sculptors not only in this country but throughout the world, for it is admitted by all those who have seen the new work of this American sculptor that he has, in this group, achieved a masterpiece that will rank with the greatest productions of its kind.[90]

The following month *Architectural Record* published a more scholarly preview of Bartlett's an-

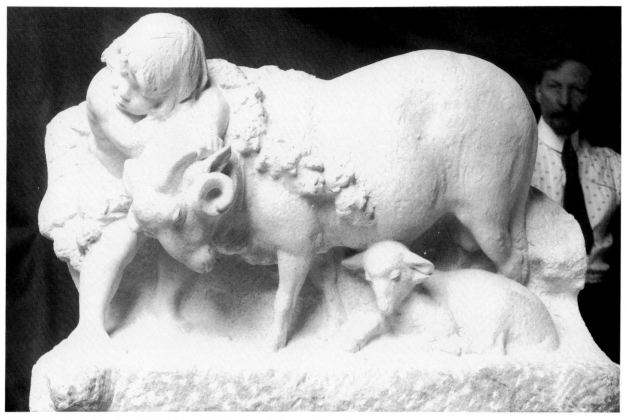

Fig. 43. Paul Wayland Bartlett, Child Wrestling with a Ram, *modeled, 1909–11; carved in marble, 1915–16. Photograph: Peter A. Juley & Son, National Museum of American Art, Smithsonian Institution.*

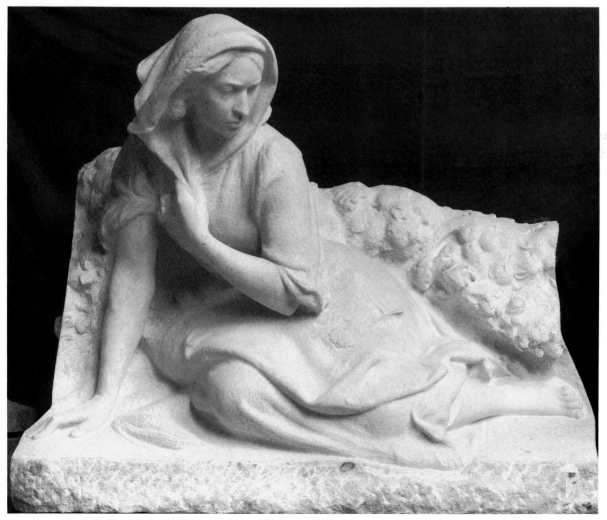

Fig. 44. Paul Wayland Bartlett, Mother, *modeled, 1909–11; carved in marble, 1915–16. Photograph: Peter A. Juley & Son, National Museum of American Art, Smithsonian Institution.*

ticipated pediment entitled "Paul W. Bartlett's Latest Sculpture." The most compelling aspect of this article was the author's assertion that even at this late date there was an intention to replace the sculpture of the two other pediments on the east front of the Capitol Building:

This pediment group, as Mr. Bartlett has conceived it, is only part of a larger project for future development. The existing sculptures in the pediment of the Senate Wing, as well as in that of the central portico, are so inadequate that they must be replaced at some future date, if the building is to produce its full effect. Mr. Bartlett has taken this fact into consideration in his choice of a subject for the House Wing. As this represents the working classes, so the Senate Wing pediment, in his scheme for future improvements, should symbolize the intellectual elements of the country, the arts and sciences balancing agriculture and industry, while the central group would be symbolical of the majesty of the government and the strength of the Union.[91]

A comprehensive approach to the decoration of all three pediments was not a new idea; Congressman McCall was probably considering a similar program even before Bartlett's contract was signed in 1909. But, while such sentiments do reveal the low esteem in which the earlier pedimental groups were held, especially in the twentieth century, the idea of replacing them never went beyond the stage of speculation.

After the installation of Bartlett's figures for the New York Public Library, the Piccirilli Brothers shifted their full energies to the sculptor's marbles for the House pediment. On 1 March 1916 Getulio wrote Bartlett that in view of the large sum of money outstanding in regard to their work on the pediment, they soon would need a payment; otherwise, they might run short of the funds necessary to continue the operation.[92]

Bartlett replied that he required a statement of work completed so that he could petition Superintendent Woods for another partial payment. Consequently, on 7 March 1916 Piccirilli sent the sculptor the following status report:

We have group of central figure and group of farmer 80 per cent finished in pointing—group of farmer with bull completely pointed—Foundry group and Iron worker's group all roughed out and fine pointing just begun. We have five figures finished—they are Boy now at your studio, boy with ship, group of boy and sheeps [sic]. Woman farmer, Woman with spinning wheel, and also the two ends of decoration for pediment are finished. We have spent to date $4,200.00 for marble and $7680 for wages, ecct. making a total of $11,880.00. We would like to get $8,000.00 on account of our agreement and we feel that with this sum we can carry the work through.[93]

Bartlett immediately sent a check for $2,000 to the Piccirillis; then, soon after receiving his third partial payment from Woods on March 21st, he sent the Italians another check for $5,000.[94]

The finishing of the final marble groups for the pediment now proceeded rapidly. Bartlett, eager to follow the carving of his marbles and to add his own retouches to the finished pieces, was a frequent visitor to the Piccirilli studio during these final weeks. By the end of March 1916, the Piccirillis were working on *The Ironworker and Printer*, probably the last group to be carved. Finally, in mid-to-late May the work was done and the marble figures were shipped to Washington.[95]

A series of photographs in the Juley Collection at the National Museum of American Art in Washington shows Bartlett's finished marbles in the Piccirilli studio shortly after the completion of their carving (figs. 43–51). The respective working plaster model is visible in the background of each photograph and Bartlett himself appears in several of the views. In two of the photographs there is evidence of the precautions the carvers took to avoid possible damage to the groups while in transit or during installation. For example, in the marble version of *The Ironworker and Printer* (fig. 51) the Piccirillis did not remove the material connecting the ironworker's hammer to the central block of the group. The Italians also left a small portion of stone in place to support the torch of the young genius in the central group (fig. 47). Once the marbles were set in place within the pediment Bartlett himself would have to remove the reinforcing material.

On the order of the Piccirilli Brothers, the George A. Fuller Company, a construction firm with offices throughout the United States and Canada, was contracted to install Bartlett's marbles on the Capitol Building. In late May 1916, the company began erecting the scaffolding and positioning the equipment needed to hoist the heavy marble pieces, each weighing between three and seven tons, into place within the pediment. Some time in late June or early July the installation began. A series of photographs in the Office of the Architect of the Capitol depicts various stages of the operation (figs. 52 and 53).

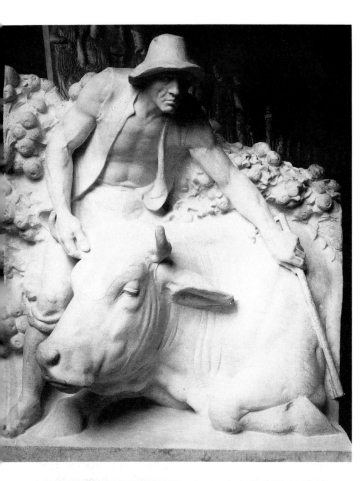

Fig. 45. Paul Wayland Bartlett, The Husbandman, *modeled, 1909–12; carved in marble, 1915–16. Photograph: Peter A. Juley & Son, National Museum of American Art, Smithsonian Institution.*

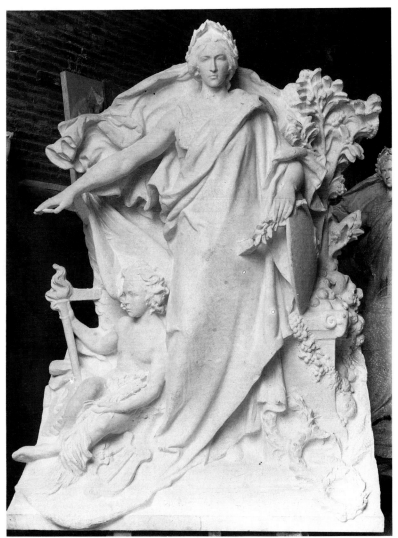

Fig. 47. Paul Wayland Bartlett, *Peace Protecting Genius, modeled, 1909–13; carved in marble, 1915–16. Photograph: Peter A. Juley & Son, National Museum of American Art, Smithsonian Institution.*

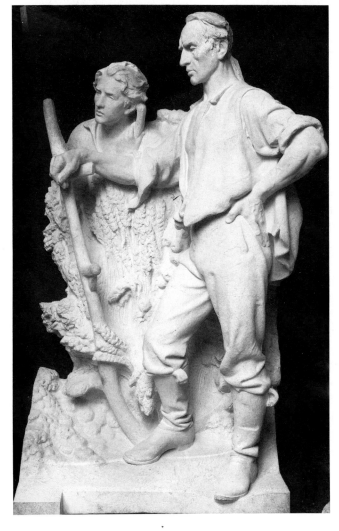

Fig. 46. Paul Wayland Bartlett, *The Reaper and His Attendant, modeled, 1909–13; carved in marble, 1915–16. Photograph: Peter A. Juley & Son, National Museum of American Art, Smithsonian Institution.*

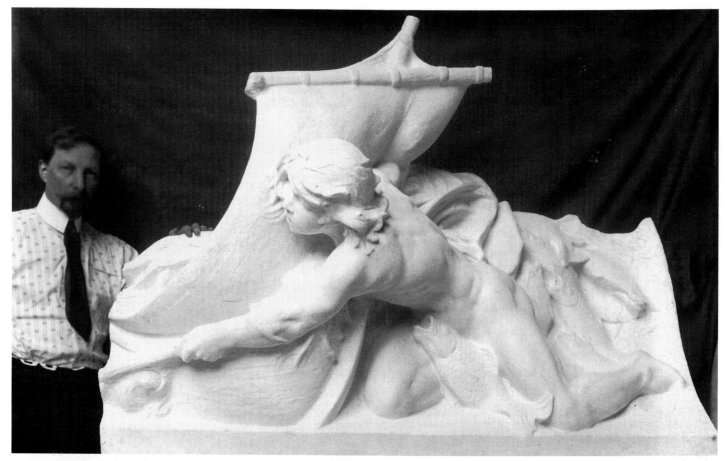

Fig. 48. *Paul Wayland Bartlett,* Fisherboy, *modeled, 1909–14; carved in marble, 1915–16. Photograph: Peter A. Juley & Son, National Museum of American Art, Smithsonian Institution.*

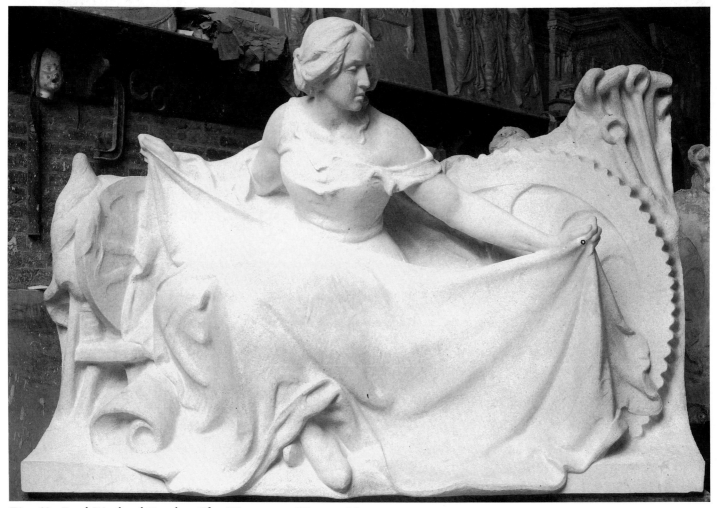

Fig. 49. *Paul Wayland Bartlett,* The Weaver, *or* Woman Measuring Cloth, *modeled, 1909–14; carved in marble, 1915–16. Photograph: Peter A. Juley & Son, National Museum of American Art, Smithsonian Institution.*

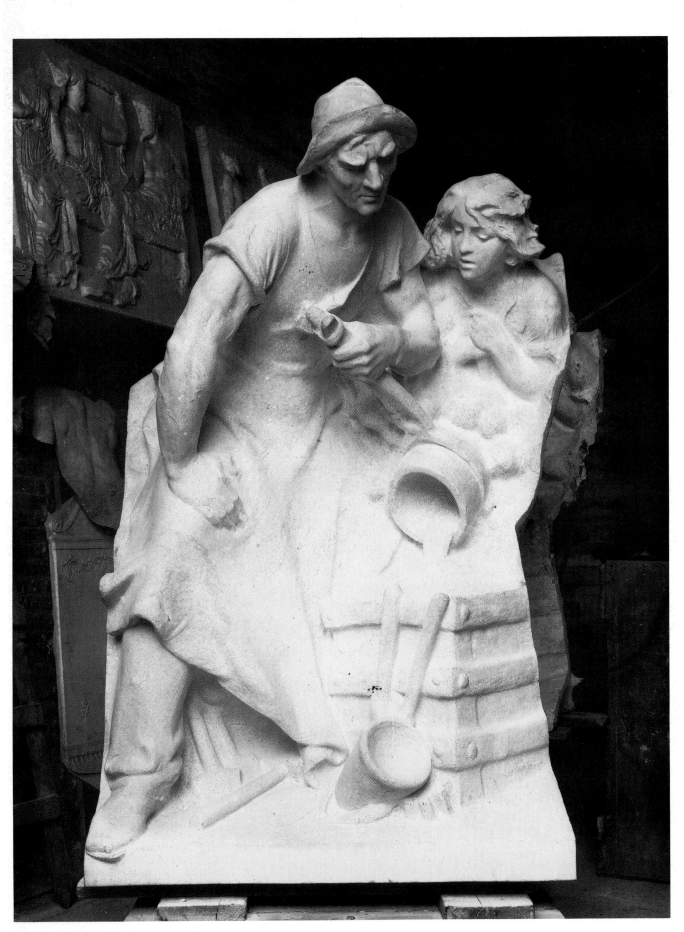

Fig. 50. Paul Wayland Bartlett, The Founder and His Assist-
ant, *modeled, 1909–15; carved in marble, 1915–16. Photograph:
Peter A. Juley & Son, National Museum of American Art, Smith-
sonian Institution.*

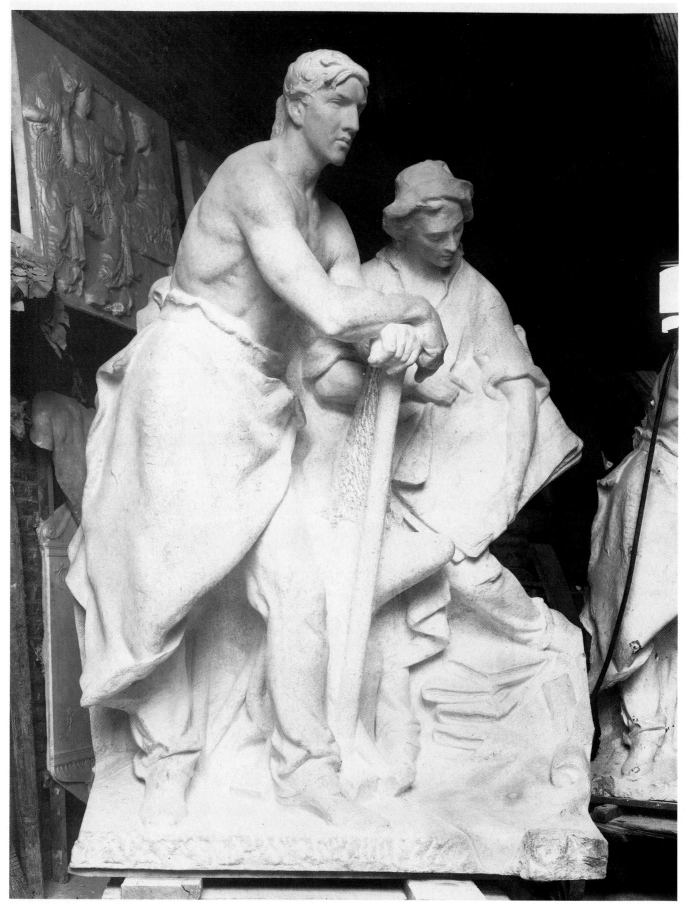

Fig. 51. Paul Wayland Bartlett, The Ironworker and Printer, *modeled, 1909–15; carved in marble, 1915–16. Peter A. Juley & Son, National Museum of American Art, Smithsonian Institution.*

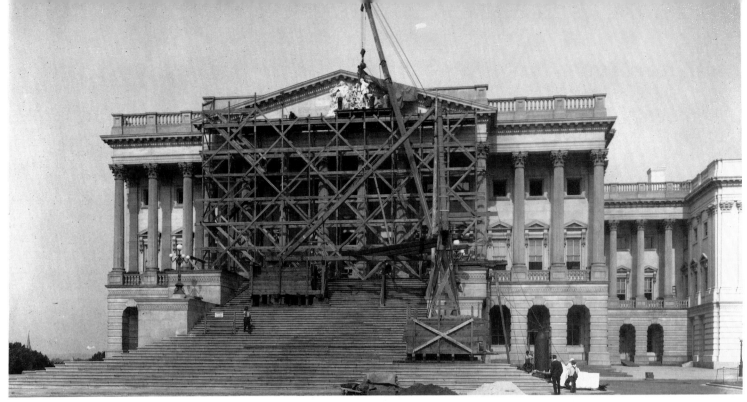

Fig. 52. The Reaper and His Attendant *being placed into position on the north side of the House Pediment, late June or early July 1916. Photograph: Architect of the Capitol.*

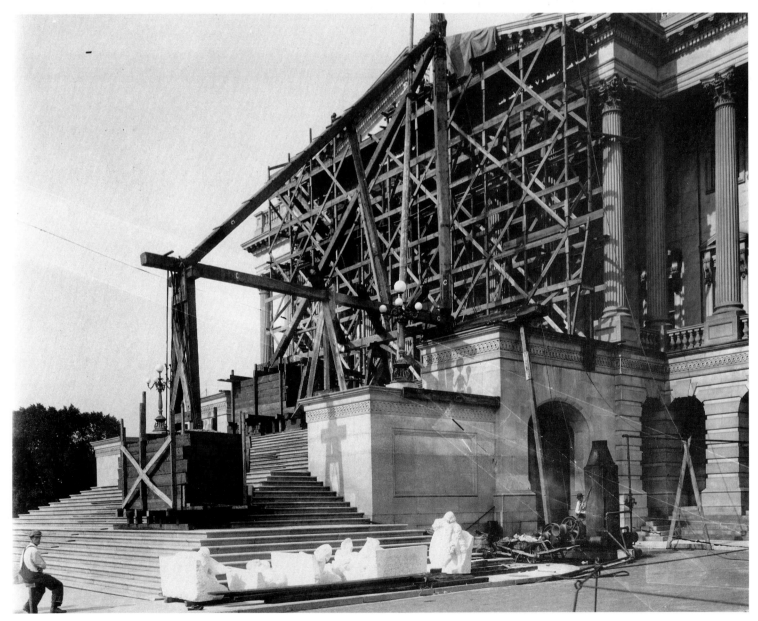

Fig. 53. Scaffolding constructed to erect Bartlett's marbles within the House Pediment. Photograph: Architect of the Capitol.

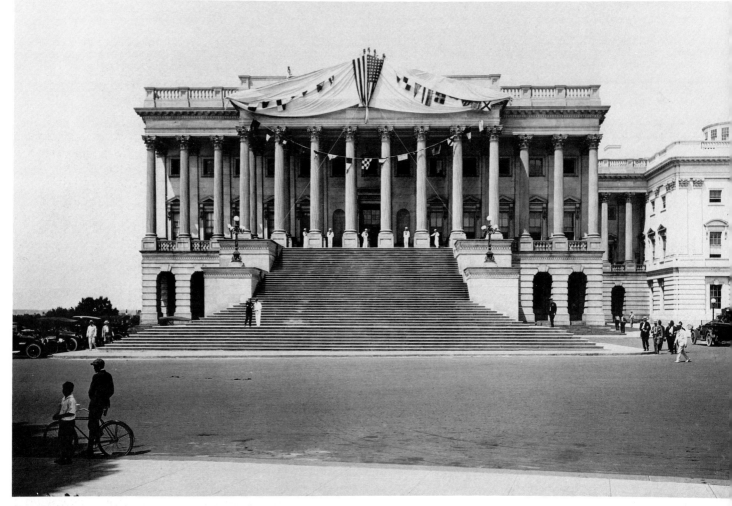

Fig. 54. House Pediment just prior to unveiling ceremonies, 2 August 1916. Photograph: Architect of the Capitol.

Following the completion of the installation in late July, the commission to complete the House pediment met to formulate a plan to submit to Congress for the acceptance and unveiling of the new statuary. Subsequently, on 27 July 1916 the House of Representatives passed the following resolution:

Resolved, That the Committee on the Library shall arrange for appropriate exercises at the unveiling of the pediment on the east front of the House wing of the Capitol at 10:30 o'clock a.m., Wednesday, August 2; and be it further
Resolved, That the Members of the Senate be invited to be present at the exercises.[96]

The committee decided to hold the exercises on the grassy plaza just east of the House wing. Bartlett himself suggested the hour of the exercises because that time of day offered the best view of the statuary. In preparation for the ceremonies the pediment was veiled in canvas and adorned at the center with an American flag (fig.

54); a decorative series of international code flags lent to Woods by the secretary of the Navy and displayed across the entire length of the pediment spelled "House of Representatives, Aug. 2, 1916."[97]

The ceremonies began with opening remarks by Representative James L. Slayden of Texas, the current chairman of the House Committee on the Library and a member of the commission for completing the House pediment. Slayden spoke briefly on the economic, intellectual, and moral value of the soon-to-be-unveiled pediment, noting, in particular, the timeliness of Bartlett's central theme—"Peace Protecting Genius"—in view of the current military struggle overseas. Following Slayden's remarks, the unveiling of the pediment took place accompanied by the music of the United States Marine Band (fig. 55).[98]

Immediately after the unveiling, Bartlett addressed the assembly (fig. 56). The sculptor re-

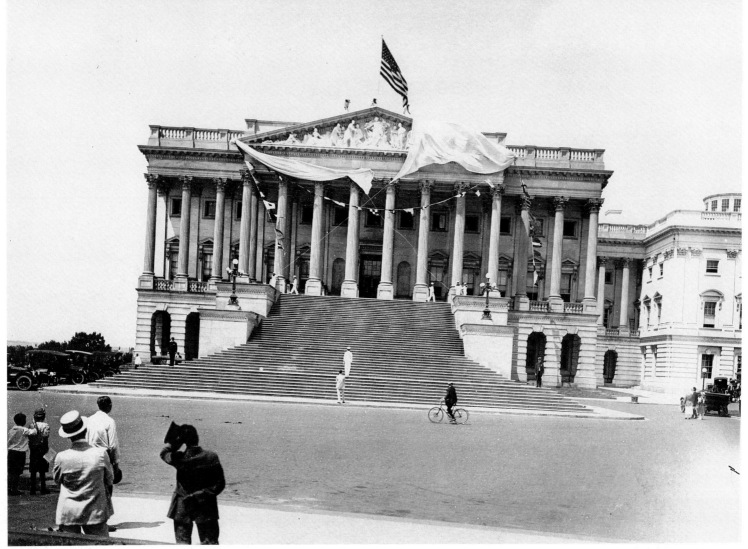

Fig. 55. *House Pediment being unveiled, 2 August 1916. Photograph: Architect of the Capitol.*

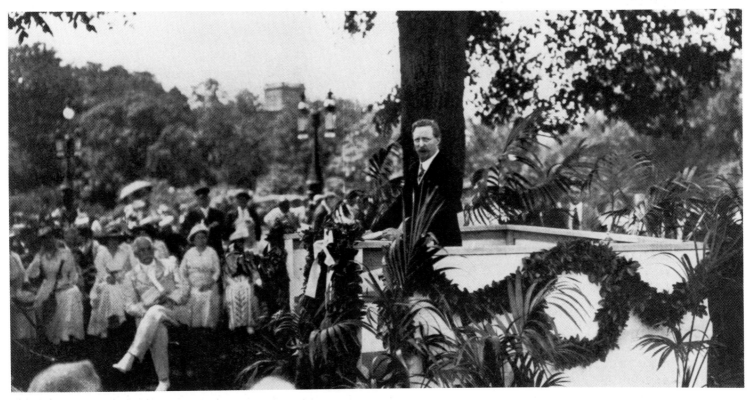

Fig. 56. *Paul Wayland Bartlett speaking at the unveiling ceremonies, 2 August 1916. From Charles E. Fairman,* Art and Artists of the Capitol of the United States of America *(Washington, D.C.: U.S. Government Printing Office, 1927), 484.*

viewed the history of the commission and discussed some of the aesthetic and technical problems that this particular project had presented. He concluded by complimenting Elliott Woods and the members of the committee on the Library for their confidence in him and for allowing him to execute the pediment in his own way and within his own time.[99] The final speaker on the program was Champ Clark, speaker of the House and chairman of the commission for completing the House pediment. Clark officially accepted Bartlett's pediment on behalf of the American people and proclaimed that the long-awaited statuary provided "the finishing touch to the Capitol Building and especially to the House of Representatives." The rest of Clark's address dealt with America's expanding role in world politics, particularly with respect to the Western hemisphere.[100]

Once the statuary for the House pediment had been completed, installed, and officially accepted on behalf of the government, little remained to be done in connection with the commission. On 26 July 1916, barely a week before the unveiling, Bartlett had received his fourth partial payment in the amount of $13,500. On August 10th a fifth and final payment was made to him in the amount of $15,500.[101] Between 9 August and 19 October 1916 the Piccirilli Brothers received three more checks from the sculptor totalling another $10,000 on account of their work on the pediment. Added to the $7,000 previously paid to them by Bartlett, this brought the total cost of carving the pediment to $17,000, a sum that presumably included the purchase of the marble. Upon receipt of their final check the Piccirillis shipped the working plaster models of Bartlett's figures back to Washington where they were stored in the sculptor's studio.[102]

3

The Pediment: Design, Style, and Iconography

Design and Style

WHEN PAUL WAYLAND BARTLETT RECEIVED THE COMmission to design the statuary for the House pediment of the United States Capitol, he was at the height of his career. His *Equestrian Statue of Lafayette,* recently unveiled in the gardens of the Louvre, had secured his reputation, particularly as a maker of public monuments, and would soon bring him numerous academic and professional honors.[1] Indeed, with the deaths of Augustus Saint-Gaudens in 1907 and John Quincy Adams Ward and Emmanuel Frémiet in 1910, Bartlett seemed well poised to assume a strong leadership role within the academic circles of both French and American sculpture. Still, he must have been humbled somewhat by the unique challenge that lay before him. After all, no one in France had attempted a commission similar to the decoration of the House pediment in quite some time; and, in America, except for the New York Stock Exchange pediment upon which he and Ward had collaborated, there were few, if any, appropriate precedents from which to draw insight or inspiration.

The development and maturation of architectural sculpture in America had itself been a relatively recent phenomenon.[2] In fact, not until the final decade of the nineteenth century had architectural sculpture truly become an autonomous art form in the United States. The status of architectural sculpture rose under the dual impetus of the 1892 World's Columbian Exposition, which established the academic philosophy of the Ecole des Beaux-Arts as a significant force in American art, and the founding that same year of the National Sculpture Society, which dedicated itself to the promotion of sculptural decoration for public buildings. However, despite its recent flowering, architectural sculpture soon began to lose its force and direction.[3]

Already by the time of the unveiling of Bartlett's pediment in 1916, the viability of architectural sculpture as a relevant art form had been severely compromised. The chief reasons for the decline of architectural sculpture after the turn of the century were the increasingly submissive role of the sculptor to that of the architect and the waning influence of Beaux-Arts classicism, the latter coupled with the rise of modernism, which argued for personal expression rather than public commitment in the creation of art. The sculpture adorning the buildings of the Federal Triangle erected in Washington between 1926 and 1938 would mark an end to the relatively brief tradition of academic architectural sculpture in America.

Nevertheless, undaunted by the theoretical obstacles surrounding his new pedimental commission, Bartlett proceeded as he would have with any other sculptural project. The artistic method that Bartlett had inherited through his training at the Ecole des Beaux-Arts and through his masters, Frémiet and Rodin, was comprised

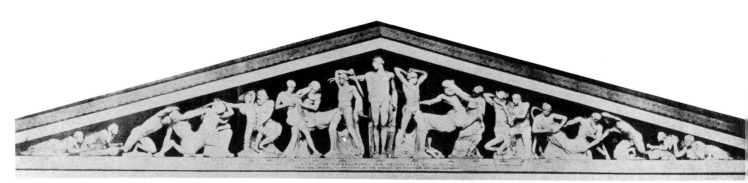

Fig. 57. Battle of the Lapiths and the Centaurs, *ca. 468* B.C.
*West Pediment of the Temple of Zeus at Olympia, reconstruction
by Treu, Archeological Museum, Olympia.*

Fig. 58. David d'Angers, Aux grands hommes, la patrie recon-
naissante, *1830–37. Marble, Panthéon (St. Geneviève), Paris.
Photograph: Foto Marburg/Art Resource, New York.*

of two distinct but related components: first, a comprehensive study of established models from the past history of art which, by reason of design, iconography, or pose, might prove relevant to the current problem under investigation; and second, the realization of an original and modern solution based on a scholarly knowledge of the past but effectively transformed by the sculptor's need to address the particular conditions of the new commission. Such a method maintained continuity with the past, an idea fundamental to the academic approach, but also encouraged originality, that is, it promoted innovation within tradition as opposed to the modernist preference for rejecting tradition altogether.

Just as other nineteenth-century sculptors faced with the prospect of designing statuary for a classical pediment had done, Bartlett adopted a general scheme based on solutions originally evolved by the ancient Greeks during the sixth and fifth centuries B.C. *Battle of the Lapiths and the Centaurs* (fig. 57), ca. 468 B.C., from the west pediment of the Temple of Zeus at Olympia is a representative example. The statuary is divided into three portions, a prominent central figure and two multifigured groups of constantly diminishing heights to either side. Here, the central figure represents the Greek god Apollo, who, as the embodiment of reason, descends to intervene in a ferocious battle waging between the Lapiths, a tribe of Greek men and women, and the bestial centaurs. The successful design, as typified by the Olympia pediment, not only unifies the three distinct parts of the composition into one coherent and harmonious whole, but also fills the awkward declining spaces of the pediment with figures that are consistent in scale, comfortable in attitude, and varied in pose and disposition.[4]

Recent or contemporary precedents for Bart-

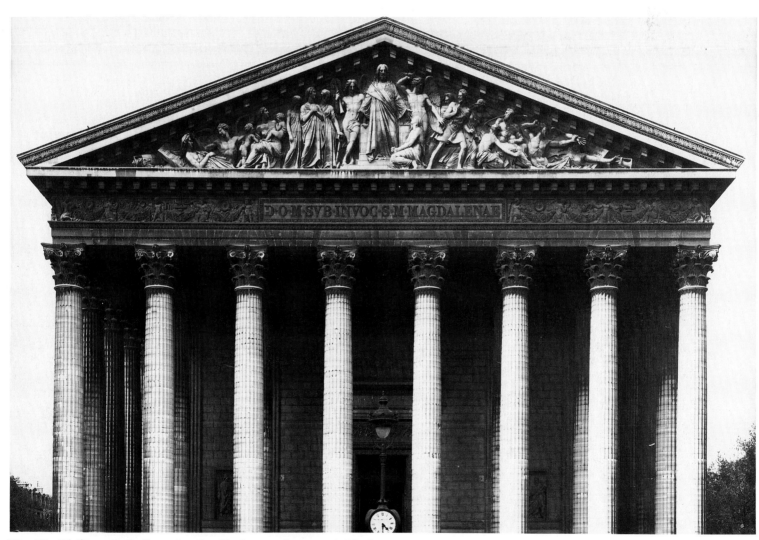

Fig. 59. Philippe-J.-H. Lemaire, Le Christ pardonnant à Madeleine lors du jugement dernier, *1830–34. Marble, La Madeleine, Paris. Photograph: Giraudon/Art Resource, New York.*

lett's commission were few. In France, pediments by David d'Angers (1788–1856) for the Panthéon (Ste. Geneviève), *Aux grands hommes, la patrie reconnaissante* (fig. 58), 1830–37, and Henri Lemaire (1789–1880) for La Madeleine, *Le Christ pardonnant à Madeleine lors du jugement dernier* (fig. 59), 1830–34, were the most prominent examples.[5] In America, Thomas Crawford's pediment for the Senate wing of the U.S. Capitol (fig. 4), 1853–63, and the Stock Exchange pediment in New York (fig. 24), 1901–4, offered the best opportunities for Bartlett to study modern solutions to the problems of designing pedimental sculpture.

In strictly practical terms, Bartlett understood the challenges of his commission to be essentially two-fold: first, the statuary should be as visually accessible as possible to viewers on the ground some sixty feet below; and second, the individual figures should appear natural despite the confining spatial limitations of the triangular pediment.[6] Regarding the first problem, Bartlett took special notice of the House pediment's subordinate location on the east front of the Capitol and of the fact that the South wing is generally approached from the sides rather than head-on. In his unveiling speech Bartlett emphasized this aspect of the commission:

Usually, pediments are composed for a general front view, and are approached by a spacious avenue forming a vista. This happens here [U.S. Capitol] only for the central pediment. The fact that this building has such a wide façade and three pediments, that it is generally approached by the sides, and that a person standing on the plaza has a slanting view of at least two pediments, changes entirely the ordinary scheme, and has necessitated a new principle of composition. The means employed to meet this contingency are not very visible from the plaza: they were not meant to be visible; but great care has been used in the effort to make the side views equal in interest to the full front view.[7]

Bartlett, in other words, designed his groups so as to secure pleasing and valuable points of view from the left (southeast) and the right (northeast) as well as from directly in front of the pediment. Thus, the key figures in the design present distinct silhouettes when viewed either frontally or at an angle and are as equally interesting and impressive from more than one point of view. Bartlett even orchestrated his groups so that alternating figures "look" to the left or right, "greeting," as it were, visitors approaching the House wing from either one side or the other (fig. 60). This principle of multiple viewpoints is unique to Bartlett's conception and distinguishes it from all other pedimental designs, ancient or modern. Its chief significance, however, lies not simply in its originality but in the fact that it grew out of a studied response to the intrinsic demands of the commission. Different circumstances would have required different solutions, an idea fundamental to understanding Bartlett's general working method.

To make the statuary easier to see from ground level, Bartlett pulled his figures up and out from the back wall of the pediment. Thus, seen from an eye-level position (as in the photographs from the Juley Collection) many of the figures seem to be standing "uphill" with that side closest to the building on slightly higher "ground." This adaptation required skill and caution on the sculptor's part to insure that the marbles would remain securely placed within the pediment. The high-relief nature of the sculpture in contrast to isolated, free-standing statues helped in this regard, for it made it possible to design larger blocks of marble whose weight distribution would provide greater stability when placed onto the building.

The second design problem that Bartlett believed had to be resolved was how to avoid the appearance of being forced to adjust his statuary to the severe limitations of the pediment's awkward triangular space. He conceived the answer in terms of the scale, spacing, and attitudes of his figures. Bartlett's handling of these features enabled him to mitigate the preeminence of the architectural setting (a motive characteristic of all his architectural sculpture), producing a design that is coherent without being rigid. Individually, Bartlett's figures inhabit their assigned spaces in a natural manner, maintaining their own internal logic and separate identity without compromising or overwhelming the delicate classical detailing of the House portico.

Emulating the Greek sculptors of the fifth century, Bartlett observed a unity of scale, adjusting only the poses of his figures to fit the two diminishing arms of the pediment. The problem of scale was particularly crucial in the compressed corners of the pediment where the tendency for the lower horizontal cornice to cut off a portion of the statuary is more pronounced. If not handled correctly the results could be ruinous, either severely limiting the visibility of these corner figures from below, as in Crawford's pedi-

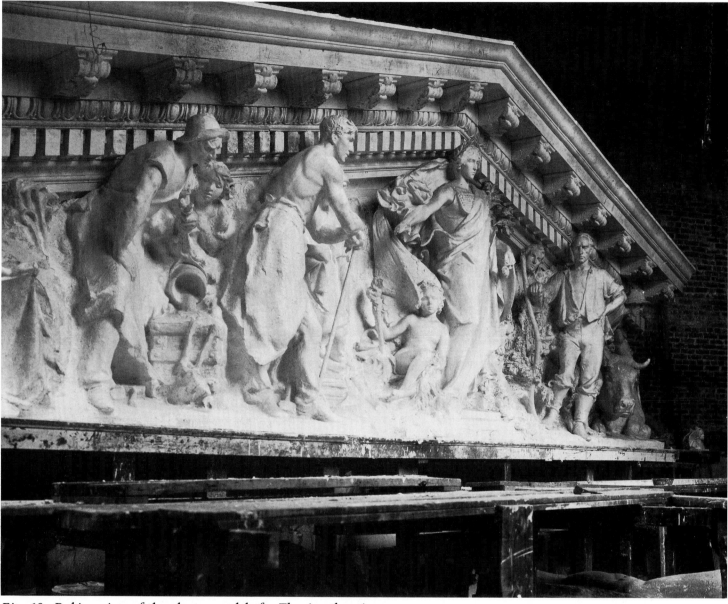

Fig. 60. Raking view of the plaster models for The Apotheosis of Democracy *in Bartlett's Washington studio, July 1916. Photograph: Architect of the Capitol.*

ment, or, as in Ward's pediment in New York, creating the sensation that the figures in the corners are too big and about to topple from their resting places.[8] With respect to maintaining a uniform scale, Bartlett seemed more able to assimilate the lessons of the ancient Greeks than did his American predecessors. However, unlike the example of ancient pediments, the heads of Bartlett's figures do not follow precisely the lines of the two raking cornices above but rather, reflecting the sculptor's desire to counteract the strict geometry of the space, they describe a more spontaneous, undulating pattern, often extending beyond the framing modillions.

Bartlett arranged his groups so as to enhance the variety and rhythm of the composition and to suggest the possibility of action among and between his figures, qualities especially evident on the side of the pediment celebrating agriculture. In addition, by separating the more deeply cut groups with those characterized by broad surfaces, Bartlett produced a series of alternating light and dark volumes, thereby avoiding not only the monotony of Crawford's pediment, but also the overcrowding and confusion of the French pediments by David d'Angers and Lemaire.

The judicious spacing of Bartlett's figures and

his manipulation of light and shade also help to unify the composition by balancing each group on one side of the pediment with a group of similar attitude, stance, or tonal treatment from the opposite side, an aspect of Bartlett's design that Glenn Brown identified as its most salient feature:

This composition of balanced sculpture in a pediment has never been secured in the same degree before, and for this reason the House wing of the Capitol will have a dignity and impressiveness new in pedimental decoration.[9]

The symbolic character and emphatic frontality of the central figure of *Peace*, traits that the figure shares with the *Apollo* from the Temple of Zeus at Olympia, further serve to link the two opposing sides of the composition and to effect a consonance between Bartlett's design and the style of the building. Such a harmonious relationship between the sculpture and the architecture is enhanced by the rhythm of the figures, which matches the rhythm of the columns beneath as in Greek architectural sculpture, and by the use of a toned as opposed to a pure white marble: both features allow for the impression that the statuary is not merely a decorative adjunct but rather an organic extension of the original stone building.[10]

With respect to the style of Bartlett's pediment, the major problem to be solved was how to reconcile the contemporary nature of the subject matter with the classical details and historical grandeur of the building. In fact, the ultimate success of Bartlett's imagery rested largely on this point. Previous designs for the decoration of the House pediment had fallen short in this regard, either failing to rise above the purely anecdotal as in Henry Kirke Brown's sketch models, or by adhering too strictly to classically derived formulas as in the models submitted by Charles Henry Niehaus. In his unveiling speech Bartlett explained the challenge as he saw it:

In using our brawny types of men and women from factory and field, in modeling their simple working clothes, it was necessary to execute these figures in such a manner that they should not conflict with this distinguished but rather delicate architecture. It was necessary that they should have a distinctive character in harmony with their immediate surroundings. Too much realism would have been ugly. Too much classicism would have been fatal.[11]

Bartlett's figures not only had to be sufficiently realistic and American in type in order to be easily recognizable by even "the least imaginative of the public," they also had to transcend the commonplace so as to attain the proper dignity and stature demanded of the architectural setting without resorting to "the banality of expressing American ideals by classical forms." Neither could Bartlett's figures assume too great a sense of force or drama for then they would threaten to overwhelm the architectural delicacy of the House wing.[12]

In composing his design, therefore, Bartlett rejected the academic classicism adopted by Ward for the Stock Exchange pediment, a work that also depicted American workers from the field and factory, as incompatible with the character of the commission.[13] Instead, Bartlett took his forms from more immediate American experience but included only enough realism to make his figures intelligible and to suggest their Americaness, avoiding the kind of specificity that would have fixed his workers to a particular time and place. Furthermore, by simplifying his forms, emphasizing the silhouette at the expense of descriptive detail, and carefully ordering his composition in a rational manner, Bartlett was able to endow his figures with an implicit sense of monumentality without the need to rely on antique formulas.

Bartlett's approach to decorating the House pediment effectively answered the call of many contemporary American critics who urged the development of a public art that incorporated American themes and values. One critic writing in 1901 had described the decorative programs of two recent buildings—the New York Stock Exchange and the Library of Congress—as impressive technical achievements but "without savor of the soil and having no roots in the rich mould of this western world." The same writer believed that if American architectural decoration was

ever to become vital and living . . . it must become more than an academic echo, a Renaissance reminiscence. The artist must learn to make the walls of our public buildings splendid with pictured records of American exploit and achievement, of American industry and commerce, of American life and culture.[14]

On these very points, however, later critics uniformly praised Bartlett's pediment:

The aim of most of our sculptors, particularly in monumental work, has always been to copy, as closely as possible, the work of classical antiquity, and above all the Greeks. But Greek sculpture, beautiful as it is, is the expression of a civilization very

different from ours, and is no more suited to our aesthetic needs than is Greek architecture to our practical needs. Mr. Bartlett has shown, in his work, how sculpture can be modern without ceasing to be monumental, and has pointed out the lines on which American sculpture may attain to a far higher standard than it has yet reached.[15]

Thus, neither a matter-of-fact depiction of Americans at work nor an exercise in classical imitation, Bartlett's statuary for the House pediment assumes both a modern and a universal or ideal character, one that conveys in terms consistent with the contemporary American scene the impression not of dull manual labor but rather of noble human endeavor.

Bartlett enhanced the Americaness of his conception by selecting subjects that, by their very nature, embodied attributes traditionally associated with the moral development of the nation. For example, most commentators on the House pediment recognized the facial resemblance of Bartlett's *Reaper* to the young Abraham Lincoln who, according to one writer, had "come to be generally accepted as the type that best characterizes American manhood."[16] Another critic affirmed the appropriateness of Bartlett's use of the famous likeness by proudly asserting that "the thousands of Lincolns still unknown to fame are the backbone of the nation."[17] The powerful and rugged *Husbandman*, on the other hand, was often described in more virile terms as representative of the "pioneers who hewed a nation out of the wilderness" or "the hardy adventurous settlers who early crossed the plains to the West."[18]

Of course, Bartlett's effort to incorporate American forms within his design for the House pediment did not preclude influences from the antique; but any such prototypes to which the artist may have referred in composing his figures, with the exception of the central group, were necessarily transformed according to Bartlett's need to invoke the character of modern-day Americans. The posture and physique of his *Ironworker*, for example, call to mind ancient representations of Hercules resting after his labors, especially the influential Lysippan model, the *Farnese Hercules*. Likewise, the *Fisherboy* and the figures comprising *Mother and Children Harvesting the Field* suggest anonymous Praxitelean, Lysippan, or Hellenistic prototypes assimilated through later seventeenth-century French and Italian variations such as *Nymph with a Shell* (fig. 61), 1683–85, by Antoine Coysevox (1640–1720), the probable inspiration for Bartlett's reclining *Mother*.[19]

Fig. 61. Antoine Coysevox, Nymph with a Shell, *1683–85. Marble, Musée du Louvre, Paris. © Photo R.M.N.*

Iconography

The iconographical program of *The Apotheosis of Democracy* is a conflation of three separate motifs traditional to the expression of public or political content in Western art: allegories of good government; themes of peace and abundance, or the plentiful harvest; and the concept of apotheosis, or deification. The first two motifs are closely related and often appear together since the conditions of peace and economic prosperity are among the natural consequences of the exercise of good government. A central theme of Bartlett's design is the glorification of the American worker as the fundamental source of the country's wealth. However, the primary

and unifying theme of the pediment expands to include the concept of peace and can be stated as follows: that only under the conditions of a competent peace can the democratic ideals of individual freedom and economic opportunity remain secure and ever-expanding.

Apotheosis, or the conferring of divine status upon a mortal, was a common practice in the ancient world. Traditionally it was accorded to a king or ruler and reflected the presumed divine nature of his earthly authority. Upon his death the recipient of deification was accepted bodily into the presence of the gods.[20] The custom was revived symbolically during the baroque period, and by the nineteenth century it was not uncommon, especially in French and American art, to

Fig. 62. Ambrogio Lorenzetti, Allegory of Good Government, *1338–39. Palazzo Pubblico, Siena. Photograph: Alinari/Art Resource, New York.*

find the honor extended not only to political leaders—Napoleon and Washington are the most prominent examples—but also to exemplary citizens including military heroes, statesmen, scientists, and men of letters. Bartlett's glorification of the American worker is an example of the further democratization of this tradition.

Harvest festivals are among the most ancient of human customs and images in Western art celebrating the bounty of the earth can be traced back to the Greeks. The Roman mother goddess, Terra Mater, symbolized peace and prosperity and was often shown holding stalks of corn and with children nestling in her lap. Ceres, one of the Roman manifestations of the mother goddess (Demeter is her ancient Greek counterpart), was worshipped as the protectress of grain and the source of fertility. Traditional representations of abundance often show Ceres accompanied by the young Bacchus, god of wine, whose presence complements the idea of plenty. The figures making up Bartlett's *Mother and Children Harvesting the Field* are modern translations of these ancient prototypes. Other traditional allusions to the harvest theme include the ox, which Bartlett has coupled with the *Husbandman,* and the sickle, or scythe, held by Bartlett's *Reaper.* As the principal draft animal of the ancient world and a common sacrificial beast, the ox is traditionally linked to planting and harvest scenes; the sickle is the ancient attribute of Saturn, the Roman god of agriculture or of summer personified.[21]

An expression of the social and economic advantages of living under the jurisdiction of a

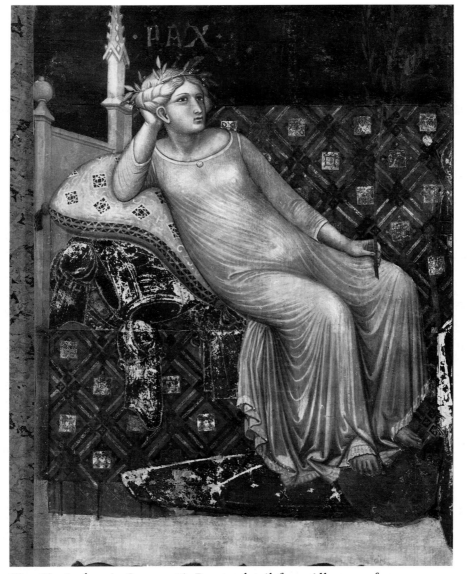

Fig. 63. Ambrogio Lorenzetti, Peace, *detail from* Allegory of Good Government. *Photograph: Alinari/Art Resource, New York.*

Fig. 64. Léopold Morice, Monument to the Third Republic,
*1879–83. Marble, Place de la République, Paris. Photograph:
Foto Marburg/Art Resource, New York.*

wise and competent government relates *The Apotheosis of Democracy* to traditional allegories of good government. Ambrogio Lorenzetti's fourteenth-century fresco painting for the Palazzo Pubblico in Siena, Italy (fig. 62), is one of the best-known examples of this genre. The artist even included a female personification of Peace (fig. 63) among the distinguished list of dignitaries in attendance. Additional scenes in Lorenzetti's cycle illustrate the effects of good government in the city and in the country, a natural division of the commercial interests of the community that, in general, corresponds to Bartlett's separation of the *Powers of Labor* into industry and agriculture.[22]

Not surprisingly, Bartlett's pediment is more closely linked to nineteenth-century French Republican versions of the good government theme, such as *Monument to the Third Republic*

(fig. 64), 1879–83, by Léopold Morice (1846–1920) and the *Triumph of the Republic* (fig. 65), 1879–89, by Jules Dalou (1838–1902). Drawing upon more than a century of Republican imagery, both public monuments celebrated the new political security achieved following the reunification of the French under the Third Republic (1870–1940).[23] Fundamentally conservative in nature, Morice's *Republic* carries tablets of law and an olive branch, and holds at her side a sword intimating her willingness to use force if necessary to maintain the new social order. Dalou's figure incorporates more contemporary Republican ideas, creating an iconography calculated to champion middle-class values and virtues. In thematic terms, a special affinity exists between Dalou's monument, which was not inaugurated until 1899, and Bartlett's *Apotheosis of Democracy*. From her global perch Dalou's

Fig. 65. Jules Dalou, The Triumph of the Republic, *1879–89.*
Marble, Place de la Nation, Paris. Photograph: Foto Marburg/
Art Resource, New York.

personification of the *Republic* presides over a
contemporary group of attendants who, like
Bartlett's figures for the House pediment, are a
mixture of working-class fact and ideal fiction.
Led by a young Genius of Liberty holding a
torch, the procession includes a mother and
child group, an iron worker, and a female figure
representing peace and abundance, all of which
can be found in Bartlett's design as well.[24]

With specific regard to the glorification of
manual labor, Bartlett's pedimental figures con-
tinued the interest in such themes that had
characterized the work of a number of late
nineteenth-century European sculptors includ-
ing, besides Dalou, the Swiss-born Vincenza Vela
(1820–91) and the Belgian Constantin Meunier
(1831–1905). Reflecting the general notion that
the worker was the fundamental unit in a mod-
ern economic system and that work itself was a

major force in society, characteristic works such
as Vela's *The Victims of Labor*, 1883, Dalou's *The
Peasant* (fig. 66; see color section), 1897–99, and
Meunier's *Le Marteleur* (fig. 67), 1890, monumen-
talized the common laborer by casting his strug-
gle with the material world in decidedly heroic
terms. Eschewing the distinctive class conscious-
ness and social realist sentiment that clearly in-
forms these sculptures, Bartlett, nevertheless,
adopted a similar heroicizing stance in his depic-
tions of labor.

Given the nationalistic character of Bartlett's
commission, the aesthetic theory underlying his
House pediment is consistent with the more
conservative elements of French Republican
thought regarding the relationship between art
and economics. Sensitive to the harmful effects
of industrialization and wary of the pace of tech-
nological change, Republican theorists such as

Fig. 67. Constantin Meunier, Le Marteleur, *1890. Bronze, Musées royaux des Beaux-Arts de Belgique. © A.C.L.—Bruxelles.*

Victor Hugo (1802–85), Jules Perry (1832–93), and Antonin Proust (1832–1905) promoted an ideology that favored the economic and social values of the working classes over those associated with mass production and the rise of the factory system. And, significantly, they believed that art could play a major role in the advancement of their liberal political agenda.[25]

As Miriam Levin has described, lying at the root of Republican aesthetics was the idea that merging the commercial and industrial way of life, upon which the welfare of the middle classes was so dependent, with the formal reality cre-

ated by the artist could provide the basis for a new social order. That is, the adoption of a rational method for ordering modern visual experience could produce similar harmonious effects in society at large. Consequently, the Republicans' notion of an ideal style was one that incorporated the modern culture and life experience of the middle classes into artistic forms and patterns that were integrated, balanced, and rational.[26]

For Republicans, the "union of abstract order and material substance" was a major aesthetic of democracy, striking a balance "between the artist's characterization of the democratic system through the handling of the media and the need for verisimilitude." Republicans disapproved of focusing on "material things for their sake," because it isolated them "from the more enduring realm of moral and social relationships by not having these elements contribute to a well-integrated compositional order." The special significance of work to Republicans as a means for progressive change is thus explained by their interpretation of the transformation of raw materials into finished goods in terms of changing "the shape of material reality from disorder to order."[27] Clearly, Bartlett's stylistic choices in handling a modern labor theme and the sense of order inherent in Bartlett's pedimental design benefited from these ideas, and, to the extent that form and content coincide in *The Apotheosis of Democracy,* these features establish the essentially symbolistic character of Bartlett's imagery.[28]

The formal balance and orderliness of Bartlett's display of contemporary workers also tapped into the growing belief among American turn-of-the-century social reformers such as Herbert Croly (1869–1930), John Dewey (1859–1952), and Edward A. Ross (1866–1951) that the civic environment was crucial in shaping human behavior, and that, if handled properly, various elements within that environment—public schools, playgrounds, parks, civic sculpture, municipal pageants and ceremonies, etc.—could be effective tools in promulgating a new social and moral order.[29]

In *Social Control: A Survey of the Foundations of Order,* first published in 1901, Edward A. Ross celebrated public art for its ability to promote social cohesiveness by convincing the urban masses that all members of society were bonded to one another in a system of "ideal relationship:"

He [the artist] calls forth fellow feeling and knits anew the ever-ravelling social web. Without his filaments to bind hearts together, it is doubtful if the vast free groups of today could last. Certainly a nation like ours could not endure without the mutual comprehension and sympathy established within the folk-mass by artists living and dead. It is they who have put breath into the common past and joined men in love of it. It is they who have discovered the common character and enamored the people of its type. And they are still at work cementing classes, conciliating local groups, keeping all parts of the nation *en rapport*.[30]

Part of the motivation behind such notions was the desire of "oldstock" Americans to impose the values of the Protestant moral tradition on an urban population that, through industrialization and immigration, was undergoing a radical transformation. Nevertheless, reformers like Ross firmly believed that civic art could play a significant role in structuring an urban environment that would encourage acceptable social behavior and safeguard the future integrity of the American moral order.

From a broader historical and cultural perspective, Bartlett's conception of the powers of agriculture and industry as the primary source of America's wealth can be traced ultimately to Adam Smith's *An Inquiry into the Nature and Causes of The Wealth of Nations*, the foundation work of modern political economic thought originally published in 1776.[31] Smith conceived of wealth not in traditional terms as the past accumulation of currency or material goods, but rather in terms of the annual productive labor of a nation with respect to "the necessaries and conveniences of life" which that nation annually consumed. Within such a scheme it naturally followed that the greater the proportion of productive labor to the number of people who consumed that which was produced, the greater the nation's overall welfare.[32]

Smith noted, however, that "among civilized and thriving nations . . . though a great number of people do not labour at all . . . yet the produce of the whole labour of the society is so great, that all are often abundantly supplied . . . even of the lowest and poorest order." Smith attributed this improvement in productive powers to a fundamental division of labor into the agricultures and the manufactures, and the resulting vastly greater production as the real source of society's wealth.[33]

Smith explained further that the division of labor had arisen naturally out of individual self-

interests and the intimate relationships between towns or communities and their surrounding countrysides, relationships shaped by the exchange of subsistence goods (agriculture) for manufactured goods (industry):

The inhabitants of the town and those of the country are mutually the servants of one another. The town is a continual fair or market, to which the inhabitants of the country resort, in order to exchange their rude for manufactured produce. It is this commerce which supplies the inhabitants of the town both with the materials of their work, and the means of their subsistence. The quantity of the finished work which they sell to the inhabitants of the country, necessarily regulates the quantity of the materials and provisions which they buy. Neither their employment nor subsistence, therefore, can augment, but in proportion to the augmentation of the demand from the country for finished work; and this demand can augment only in proportion to the extension of improvement and cultivation. Had human institutions, therefore, never disturbed the natural course of things, the progressive wealth and increase of the towns would, in every political society, be consequential, and in proportion to the improvement and cultivation of the territory or country.[34]

This natural progression of wealth would continue, if unimpeded by governmental intrusion, until the entire territory was fully developed, at which point manufactures would be designed for distant sale and foreign commerce, the ultimate phase of the nation's material destiny, would begin.

These principles—rooting modern economic wealth in individual material self-interest and the division of labor—had been discussed in one form or another by earlier economic theorists; but Smith's book firmly established them in the popular consciousness, for he gave them a particularly eloquent expression at a time when an aggressive capitalist mercantile class was coming to power in Europe and America.[35]

If French Republican aesthetics and modern capitalist economic principles supplied the general background for Bartlett's celebration of the powers of labor, the advance of progressive thought in America around the turn of the century, particularly with regard to the role of the common worker, provided a suitable environment for such expression. Bartlett's decision to glorify the contribution of the anonymous common worker over the public deeds of a few select men from America's past represented a significant shift away from the traditional historical portraiture that had dominated his public art up to that point. But by the early twentieth century,

Bartlett, like many Americans, had come to believe that anonymous working men and women rather than isolated historical figures best represented the strength of the nation. "The genius of the country," Bartlett declared in a 1914 interview, "is found in the working man, who is more truly a national figure with us than any other."[36]

Since the Civil War the plight of the American worker and social betterment schemes had attracted increasing national attention until, by the end of the century, as Merle Curti has noted, "No other intellectual interest excited more general enthusiasm than protest against political, social, and economic ailments and grievances."[37] During the decades immediately preceding Bartlett's commission, Progressives and Wilsonian Democrats led the fight, allying themselves with farmers and industrial workers in a popular movement committed to restoring the individual's ability to compete fairly in the economic and political life of the country.[38] There is little doubt that the progressive movement set the general climate in which Bartlett's *Powers of Labor* could find popular acceptance.

The mood of Bartlett's pediment is perhaps most sympathetic with Woodrow Wilson's concept of the New Freedom, a political philosophy based squarely on the acknowledged need to preserve economic freedom for the individual American laborer and small businessman.[39] In fact, an extract from Wilson's book, *The New Freedom* (1913), provides a fitting subtext to Bartlett's imagery:

Everything I know about history . . . has confirmed me in the conviction that the real wisdom of human life is compounded out of the experiences of ordinary men. . . . The great struggling unknown masses of the men who are at the base of everything are the dynamic force that is lifting the levels of society. . . . Only he is fit to speak [for America] who knows the thoughts of the great body of citizens, the men who go about their business every day, the men who toil from morning till night, the men who go home tired in the evenings, the men who are carrying on the things we are so proud of.[40]

However, while Bartlett's pediment owes allegiance to progressive sentiments such as these, it would be wrong to attribute to the commission any of the activist elements of the populist or progressive agenda. Nowhere in Bartlett's program, for example, is there a critique of current economic conditions or a sense of the escalating struggle of workers to wrest some control over their economic lives from the clutches of big

business. Neither is there, in contrast to the earlier European sculptures of Meunier and Dalou, any real sense of the workplace, nor of the degrading aspects of repetitive manual labor, nor even of genuine physical effort.

Cultural critics and welfare capitalists were, by this time, constructing elaborate challenges to traditional capitalist dogma in the name of improving the general welfare of laborers. In *Fields, Factories and Workshops, or Industry Combined with Agriculture and Brain Work with Manual Work* (1898), for example, Peter Kropotkin (1842–1921) championed the integration of labor versus the division of labor popularized by Smith as an effective means of raising the social and moral conditions of all workers. Building on the idea, derived ultimately from the theories of Herbert Spencer (1820–1903), that along with differentiation the integration of aptitudes and activities also played a fundamental role in progressive cultural evolution, Kropotkin questioned the emphasis in modern economies on division of labor in order to maximize profits. The concept, in his view, had been pushed so far that it was dividing society into class structures—farm/factory, producers/consumers, manual work/brain work, etc.—almost as rigid "as those of old India."[41]

Kropotkin envisioned instead an ideal society of integrated labor:

The greatest sum of well-being can be obtained when a variety of agricultural, industrial and intellectual pursuits are combined in each community . . . man shows his best when he is in position to apply his usually-varied capacities to several pursuits in the farm, the workshop, the factory, the study or studio, instead of being riveted to one of these pursuits only.[42]

But such notions were probably of little or no concern to the sculptor of the House pediment, or, for that matter, to the congressmen who presided over the commission. Bartlett's purpose, in fact, was rather the opposite. That is, he wished to dignify the modern experience of labor by presenting the subject in a positive light, disregarding any features that might have suggested exploitation or the deteriorating effects of labor on the worker's character.

To appreciate better the motivations behind the iconography of the House pediment, the commission should be seen against the backdrop of the American Renaissance, that episode in the cultural history of the nation generally recognized as beginning with the Centennial in 1876

and ending in 1917 with America's entry into World War I.[43] Much of the art of this period—especially the monumental sculpture and mural painting—represented the convergence of political motive and a perceived public necessity. Essentially didactic in nature, it was created primarily to instruct the general population in what the artists believed to be America's leading role in the advancement of Western art and culture. Characterized by a fundamental conservatism, art of this kind was also calculated to serve the State by promoting existing political and economic conditions rather than seeking reform or social change.

Within a more defined economic context, Bartlett's monumental depictions of American laborers can be understood as twentieth-century embodiments of the cult of the self-made man or woman, the idea that through self-effort and initiative, individual material success was within the reach of all Americans regardless of initial economic or social obstacles. This fundamentally American notion, linked with the destiny of the continent virtually from the beginning of European colonization, was progressively advanced during the post-Civil War years and remained a powerful assumption into the next century, symbolizing "what ordinary men might accomplish under American conditions of opportunity."[44] Thus is revealed the significance of the presence of Abraham Lincoln's likeness on Bartlett's national pediment: he and Benjamin Franklin are the two most famous examples of the self-made man in American history.

Despite its celebration of the common man, however, the ideology of success also fit into a conservative defense of the status quo constructed to help maintain the current economic order along with its many injustices. It did this by denying the harsh realities of the system and by holding out the hope to all Americans that considerable material prosperity was attainable regardless of their present circumstances, when, in fact, such material longing could be fulfilled only for a fortunate few.[45]

Turn-of-the-century versions of individual success often invoked the cult of the self-made in order to boost confidence in the American factory system. An interesting example is *Loom and Spindle, or Life Among the Early Mill Girls*, published in 1898. Offering an "inside view" of the early years of the textile mills at Lowell, Massa-

chusetts, particularly with respect to the beneficial effects on the female workers employed there, the author of *Loom and Spindle* proudly asserted the Lowell women "were all self-made in the truest sense" and that "a woman ought to be just as proud of being self-made as a man." But the writer of the book's introduction left little doubt as to the real "hero" of this success story—the factory:

The factory girl of the early period was not degraded through her employment or her surroundings. She stepped out of factory life into professional or semi-professional occupations. She was succeeded by a class originally beneath her, the members of which have in their turn graduated from the factory, and stepped into higher callings. This process has been repeated, the destiny of the factory being ever to reach down and lift people up out of lowly into higher conditions.[46]

That the statuary of the House pediment could be understood in strikingly similar terms is revealed by Glenn Brown's assessment of Bartlett's imagery:

Refinement, culture, and intelligence in the faces and forms of the figures give the dominant note throughout the work, impressing upon us the feeling that working and living with nature is not as beastly and degrading as some sculptors have endeavored to make it appear in marble and bronze, but elevating and refining in its nature. This fact is illustrated in all periods of our history by the men who have come to the front from the farm, as statesmen, soldiers, scholars, and poets. This sculpture reminds us that dealing with machinery, which fosters invention and requires method and organization, does not starve the brain and dull the intellect, but is an influence quickening the imagination and developing both the mind and the body. History shows that the inventors, designers and organizers, who have come to the front from the factory and workshop have been men of intellect and aspiration, of untold benefit in bending the forces of nature and the power of imagination to the use of man. I am much pleased that Mr. Bartlett has expressed so clearly the two elements in our life upon which the prosperity of the country is based, showing the intellectual and refining effects of an intimacy with nature and the mechanic arts.[47]

Members of the privileged classes frequently alluded to self-help doctrine to "prove" that economic inequalities were inevitable, arguing that "the vast majority, owing to defects of character, squandered their chances and doomed themselves to inferiority." Conservatives even preached self-help ideas as an antidote to socialist sentiment and political radicalism, maintaining that "workingmen had more to gain from

honest industry than from vague projects of
social regeneration."[48] As a major federal com-
mission and monument of the American Renais-
sance, the House pediment reflected all of these
ideas to one degree or another. At the least, and
despite a general debt to progressive thought,
Bartlett's *Powers of Labor* defended the prevail-
ing economic order by identifying conservative
values with the interests of the common man.

The focus of *The Apotheosis of Democracy* both
in terms of subject and composition is the cen-
tral group, *Peace Protecting Genius*. At the unveil-
ing ceremonies, Bartlett described the group as
follows:

"Peace," an armed "Peace," stands erect, draped in a
mantle which almost completely hides her breast-
plate and coat of mail; her left arm rests on her buck-
ler, which is supported by the altar at her side. In the
background is the "olive tree of peace." Her right arm
is extended in a gesture of protection over the youth-
ful and winged figure of "Genius," who nestles confid-
ingly at her feet, and holds in his right hand the torch
of "Immortality."[49]

Because of the truly allegorical nature of the
group in contrast to the *Powers of Labor*, Bartlett
tended to rely more on his specific sources in
designing this portion of the pediment. The most
prominent ancient prototype from which the
sculptor could have drawn inspiration is the
celebrated Greek work by Kephisodotos the el-
der, *Eirene and Ploutos*, or *Peace Bearing the Child
of Wealth in Her Arms* (fig. 68), dated ca. 375–70
B.C.[50] Despite the similar subject matter, how-
ever, the two groups are only superficially re-
lated. Actually, the masculine character of
Bartlett's central figure and its barely disguised
martial inclination distinguish it from tradi-
tional representations of Peace; reflecting the
feminine qualities of gentleness, humility, and
compassion, such figures are generally more
passive and docile creatures (see fig. 63). The
emotional temper and physical attributes of
Bartlett's personification, in fact, identify her
more accurately as a modern-day descendant of
Athena, the ancient Greek goddess of war and of
wisdom, and more closely link Bartlett's figure
to statues such as the *Athena* from the west pedi-
ment of the Temple of Aphaia at Aegina, ca. 510–
480 B.C.

Although a warrior goddess, Athena was typi-
cally the defender of just causes, and, like her
half-brother Apollo, essentially a benevolent in-
fluence. Despite the goddess's warlike character,

Fig. 68. Kephisodotos the elder, Eirene and Ploutos, *or* Pea
Bearing the Child of Wealth in Her Arms, *ca. 375–70* B
*Marble, Roman Copy, Glyptothek, Munich. Photograph: Foto
bor Rehm & Zingel.*

which reflected her role as guardian of Athens
and protectress of civilization, she more often
than not acted with discipline and restraint,
even in battle:

For her [Athena], warfare is primarily political, tacti-
cal, and expedient—one way among others to obtain
some goal or to protect some cherished value. . . . Her
presence in battle does not incite rage and fury; her
presence incites courage and daring, tempered with
control of the passions that can make a person reck-
less and vulnerable.[51]

Clearly, it is this aspect of Athena as the voice
of reason and the defender of civilization that
Bartlett drew upon in conceiving his modern
version of the figure.[52]

Fig. 70. Antoine Etex, Peace, *1833–36. Marble, Arc de Triomphe, Paris. Photograph: Giraudon/Art Resource, New York.*

The Athena-like qualities of Bartlett's personification of Peace relate the figure to other contemporary American depictions of Athena, or of Minerva, the goddess's counterpart in Roman mythology. Typical of such depictions is the commanding mosaic of *Minerva* (fig. 69; see color section) executed in 1896 by the American artist Elihu Vedder (1836–1923) for an interior wall of the Library of Congress in Washington. Like Bartlett, Vedder deemphasized the traditional warlike attributes of the goddess to extol instead her civilizing aspects.[53]

Vedder's personification embodies certain cultural values that were among those held in highest esteem during the American Renaissance. Namely, that America, as rightful heir to the traditions of Western culture, was obliged to preserve all that was of value from the past—a concept that the cultural historian Matthew Arnold termed "the saving remnant"—and to use

such knowledge as the foundation upon which to build the future course of Western progress.[54] Of course, what distinguishes Bartlett's figure from images like Vedder's is that the sculptor attached such cultural meanings to an Athena-like personification of Peace rather than a straightforward representation of Athena or Minerva. In fact, Bartlett's intentional "reshuffling" of allegorical meanings is one of his figure's most salient features.

Nonetheless, Bartlett's peaceful Athena is not without precedent. Praxiteles' *Pacific Athena,* for example, a Roman copy of which is in the Louvre, depicts the goddess unarmed with one hand on her hip and the other extended palm upward.[55] A nineteenth-century French example of an Athena-like personification of Peace is the great relief by Antoine Etex for the Arc de Triomphe (fig. 70). Wearing the helmet and aegis of Athena and holding the end of a spear in one

hand, Etex's statue, like Bartlett's *Peace*, is stern and impassive as she assumes the role of protectress for an assortment of contemporary characters including a warrior sheathing his sword, a mother and child group, and a kneeling male figure symbolizing agriculture.[56]

Sculptural antecedents notwithstanding, probably the most direct source for Bartlett's central figure is not a statue but rather a painting by the French artist Théodore Chassériau (1819–56). Entitled *La Paix protectrice des arts et des travaux de la terre,* the painting, now destroyed, was part of an ambitious project undertaken by Chassériau during the late 1840s to decorate the stairway of the Cours des Comptes in the Palais d'Orsay in Paris. A preparatory drawing for the work dated about 1846 survives in the collection of the Louvre (fig. 71).[57]

Chassériau's *Peace* dominates the composition at center while figures representing the arts and the labors of the field, as in Bartlett's pediment, occupy spaces to her left and right. The nobility and stoicism of the allegorical figure, the conspicuous frontality that renders her immune to the "deforming" elements of the material environment into which she has descended, and especially the commanding protective gesture of the right arm, argue convincingly for the influence of Chassériau's image on Bartlett's *Peace Protecting Genius*. These traits, as Chassériau scholars have already pointed out, can be traced ultimately to the majestic figure of Apollo from the Temple of Zeus at Olympia (see fig. 57). Clearly, Chassériau's adaptation of Apollo's gesture for his modern-day *Peace* was an important precedent for Bartlett's handling of a similar figure.

The two works also share a common politics. Chassériau's imagery echoes the conservative political atmosphere that existed in France in the late 1840s, and reflects the increasingly authoritarian sentiment of the period leading up to the establishment of the Second Empire in 1852. In such imagery, which also found unofficial expression in the popular press (see fig. 72), a fully-draped personification of the Republic is usually accompanied by economic allegories of Industry, Trade, Agriculture, or the Arts. And, any realistic figures that may appear usually demonstrate reconciliation between the classes or the spread of French influence throughout the world.[58] The political and economic values embodied in Bartlett's House pediment are not inconsistent with these general attitudes.

As instructive as art historical influences may be to the appreciation of Bartlett's figures, the full meaning of *Peace Protecting Genius* can only be understood by measuring the group against the political values of pre-World War I America. Even before its unveiling in August 1916, *The Apotheosis of Democracy* and especially *Peace Protecting Genius* was perceived by members of the press and the public in relation to the war in Europe. For example, the author of an article published in November 1914, on Bartlett's new sculpture for the Capitol wrote:

In view of the struggle of the Powers in Europe, with the incidental destruction of industries and antiquities, and in view of the passive attitude of the United States toward the warring nations, there is a happy coincidence in the fact that Mr. Bartlett has chosen for his composition the subject, "Peace Protecting the Genius of the Nations."[59]

That the sculptor intended such a connection to be made is certain. During the pediment's installation, Bartlett himself noted:

How extraordinary it is that at this time the United States should be erecting a figure of Peace protecting Genius on the front of its Capitol—now, when the rest of the world is engaged in war.[60]

But what specifically did Bartlett's statuary have to say about the ongoing conflict overseas and America's relationship to it?

Two assumptions regarding the current situation in Europe were represented in *The Apotheosis of Democracy*: first, that while Europe convulsed under the ravages of war, the highest ideals of Western culture—democracy and individual economic opportunity—were safeguarded in America where the conditions of a competent peace were still operating; and second, that the idea of a competent peace meant America was prepared to do whatever was necessary to insure that those ideals remained safe and secure. A further more subtle implication of Bartlett's iconography was that the United States was obliged not only to defend democratic values, but also to extend the benefits of a democratic form of government to other nations of the world especially those within its own hemisphere.

The symbolism residing in Bartlett's Peace group was given public recognition at the pediment's unveiling ceremonies by Speaker of the

Fig. 72. Allegorical engraving of the conservative Republic, with connotations of serenity and reconciliation. Private Collection. Photograph: Maurice Agulhon.

House Champ Clark. Clark's speech focused on the United States' political position in the world, specifically reaffirming the Monroe Doctrine the adherence to which Clark declared was responsible for the stable spread of democracy throughout the Western Hemisphere, particularly in Latin America.[61] Clark ended the speech with his vision of America's unfulfilled destiny:

Our mission in the world has been to carry government of the people, by the people, and for the people to the ends of the earth as missionaries . . . and we have worked at it faithfully. . . . We here and now finish the Capitol building. May it stand forever as the emblem and symbol of a free people, and may our missionary work never end until all people everywhere are free.[62]

Of course, paternalistic/imperialistic notions of this kind had characterized the international dealings of the American government since the late nineteenth century. With greater relevance to Bartlett's commission, however, these ideas are particularly meaningful in relation to the war in Europe and to the dynamics of U.S. foreign policy as conducted during the administrations of Woodrow Wilson (1913–1921).

Described by the political historian and Wilson scholar, Arthur S. Link, as missionary diplomacy, the approach of President Wilson and his secretary of state, William Jennings Bryan, to foreign affairs was motivated primarily by their "ambition to do justly, to advance the cause of international peace, and to give to other peoples the blessings of democracy and Christianity."[63] Wilson's missionary diplomacy most directly manifested itself in a series of treaties of conciliation that Bryan actively negotiated between 1913 and 1914,[64] and in the administration's attitude toward the Caribbean the stability of which both Wilson and Bryan believed was absolutely dependent upon American supremacy in the region. Link notes:

As evangels of democracy, they [Wilson and Bryan] thought they could teach the Mexican, Central American, and Caribbean peoples how to elect good leaders and establish stable institutions. Intervention, therefore, was always rationalized in terms of the good neighbor rescuing his helpless friends from foreign dangers and internal disorders.[65]

While such thinking, in actuality, provided the rationale for American intervention in the Caribbean region of an unprecedented scale between 1913 and 1921, Wilson and Bryan sincerely hoped their policies would lead ultimately to a secure and unified Western Hemisphere.[66]

Wilson's concept of a peaceful community of nations and the primacy of America's role in establishing and maintaining world peace was put to its severest test with the advent of World War I, the country's involvement in which Wilson fervently opposed. In this context Wilson's attitude coincided with a fundamental American belief in the righteousness of peace and the inappropriateness of overt militarism. Relatively isolated from foreign entanglements since the Civil War, America had been free to direct its energies for the next half-century on national development. Consequently, by the beginning of the twentieth century most Americans considered major armed conflict a remote possibility. Indeed, with the inauguration of The Palace of Peace at the Hague in August 1913, an era of international peace seemed at hand.[67]

It had long been an American opinion that war was a "peculiarly European disease" and "an atavism which Christianity, trade, and education would stamp out."[68] Modern military historians, such as Urs Schwarz from the Institut Universitaire de Hautes Etudes Internationales in Geneva, have written of this basic American view that considers peace a natural, normal condition and war an aberration from the norm. This is opposed to the classic or European view (prior to the twentieth-century concept of total warfare) that considered war and warlike actions as a legitimate extension of diplomacy when directed toward the achievement of limited and well-defined political objectives.[69]

Schwarz traces the American viewpoint to the country's relatively recent experience of building a modern republic on the basis of Enlightenment principles, the result being a fundamentally idealistic nation-state by whose standards the waging of war was considered inappropriate or unnecessary. Such a view gained added currency during the nineteenth century in light of the optimistic evolutionary theories of Auguste Comte (1798–1857) and Herbert Spencer, both of whom, as Schwarz notes, "assumed that war belonged to primitive and feudal societies and would be eliminated by the development of an industrial society, and of democracy."[70] War, in short, was thought to be alien to the very nature of American society and to America's destiny as a nation. If, however, America should be compelled to enter a war, the main object would then be to end the war as quickly as possible, to

punish the aggressor, to right the wrong, and to reestablish the normal conditions of peace; peace being the only real guarantee that the world would remain safe for democracy.

As we have already seen, some of these ideas found visual expression in the statuary for the House pediment where Bartlett sought to link the future of democracy with a strong and stable peace. In particular, the sculptor's choice of a peaceful Athena as his central motif, a figure whose traditional symbolism incorporates a fundamentally rational, pragmatic, and humane attitude to the practice of war, is especially relevant.

During the early months of World War I most Americans agreed with Wilson that the United States had no vital interest in the war and that the wisest course of action was to maintain a policy of complete neutrality. But following the sinking of the *Lusitania* on 7 May 1915, an increasing number of Americans came to believe that the United States would have to join the Allied cause eventually, and that, militarily speaking, the country was not equipped for such an undertaking. This shift in attitude helped spark the preparedness controversy, a movement whose adherents challenged America's peace stance, arguing that the nation should begin immediately to prepare for war.[71] Not surprisingly, preparedness advocates originally met with strong opposition from the Wilson administration. Still, within months of the sinking of the *Lusitania* preparedness had become a virtual crusade for many Americans (fig. 73; see color section). Fearing that the Republican party would make significant political gains by allying itself with the movement, even Wilson, himself, became a reluctant convert to preparedness in late 1915.[72]

That Bartlett also sympathized with the preparedness movement is certain; that he advocated American military involvement in the war as soon as possible is less certain but most likely given his close personal ties with France. Regarding America's official policy of neutrality, Paul probably shared the following sentiments of his father, Truman Bartlett:

It seems to me that if there is a God, we ought to be punished for not helping France, protesting against the butchery in Belgium, [and] standing up for England. Perhaps we shall be. It is both sad [and] interesting to be living at this time, especially in this country of 1,000,000 creatures without any definite aim of government or prospect of unison.[73]

As the sculptor of the House pediment, however, Bartlett seemed hesitant to express such views openly, especially during the early years of the war. Nevertheless, various actions taken by the sculptor confirmed his allegiance to the Allied cause and to preparedness.

Both before and after America's entry into the war in April of 1917 Bartlett was a tireless supporter of French and Belgian relief efforts. In July 1915, he was designated by the Comité France-Amérique as one of only a handful of agents in the United States who were authorized to receive donations on their behalf for the French National Fund. The Fund, in turn, provided assistance to groups such as the Secours National, a noncombatant relief organization formed in France "to meet the necessities of French women, children, old people and Belgian refugees rendered homeless or in want by the war."[74] And Bartlett's relief activities did not end there. During the winter of 1915–16 the sculptor authorized the sale of plaster casts of the head of the *Genius* from the House pediment in order to raise money in support of French artists fighting in the war; the following May he took part in a British benefit for wounded soldiers held at the Octagon House, in Washington.[75] But the sculptor's most direct reaction to the war apparently came in response to the sinking of the *Lusitania*: some time after the tragedy (probably in late 1915 or early 1916) he modeled an *Eagle of Preparedness* (fig. 74) to declare his sympathy with the rapidly escalating preparedness movement.[76]

Unlike the *Eagle of Preparedness*, the modeling of Bartlett's *Peace Protecting Genius* had been completed by the end of 1913. Thus, it cannot be argued reasonably that the imagery of the central group was related directly to the preparedness controversy or to specific events surrounding the war. Yet it was in relation to those events, especially the preparedness controversy, that Bartlett's figure of an armed and competent Peace took on its most vital significance. The Americans who watched the unveiling of Bartlett's pediment in the summer of 1916 saw emerge a central figure that celebrated neither a soft peace nor a peace achieved through the premeditated use of power but rather a defensive peace; that is, a peace made possible by the perception of strength and secure by adequate preparation and the resolve to take military action should it become necessary. When, less than

Fig. 74. Paul Wayland Bartlett, Eagle of Preparedness, *modeled 1915–16. Bronze, National Museum of American Art, Smithsonian Institution, Gift of Mrs. Armistead Peter III.*

without some attention given to the relationship of Bartlett's pediment to the future course of American art. Within the limited field of architectural sculpture, the statuary for the House pediment exerted little if any subsequent influence. The main reasons for this were the lack of a strong tradition of architectural sculpture in America, the gathering influences of modernist design principles, and the decreasing autonomy of the decorative sculptor vis-à-vis the supervising architect. Michele Bogart has accurately assessed the position in which architectural sculptors found themselves during the decades following World War I:

As more architects embraced the modernist idea that architectural forms, spaces, and structures could be expressive without allegorical embellishment, sculptors were caught in a difficult position. They either had to conform to the architect's wishes—which effectively deemphasized the literary content, hence the meaning of their art—or had to see architectural sculpture eliminated from further structures. Interpreted in this light the flatter "archaizing" look and ultimate disappearance of architectural sculpture were not merely the result of new aesthetic trends. They were symptomatic of a situation that had existed since the first decade of the twentieth century: the inability of architectural sculptors to stand out on their own.[77]

To be sure, Bartlett had benefitted from an unusual situation; not only had he been selected to design the statuary for a building already long in existence, but also the architect-in-charge, Elliott Woods, was interested only in obtaining for the government the best possible work. The end result was relative personal freedom for the sculptor in the execution of his commission. By contrast, few sculptors decorating buildings in the 1920s and 1930s would enjoy such a free hand. Nevertheless, Bartlett's individualistic approach to pedimental design, one that asserted the integrity of the statuary as compatible with the building yet distinctive in its own right, was fundamentally at odds with the direction architectural sculpture would take in America after the war.

The extent to which pedimental sculpture would come to assume the character of its architectural setting is exemplified by one of the decorative projects for the Federal Triangle in Washington, Adolph A. Weinman's *Spirit of Progress and Civilization* (fig. 75), 1932–34, for the Twelfth Street façade of the Post Office Building. Certain affinities exist between this work and

one year later, America did enter the war, that same figure must have come to symbolize not only President Wilson's failed hope in a peaceful community of nations, but also the unification finally of a people committed to the idea that the world must be made safe for democracy.

A discussion of the iconography of *The Apotheosis of Democracy* would not be complete

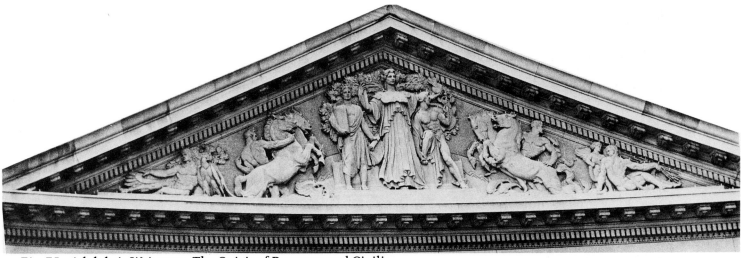

Fig. 75. Adolph A. Weinman, The Spirit of Progress and Civilization, *1932–34. Limestone, Pediment, Twelfth Street Façade, Department of the Post Office Building, Washington, D.C. Photograph: George Gurney/David Bloom.*

The Apotheosis of Democracy both in terms of content and organization. The focus of Weinman's pediment is a central group comprised of three figures. A female personification, bearing the attributes of Athena and holding in her left hand a winged ball symbolizing Progress, dominates the group. To her right, a male figure represents the power of the written word; to her left, Mercury, fastening his sandal, alludes to the swift delivery of the mail. To either side of this central trio Weinman has arranged various ideal male nudes and rearing horses symbolizing the transportation of the mail by land, sea, and air.[78]

Weinman, like Bartlett, believed that the style of his sculpture had to blend with the classical language of the building. But unlike Bartlett, who sought to infuse his forms with the immediacy of contemporary American experience, Weinman felt compelled

to employ stylized forms that suggested the idealization associated with classical structure. The human figures therefore become vehicles for symbolic rather than realistic representation. Realism was to be relegated to minor details for associative purposes tied to the symbolism.[79]

The adherence to traditional allegorical representation with its accompanying loss of comprehensibility, especially for an American public inexperienced in the reading of such forms, clearly distinguishes Weinman's approach to designing architectural sculpture from Bartlett's some fifteen years earlier. The truly symbolist nature of Bartlett's statuary—the merging of

realism and formalism—was simply not a part of Weinman's aesthetic. Consequently, his images are not as vital or relevant to the activities of ordinary men and women as Bartlett's nor do they engage the viewer as directly. Furthermore, Weinman's figures are stiff and planar, reflecting the aesthetic predominance of the architecture, and the ordering of his composition seems formulaic in contrast to the House pediment where the design resulted from the sculptor's studied response to the intrinsic demands of the particular commission.

While *The Apotheosis of Democracy* had little impact on the future development of architectural sculpture in America, the iconography of Bartlett's pediment, particularly as it relates to American labor, reemerged stronger than ever after the war in painting and freestanding sculpture. Similar stylistic and thematic strategies can be found in the work of a variety of artists, including the American scene painters Thomas Hart Benton (1889–1975) and Grant Wood (1892–1942) and socially relevant realist sculptors such as Max Kalish (1891–1945), all of whom frequently elevated the common American worker to heroic status.

Wood's mural painting entitled *Adoration of the Home* (fig. 76), 1921–22, commissioned as an advertisement for a realtor's office in Cedar Rapids, Iowa, Wood's hometown, is a typical example of the survival in American art of Bartlett's prewar celebration of American labor. Just as in *The Apotheosis of Democracy*, Wood's painting

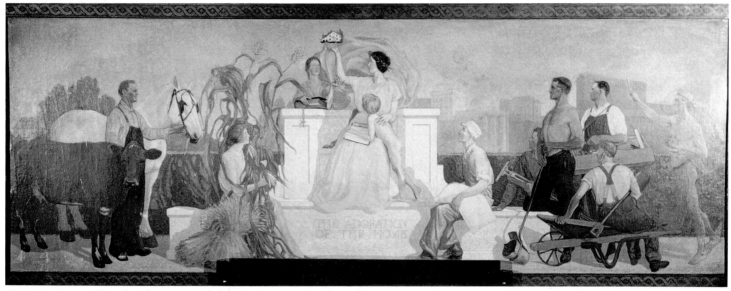

Fig. 76. Grant Wood, Adoration of the Home, *1921–22. Cedar Rapids Museum of Art, Mr. and Mrs. Peter F. Bezanson Collection.*

glorifies those attributes which Americans had come to associate with the moral character of the nation. Specifically, the mural pays homage to the virtues and resources that helped Cedar Rapids develop in only a few generations from a primitive frontier community into a modern and progressive metropolitan center.

Seated upon a marble throne, a majestic female figure protects a young male child symbolizing Education, while, supported by the personification of Religion, she lifts for the purposes of public adoration an ideal model of the American home, a middle-class icon and the rock upon which a mobile democratic society is built. Figures representing animal husbandry and agriculture, to the left of the throne, and factory workers and craftsmen, to the right, symbolize the source of the city's wealth and advancement—the common laborer.[80] But what ties Wood's painting stylistically to Bartlett's pediment is that his images are derived more or less from real American experience and are made heroic not by imposing classical stylization but by ordering visual reality according to essential forms and patterns.

Bartlett's influence on Max Kalish was more direct. Kalish had studied with him at the Académie Colarossi in Paris during 1912–13, a period during which Bartlett was intensely preoccupied with modeling his figures for the House pediment.[81] The impact of this experience on the younger sculptor was seminal and is

clearly visible in later works such as *Laborer at Rest* (fig. 77), ca. 1924, and *Man of Steel* (fig. 78), 1930. Bartlett's prewar salute to the American worker and the stylistic blend of realism and monumentality that typifies his figures for the House pediment were important American precedents for these sculptures and numerous others that Kalish executed throughout the twenties and thirties, and through Bartlett, connect Kalish to the nineteenth-century realist tradition defined by Dalou and Meunier.

The economic themes embodied in *The Apotheosis of Democracy* also found a new nationalistic expression in the art of the New Deal, especially the mural decorations executed throughout the mid-thirties to early forties under the sponsorship of the Treasury Department's Section of Painting and Sculpture.[82] Many of these murals evoke the distinctive iconography of Bartlett's pediment, particularly in terms of the evolving relationship between the two basic economic spheres of agriculture and industry, but reinterpreted in light of the harsh realities of the depression era. Typical examples include *The Fusion of Agriculture and Industry,* 1938, painted by Mitchell Siporin (b. 1910) for the Post Office in Decatur, Illinois, *The Family— Industry and Agriculture,* 1939, Ambler, Pennsylvania, by Harry Sternberg (b. 1904), and Jean Swiggett's *Local Industry* (fig. 79), 1940, located in Franklin, Indiana.[83] While conforming to Bartlett's general scheme by tracing the sources

Fig. 78. Max Kalish, Man of Steel, *1930. Bronze, National Museum of American Art, Smithsonian Institution, Gift of Max Kalish.*

Fig. 77. Max Kalish, Laborer at Rest, *ca. 1924. Bronze, Collection of the Newark Museum, Purchase 1927, J. Ackerman Coles Bequest Fund. Photo © The Newark Museum.*

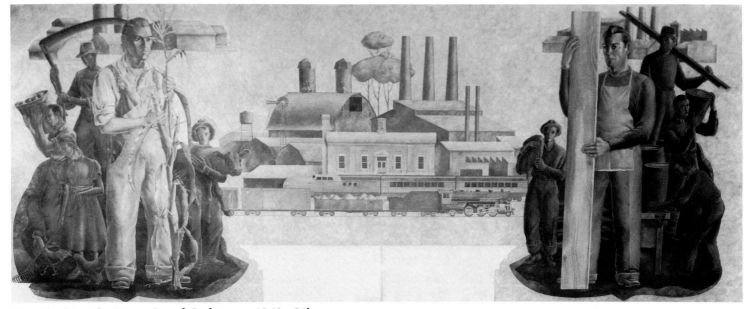

Fig. 79. Jean Swiggett, Local Industry, *1940. Oil on canvas, Post Office, Franklin, Indiana. Photograph: National Archives, Washington, D.C.*

of the country's wealth to the efforts of the common worker, these artists departed from prewar economic values by championing national unity and social cooperation versus self-interest and individual economic opportunity. Such an approach reflected the New Deal belief that the political and economic destiny of the nation no longer rested on the principle of personal ambition but on the interdependence of all groups and the delicate balance between individualism and collectivism.[84]

As this brief discussion has revealed, certain cultural values given expression in Bartlett's sculpture for the House pediment continued to assert themselves beyond the first World War, suggesting that a more exhaustive reexamination of the basic principles of American Renaissance art with an eye toward postwar developments is perhaps in order. In any case, Bartlett's *Apotheosis of Democracy* remains a major public monument of its own time and place and deserves to be recognized as a high-water mark for architectural sculpture in America.

Catalogue of Models and Casts

Sketch Models

1. Title: *Preliminary Sketch Model for the Apotheosis of Democracy*

Inscription: P. W. Bartlett (right front)
c SB (left front)
c 1927 SB (bottom right)

Date: Modeled, 1908–9; this cast, 1927

Medium: Bronze, dark brown patina

Size: H. 5⅛ W. 28⅞ in.

Location: James Monroe Museum and Memorial Library, Fredericksburg, Virginia (Accession No. JM76.286). Gift of Mrs. Armistead Peter III, 1958

Exhibitions: *Paul Wayland Bartlett, 1865–1925, Sculptures,* Musée de l'Orangerie (Jardin des Tuileries), Paris, 20 June to July 1929. This cast or a duplicate cast of the same sketch may have been one of the two following works exhibited in this show: Cat. No. 20: "Premier project pour le fronton de la chambre des Deputés à Washington," or Cat. No. 21: "Ebauche du fronton de la chambre des Deputés à Washington."

Memorial Exhibition of the Works of Paul Wayland Bartlett, The American Academy of Arts and Letters, New York, 1931. This cast or a duplicate cast of the same sketch may have been Cat. No. 14 exhibited in this show under the title, "Sketch. First Project for the Pediment on the Capitol in Washington, D.C."

Paul Wayland Bartlett Retrospective, The Corcoran Gallery of Art, Washington, D.C., 14 November 1943 to 1 January 1944. A number of early sketches for the House pediment were delivered to the Corcoran for this exhibition, but it is uncertain which works were actually included in the show.

This piece is a posthumous bronze cast of the preliminary sketch model for the House pediment illustrated in fig. 31. The cast was made in Paris by Suzanne Bartlett in 1927.

2. Title: *Northern Segment of a Preliminary Sketch Model for the Apotheosis of Democracy*

Date: Modeled, 1908–9; this cast, unkown

Medium: Plaster

Size: (15.0 × 50.0 × 10.0 cm.)

Location: Tudor Place, Georgetown, Washington, D.C. (Accession No. 90.6005.b). Gift of Felix de Weldon, 1990

Fig. 80. Paul Wayland Bartlett, Two Teams of Horses, fragment of an Advanced Sketch Model for the Apotheosis of Democracy, *modeled, 1909–10. Bronze, National Museum of American Art, Smithsonian Institution, Gift of Mrs. Armistead Peter III, 1958.*

This is a segment of a plaster cast of the same sketch model illustrated in fig. 30. The southern segment of this cast is also in the collection of Tudor Place (Accession No. 90.6005a) but the central section is missing.

3. Title:	*Two Teams of Horses, fragment of an Advanced Sketch Model for the Apotheosis of Democracy* (fig. 80)
Inscription:	P W BARTLETT (right side on base)
Foundry Mark:	B. ZOPPO / FOUNDRY. N.Y. (on left end)
Date:	Modeled, 1909–10; this cast, unknown
Medium:	Bronze, deep green patina
Size:	H. 12⅜ W. 21½ D. 6⅝ in. (31.2 × 54.5 × 16.7 cm.)
Location:	National Museum of American Art, Smithsonian Institution, Washington, D.C. (Accession No. 1958.11.23). Gift of Mrs. Armistead Peter III, 1958

This is a bronze cast of the quadriga from the same advanced sketch model illustrated in fig. 32. It was probably cast during Bartlett's lifetime.

4. Title:	*Advanced Sketch Model for the Apotheosis of Democracy*
Date:	Modeled, 1909–10; this cast, 1909–10
Medium:	Plaster
Size:	H. 5 in. L. 96 in.
Location:	Estate of Felix de Weldon. Temporary Loan to Tudor Place, Georgetown, Washington, D.C.

This plaster cast is the one that appears in the background of the photograph illustrated in fig. 33. Some time after Bartlett's death in September 1925, the Washington studio was purchased by the sculptor Fe-

lix de Weldon (b. 1907). This piece is one of the many Bartlett plasters that remained in the studio during de Weldon's occupancy. In fact, this cast was still in the same position as shown in fig. 33 until March 1990, when it was moved in conjunction with de Weldon's sale of the studio (see also next catalogue entry).

5. Title: *The Reaper, fragment of an Advanced Sketch Model for the Apotheosis of Democracy*

 Date: Modeled, 1909–10; this cast, 1909–10

 Medium: Plaster

 Size: (45.0 × 20.5 × 13.5 cm.)

 Location: Tudor Place, Georgetown, Washington, D.C. (Accession No. 90.6008). Gift of Felix de Weldon, 1990

This fragment is from the plaster cast that appears in the foreground of the photograph illustrated in fig. 33. The plaster architectural frame for the sketch model was still in the Washington studio until March 1990, but this plaster fragment was the only piece of the actual sketch still extant and in position.

6. Title: *Head and Front Quarters of a Recumbent Ox from The Husbandman, fragment of an Advanced Sketch Model for the Apotheosis of Democracy*

 Inscription: P. W. Bartlett / c 1927 SB

 Date: Modeled, 1909–10; this cast, 1927

 Medium: Bronze, brown patina

 Size: H. 6¼ L. 7 in.
 Base: 4 × 4 in.

 Location: Westmoreland Museum of Art, Greensburg, Penn. (Accession No. 58.16). Gift of Mrs. Armistead Peter III, 1958

 Bibliography: Paul A. Chew, ed., *The Permanent Collection* (Greensburg, Penn.: Westmoreland Museum of Art, 1978), 22, Cat. No. 7.

This is a bronze cast of a fragment from the sketch model that appears in the foreground of fig 33. It was cast by Suzanne Bartlett in 1927.

7. Title: *Head of The Ironworker, fragment of an Advanced Sketch Model for the Apotheosis of Democracy*

 Inscription: P. W. B. (bottom right)
 c [within a circle] (bottom rear)

 Date: Modeled, 1909–10; this cast, ca. 1927?

 Medium: Bronze, brown patina

 Size: (7.0 × 5.0 × 6.2 cm.)

 Location: Tudor Place, Georgetown, Washington, D.C. (Accession No. 6334.1).

 Exhibition: Exhibition Label: Annexe, No. 112 (attached to underside)

This is a bronze cast of another fragment from the advanced sketch model that appears in the foreground of fig. 33. A second bronze cast of this fragment is in the collection of Tudor Place (Accession No. 6334.2). Both casts were probably made by Suzanne Bartlett about 1927.

The Full-Scale Plaster Working Models

8. Title: *The Apotheosis of Democracy* (working models)

 Date: Modeled, 1909–15; cast, 1914–15; restored, 1963–65; installed, 6 April 1965

 Medium: Plaster, painted white

 Size: H. 12 ft. (at center)
 W. 60 ft. (combined)

 Location: Subway Terminal, west end of the House wing of the U.S. Capitol, Washington, D.C. Gift of Mrs. Armistead Peter III, 1962

 North Wall:
 Peace Protecting Genius; The Reaper and His Attendant; The Ironworker and Printer

 East Wall:
 The Husbandman; Boy Carrying Grapes; Mother; Child Wrestling with a Ram

West Wall:
*The Founder and His Assist-
ant; Woman Measuring Cloth;
Fisherboy*

After Bartlett's figures were carved in marble by
the Piccirilli Brothers, the working plaster models
were shipped back to Bartlett's studio in Washington.
Within weeks of the pediment's unveiling, Elliott
Woods tried to arrange for the permanent installation
of the working models in the National Museum,
Smithsonian Institution, but the extreme size of the
models made this impractical. Thus, the models
stayed in the Bartlett studio even after its sale to de
Weldon. Much later, in the summer of 1943, the office
of the Architect of the Capitol contacted the Commis-
sion of Fine Arts in Washington to see if they would
like to have the models but this offer was likewise
declined. Finally, in late 1962, Bartlett's stepdaugh-
ter, Mrs. Armistead Peter III, donated them to the
Capitol. Subsequently, on 25 February 1963, the ar-
chitect of the Capitol contracted with George L. Gia-

netti for the restoration of the models and their
installation in the new House Subway Terminal. The
models were installed there on 6 April 1965.

Peace Protecting Genius

9. Title: *Peace Protecting Genius* (cen-
 tral group from *The Apotheo-
 sis of Democracy*) (fig. 81)

 Inscription: PWB (left front on base)

 Foundry Mark: SKETCH/Fonderie Coopera-
 tive/Des Artistes/ Paris

 Date: Modeled, 1909–13; this cast,
 1927–31?

 Medium: Bronze, brown patina

 Size: H. 55 in. W. 55 in. D. 18 in.

 Location: Westmoreland Museum of
 Art, Greensburg, Pennsylva-

Fig. 81. Paul Wayland Bartlett, Peace Protecting Genius *(cen-
tral group from* The Apotheosis of Democracy*), modeled, 1909–
13; this cast, 1927–31? Bronze, Westmoreland Museum of Art,
Greensburg, Pennsylvania, Gift of Mrs. Armistead Peter III,
1959.*

nia (Accession No. 59.27). Gift of Mrs. Armistead Peter III, 1959

Bibliography: Paul A. Chew, ed., *The Permanent Collection* (Greensburg, Penn.: Westmoreland Museum of Art, 1978), 23–24, pl. 18, Cat. No. 32.

Exhibitions: *Memorial Exhibition of the Works of Paul Wayland Bartlett*, The American Academy of Arts and Letters, New York, 1931, No. 4: "Democracy Protecting the Young Genius of America. Study for central group of pediment, House of Representatives, Washington, D.C."

Paul Wayland Bartlett Retrospective, The Corcoran Gallery of Art, Washington, D.C., 14 November 1943 to 1 January 1944. Delivered; included?

Although approximately half-scale, this bronze is identical to the final marble except for various background details such as the olive tree, which, in the finished pediment, appears behind the shoulder of Peace. It was cast in Paris probably under the instructions of Suzanne Bartlett some time after the sculptor's death but before 1931.

10. Title: *Head of Peace* (detail of *Peace Protecting Genius*, central group from *The Apotheosis of Democracy*; head and partial bust) (fig. 82; see color section)

Inscription: P. W. Bartlett (left side along shoulder)
c SB 1927 (left side along shoulder)

Date: Modeled, 1909–13; this cast, 1927

Medium: Bronze, light golden-brown patina

Size: H. 10¾ in.

Location: James Monroe Museum and Memorial Library, Fredericksburg, Virginia (No Accession No.). Gift of Mrs. Armistead Peter III, 1958

Exhibitions: *Paul Wayland Bartlett Retrospective*, The Corcoran Gallery of Art, Washington, D.C., 14 November 1943 to 1 January 1944. Delivered; included?

11. Title: *Head of Genius* (detail of *Peace Protecting Genius*, central group from *The Apotheosis of Democracy*; head, partial bust, and portion of a wing) (fig. 83; see color section)

Inscription: Bartlett (right side of base) "Genius!" Fragment Peace Group of Ped. (front of base) U.S. CAPITOL (right side of base) SKETCH (left side of base)

Date: Modeled, 1911–13; this cast, ca. 1913–16?

Medium: Plaster, surface coat of varnish

Size: H. 11 W. 11⅜ D. 4 in.

Location: Tudor Place, Georgetown, Washington, D.C. (Accession No. 6226)

This piece was pointed up for enlargement possibly for the purpose of casting the full-scale plaster models. Also, surface markings and a coat of varnish indicate that this plaster probably served to make the mold for the several posthumous bronze casts of the head of the Genius that were produced by Suzanne Bartlett in 1927 (see next catalogue entry). Additional plaster casts of the head of the Genius were produced and sold by the sculptor in 1915–16 to raise money in support of French artists fighting in World War I.

12. Title: *Head of Genius* (detail of *Peace Protecting Genius*, central group from *The Apotheosis of Democracy*, head, partial bust, and portion of a wing)

Inscription: PAUL W. BARTLETT (along right shoulder)

Date: Modeled, 1911–13; this cast, ca. 1927

Medium: Bronze

Size: H. 10 W. 11 in.

Location:	The High Museum of Art, Atlanta, Georgia (Accession No. 58.24a). Gift of Mrs. Armistead Peter III, 1958
Exhibitions:	*Paul Wayland Bartlett, 1865–1925*, Ferargil Galleries, New York, 14 November to 7 December 1927. This cast is almost certainly one of the two bronze casts of the head of Genius exhibited in this show—either Cat. No. 39: "Head of Young Genius from the Pediment of Capitol, Washington, D.C.;" or Cat. No. 40: "Head of Young Genius."
	Memorial Exhibition of the Works of Paul Wayland Bartlett, The American Academy of Arts and Letters, New York, 1931. This cast or an alternate bronze cast of the head of Genius was included in this show.

The plaster head at Tudor Place was probably used to make the mold from which the Atlanta head was cast.

The Powers of Labor

13. Title:	*Mother and Children Harvesting the Field* (from *The Powers of Labor: Agriculture*, northern portion of *The Apotheosis of Democracy*) (figs. 84 and 85; see color section)
Date:	Modeled, 1909–11; this cast, unknown
Medium:	Bronze
Location:	The Columbia Museum of Art, Columbia, South Carolina (No Accession No.). Gift of Mrs. Armistead Peter III
14. Title:	*Boy Carrying Grapes* (detail of *The Powers of Labor: Agriculture*, northern portion of *The Apotheosis of Democracy*) (fig. 86; see color section)
Inscription:	P W B (lower right on base)

Foundry Mark:	Fonderie Cooperative / Des Artistes/ Paris (lower left on base)
Date:	Modeled, 1908–11; this cast, unknown
Medium:	Bronze, green patina
Size:	H. 43½ W. 22½ D. 17 in.
Location:	Tudor Place, Georgetown, Washington, D.C. (Accession No. 6016).

This bronze cast of *Boy Carrying Grapes* remained in the possession of Mrs. Armistead Peter III, long-time mistress of Tudor Place, until her death in 1965. The bronze has been set up as a fountain figure in the gardens of Tudor Place.

15. Title:	*Bust of Woman Measuring Cloth*, or *The Weaver* (detail of *The Powers of Labor: Industry*, southern portion of *The Apotheosis of Democracy*) (fig. 87)
Inscription:	c P. W. B. 19[29]
Foundry Mark:	CIRE PERDUE / LEBLANC BARBEDIENNE FILS / A PARIS
Date:	Modeled, 1911–14; this cast, 1929?
Medium:	Bronze, repatinated a rich chocolate brown in the summer of 1984
Size:	H. 18¾ in.
Location:	Munson-Williams-Proctor Institute Museum of Art, Utica, New York (Accession No. 59.36). Gift of Mrs. Armistead Peter III, 1959

This bronze was cast about 1929 probably under the instructions of Suzanne Bartlett.

16. Title:	*Mask of Fisherboy* (detail of *The Powers of Labor: Industry*, southern portion of *The Apotheosis of Democracy*)
Inscription:	P. W. Bartlett / 1927 c SB (top)
Date:	Modeled, 1909–14; this cast, 1927
Medium:	Bronze, black patina

Fig. 87. Paul Wayland Bartlett, Bust of Woman Measuring Cloth, *or* The Weaver *(detail of* The Powers of Labor: Industry, *southern portion of* The Apotheosis of Democracy*), modeled, 1911–14; this cast, 1929? Bronze, Munson-Williams-Proctor Institute Museum of Art, Utica, New York, Gift of Mrs. Armistead Peter III, 1959.*

Size: H. 7 W. 5 D. 2½ in.

Location: James Monroe Museum and Memorial Library, Fredericksburg, Virginia (No Accession No.). Gift of Mrs. Armistead Peter III, 1958

Additional Casts: The Currier Gallery of Art, Manchester, New Hampshire (No Accession No.)

The Berkshire Museum, Pittsfield, Mass. (Accession No. 59.4.8)

Appendix: Selected Documents

[Letter, Clerk's copy, Captain Montgomery C. Meigs to Erastus Dow Palmer, 28 April 1857, Records of the Architect of the Capitol.]

E. D. Palmer April 28, 1857
Sculptor
Albany, N.Y. My Dear Sir,

I have not yet been able to see the Secretary of War, who, with the other members of the Administration, is engaged in daily Cabinet meetings.

The selection of the design for the pediment of the Capitol is a matter of so much importance that I do not like to act on it definitely without first consulting with him.

It is due to you, however, that some answer be sent without further delay.

The subject you have chosen is one of great significance in our history—one which is worthy by its interest and results, to be placed upon the National Capitol.

The general manner in which you have treated it pleases me; and the skill shown in other works of your hand gives me confidence that you will be able and willing to do this subject, when fully studied, the Justice the great theme demands.

But I must say frankly that I do not feel satisfied with your grouping and composition. I do not think that you would have been so yourself had you studied it in the round, instead of in a sketch upon paper.

I think that the space is not enough filled up, and yet I am sensible of the great importance of not falling into the very common error in such works of crowding the space so much as to produce confusion.

The tympanum of the Madeleine, in Paris, is one of those which is so filled with figures as to be almost unintelligible. Of this, however, I judge from the photographs only, and perhaps a view of the work itself might not justify this opinion.

I think that if you will look at the restoration of the design for the pediment of the Parthenon, universally considered to be the work nearest perfection, you will see that it is possible to comprise a much greater variety in such a space without any confusion. I have always thought the Crawford work was defective in this—that the space was not filled, and the whole design had in consequence a rather meager look.

In such a work, at such a height as the sculpture for the pediment must be placed and viewed, the beauty of finish and the finest shades of expression must be in a great measure lost. Hence the greatest attention should be paid to the general effect, the composition of the manner and lines.

The other should not be neglected; for the time may come when these statues may be placed in galleries, as the fragments which now remain from the Parthenon; and I should hope that whenever that time comes the separate figures may do us the same credit that those from the Parthenon do the artist and the State which erected them. Therefore, while studying with great care perfection in the qualities which are peculiarly important in such a place, I would not have the higher qualities of expression and execution neglected.

I think that the arrangement of your figures is rather too symmetrical. With one principal figure in the centre, you have on each side several which seem to balance each other exactly; to be indeed almost repetitions of the same figure, in

attitude and arrangement.

A certain formality of arrangement is necessary and proper in sculpture to be combined with architecture, as this is; but I would avoid repetitions.

All attempts at making a picture or introducing perspective effect are violations of the canon of sculpture. I would not introduce so many trees as so much landscape effect.

I would place figures nearly upon the same line; as there can be no gradations of colors or strength, as in a picture, the eye sees and is offended at an attempt which cannot be successful.

The space is too valuable to be filled with trees. We look for life—for human life. A mere allusion to the forest may be tolerated. I wish Crawford had satisfied himself with one tree for his pioneers, and given us instead of the rest, another statue.

In regard to the price which you have put upon this work, I think that your observations are just. The cost of execution in this country must be much greater than in Europe, and the difference which you make is not such as to be just reason for any other artist to complain that you have been paid at rates which under value his work.

I should prefer, however, that the price should be stated at so much per figure. This would enable you to make, without loss to yourself, such additions to the number as may, upon further study, seem to you proper.

I forgot to mention that there is too much space at each end of the work unoccupied. If you will look at the Parthenon you will see with what ingenuity and care these spaces have been filled up. The head of the horse which occupies the extreme right of the Tympanum of the Parthenon is at this day a model of art. I have seen a cast of it in the Philadelphia Academy. Though it might be thought a mere accessory, it is treated with the greatest care and vigor in expression and in finish. No artist devoted entirely to animals has probably ever excelled it.

I think that this work ought, in justice to yourself and to the Government, to be worked out in the round before being submitted to the Secretary for his final decision.

I send you the original design and photograph from the sketch in clay which was sent to me by Mr. Crawford for his pediment. Preserve it carefully, as it is the original, and I value it highly. Return it when you have examined it sufficiently.

I also send larger photographs from the original sketch of the chief, the family, Commerce, and the Pioneer. This I send you to show how rough a clay sketch answers the purpose; how much more effective it is, and how much better a study than any drawing can possibly be. I hope that you will see the propriety of making such a study. I desire to have you succeed with this work, and to that end I wish it to be put into such a shape that I can, with confidence of success, recommend it.

As this model ought to be several feet in length, and its preparation will be costly in time and money, and as you have already made a sketch for the subject which justifies me in requesting you to go further, I shall be willing to pay the cost of the preparation of the design in this shape. A photograph ought to be sent from the clay as soon as that is finished. You will then of course cast it in plaster.

I suppose that $500 will cover the cost of producing such a design, and this sum I should be willing to engage for it—whether it be finally adopted and executed in turn or not.

If I am wrong in my estimate of the expense, correct me, and I shall be willing to meet any expense which I may think reasonable to procure a design thoroughly satisfactory.

I doubt whether you are right in your treatment of the subject, so far as putting the weaker members of the composition in the most dangerous situations, I feel myself as though you were casting some stain upon the diligence and prudence of our forefathers. I would put a careful watchman in place of danger. The wolves if introduced at all, ought, I think, to keep crouched in the extreme angle of the Tympanum. The Indian might be removed further from the centre; indeed, I think that it would be well to put more than one such figure in the work. The dog of the Indian I would not have so close upon his master. Ask some naturalist of Albany whether the dog is indigenous to New England. Few of the domestic animals were found here by the early settlers. If the dog was here, he is the only one. I have been so much occupied since the drawings arrived that I have not been able to give to this subject the thought which its importance demands. The writing and preparation of contracts and specifications for the Water Works [Washington Aqueduct], and the organization of that work under a large appropriation, have occupied my time.

I now write in great haste, and this letter is the

expression of thought too crude and too hastily thrown upon paper to be sent to you. My apology must be my desire to give you my views at the earliest possible moment, and to secure for you the commission, and for the Capitol the great work which I have no doubt you will be able to produce with proper study.

Of course, if the price per figure is given in making any contracts for these models, the whole cost will vary with the number of figures to be employed.

I think that fifteen hundred or sixteen hundred dollars each will be a proper price.

> With the highest respect and regard
> I am,
> most truly yours,

(signed) M. C. Meigs
 Captain of Engineers
 in charge of Capitol
 Extension

[Descriptions of *The Mother Republic* and *The Flight of the Eagle*, designs for the central pediment of the United States Capitol Building, Charles Henry Niehaus to Elliott Woods, undated, Records of the Architect of the Capitol.]

(Designed for the Central Pediment)
THE MOTHER REPUBLIC
In the model, the "Mother Republic," the intention has been to show the human quality and the protection afforded by the United States to all arts, industries and labor, and to this end the figure of a "Mother" is introduced as the keynote of the whole, whose ample cloak shields many. At her knees is a child, trusting in her tender guidance. At either side are two youths, "Promise" and "Guidance" while the Arts, Crafts and Sciences are making their respective offerings to her. On her left a laborer kneels with his sledge, an artisan is seen cutting a capital with chisel and hammer, and at the end a man is binding sheaves, thus bringing in the laborer, the artisan and the farmer. On her right, a woman is holding up a distaff, her companion is exhibiting a figure he has modeled, a sage is studying the globe, and a miner is testing for undiscovered ore. This composition is massed around the central figure, "The Mother Republic" and as the lines of the pediment meet, the figures are so posed as to also mass toward her. At either end are a skull

of a buffalo and a sheaf. It is proposed to crown the straight cornice with eagles.

(Designed for the Central Pediment)
THE FLIGHT OF THE EAGLE
The ideal aspect and the primitive conditions of the country have been considered in the composition "The Flight of the Eagle"; in the center, "Liberty" is typified by the figure of a young man whose uplifted hands have just released an eagle poised for flight; to his left, the Genius of Opportunity is seen calling through her hands, wakening the world to the possibilities of the American Republic; beside her is the figure of a man, Literature or History, fashioning a quill out of a feather dropped from the eagle; beside him is a man representing Navigation in the act of drawing a primitive boat and nearby a workman is hammering a hoop. At the end a family group of Indians is affrightedly watching the approach of civilization.

On the right, Nature is dropping a mantle of flowers and fruits and grains, and in her train are a man and woman returning from the fields, and two miners, one exhibiting a piece of ore he has just found to his fellow workman, who stays his pick in curious interest. A trapper, resting, and gazing out in the distance furnishes one of the earliest subjects of our country, and with the accessory of a dog ends the composition.

Eagles are used on the surmounting balustrade.

[Bartlett's Original Contract, 16 February 1909, Records of the Architect of the Capitol.]

1. WHEREAS, By an Act of Congress, approved April 16, 1908, entitled "An Act for completing the pediment of the House wing of the Capitol" it is provided:

That the expenditure of seventy-five thousand dollars, or so much thereof as may be necessary, be, and the same is hereby, authorized for the purpose of completing the pediment of the House wing of the Capitol by placing suitable statuary thereon, said expenditure to be made under the direction of the Speaker of the House, the Joint Committee on the Library, and the Superintendent of the Capitol;

2. AND Whereas, the Act making appropriations for Sundry Civil Expenses of the Government for the fiscal year ending June thirtieth, nineteen hundred and nine, approved May 27, 1908, contains the following provision:

Toward procuring statuary for the pediment of the House wing of the Capitol, to be expended as provided by law, including not exceeding five thousand dollars for procuring a suitable design, fifteen thousand dollars:

3. AND WHEREAS, in pursuance of the provisions of the Act approved April 16, 1908, the Commission thereby created, namely: Hon. Joseph G. Cannon, the Speaker of the House; Hon. Geo. Peabody Wetmore, U.S.S., Hon. Henry C. Hansbrough, U.S.S., Hon. Frank O. Briggs, U.S.S., Hon. John W. Daniel, U.S.S., Hon. Francis G. Newlands, U.S.S., Hon. Samuel W. McCall, M.C., Hon. James P. Conner, M.C., Hon. Edward L. Hamilton, M.C., Hon. William M. Howard, M.C., and Hon. Charles R. Thomas, M.C., being the Joint Committee on the Library; and Elliott Woods, Esq., Superintendent of the Capitol, at a meeting held on May 26th, 1908, selected Mr. Paul Wayland Bartlett, Sculptor, of New York City, to execute and install a marble sculptured group for the ornamentation of the pediment of the House wing of the Capitol, the same to be in harmony with the architecture of the Capitol Building, on designs to be approved by the Commission; and, the design, a sketch model, having been duly submitted to and approved by the Commission;

4. NOW THEREFORE, it is hereby covenanted and agreed by and between the said Hon. Joseph G. Cannon, the Speaker of the House; Hon. Geo. Peabody Wetmore, U.S.S., Hon. Henry C. Hansbrough, U.S.S., Hon. Frank O. Briggs, U.S.S., Hon. John W. Daniel, U.S.S., Hon. Francis G. Newlands, U.S.S., Hon. Samual W. McCall, M.C., Hon. James P. Conner, M.C., Hon. Edward L. Hamilton, M.C., Hon. William M. Howard, M.C., and Hon. Charles R. Thomas, M.C., being the Joint Committee on the Library; and Elliott Woods, Esq., Superintendent of the Capitol, parties of the first part, acting for and in behalf of the United States, and Paul Wayland Bartlett, of New York, County of New York, State of New York, party of the second part, as follows:

5. That the said party of the second part shall model and execute a marble sculptured group, for the ornamentation of the pediment of the House wing of the Capitol, the same to be in harmony with the architecture of the Capitol Building, to be made of the best material, and to be in accordance with the sketch model submitted by him and accepted by the parties of the first part, and to erect and place the said marble sculptured group in place in the pediment of the House wing of the Capitol, all complete, at his own cost and expense, within three years from the date of signing this contract.

6. It is hereby agreed that in the progress of the work provided for hereunder, all models, and the completed statuary shall be subject to the approval of the parties of the first part.

7. The party of the second part shall furnish the parties of the first part with a plaster copy of the sketch model and of the working model of said marble sculptured group the same to be kept for reference in the office of the Superintendent of the Capitol Building and Grounds, who is the administrative officer authorized to act for the parties of the first part in the manner hereinafter provided.

8. It is further agreed between the parties hereto that in case the party of the second part shall die after the working model shall have been so far completed that the same can, in the judgment of the parties of the first part, be completed as a finished work of art, or if he shall after the completion of the working model become incapacitated to further perform this contract, that in the execution of the work provided for in this contract one or more persons of skilled experience shall be appointed as executor, administrator or legal representative of said party of the second part with the approval of the parties of the first part, to superintend the completion of said sculptured group in accordance with the designs of the party of the second part.

9. Reasonable compensation shall be allowed to such superintendent or superintendents, as the case may be, by the parties of the first part, and after the completion of the work the compensation paid to said superintendent or superintendents, and the cost of completing the work shall be deducted from the total consideration named in this agreement, and the remainder shall be paid to the executor, administrator or legal representative of the party of the second part, or to the said party of the second part.

10. It is further agreed by the said party of the second part that this contract is to include the

furnishing of all material, labor, safe and sufficient scaffolding, tools, machinery, and appliances of all descriptions, transportation of men and material, or any other expense including minor structural changes at the site necessary to furnish install and complete all the work herein provided for;

11. The parties of the first part agree that due and reasonable access will be afforded the party of the second part to the site of the work provided hereunder, subject to the direction and approval of the Superintendent of the Capitol Building and Grounds; but the right is reserved for the United States to postpone the work or to interrupt it for such periods as may in the judgment of the Superintendent of the Capitol Building and Grounds be necessary, and for any such postponements or interruptions an equivalent extension of time will be granted to the party of the second part; and no claim for damages on account of such postponements or interruptions shall be made against the United States by the party of the second part. Should the party of the second part be delayed in the prosecution of his work by reason of fire, earthquake, cyclone, strikes or lockouts, or other casualty accepted by the Superintendent of the Capitol Building and Grounds as being beyond the control of the party of the second part under this agreement, then the time fixed for the completion of this work shall be extended for a period of time equal to that which the party of the second part can demonstrate to the satisfaction and acceptance of the Superintendent of the Capitol Building and Grounds, was lost through any of the above-mentioned causes. Any claim for an extension or an allowance of time, to be binding, must be made by the party of the second part and accepted by the Superintendent of the Capitol Building and Grounds, both in writing.

12. In consideration of the full and faithful performance of the several promises, undertakings and agreements herein contained to be kept and performed by the said party of the second part concerning the execution and erection of the said sculptured group, and when the same shall have been completed and erected in place and is made in all things complete to the satisfaction of the said parties of the first part, and the title thereto perfect in the United States, free from all incumbrances, and the same shall have been accepted by the parties of the first part, then the parties of the first part agree to pay to the said party of the second part the sum of seventy-four thousand dollars ($74,000), which sum shall be received by the said party of the second part in full satisfaction of all payments to be made by the parties of the first part or the United States for the materials to be furnished and the services to be rendered and labor performed in the erection of the said sculptured group as in this agreement herein before specifically set forth.

13. It is further agreed that the party of the second part is to assume all risks and bear any loss occasioned by neglect, by accident, by the nature of the work, by unforeseen or unusual obstructions or difficulties encountered during the prosecution of the work, or by the action of the elements during the progress of the work, until the acceptance of and final payment for the work.

14. It is further agreed that the party of the second part must provide adequate and necessary protection to public and private property and make good any damage or injury to employees or other persons, or to public or private property, which may occur by reason of the nature of, or during the execution of, the work to be done under this agreement.

15. It is further agreed that the party of the second part assumes responsibility for the correctness of all measurements, etc., heretofore made, and shall provide for himself all others which may be necessary for the execution of the work; and any work which shall be wrongfully constructed by reason of error in them shall be taken down and rebuilt as may be directed by the Superintendent of the Capitol Building and Grounds.

16. It is further agreed that the work herein contracted for must be executed in such manner as to cause no injury to the Capitol Building nor interfere with safe and convenient access thereto; and the party of the second part, must place in charge of the entire work, on the site, a permanent and competent representative during the entire time of installation, and in the absence of the party of the second part this representative shall receive and execute, as though he were the party of the second part, any orders respect-

ing the provisions of this agreement which may be issued by the Superintendent of the Capitol Building and Grounds. In the absence of both the party of the second part and the said representative orders may be given to the person, or persons, designated to represent the party of the second part.

17. It is further agreed that the party of the second part will be responsible for the maintenance of good order in the prosecution of the work to be done under this contract until it shall have been entirely completed; and the party of the second part shall, upon the demand of the Superintendent of the Capitol Building and Grounds, remove from the site any agent or employee whose work or presence is deemed by the said Superintendent to be inimical to the interests of the United Sates.

18. It is further agreed that the delivery at the site and storage of all material called for under this agreement shall at all times be subject to the direction of the Superintendent of the Capitol Building and Grounds or his authorized representative; and the location of places for the storage of material to be delivered, or for the erection of derricks, hoists, runways, or other appliances required by the party of the second part in the execution of this agreement, shall be subject to change or approval as the Superintendent of the Capitol Building and Grounds may direct.

19. It is further agreed that all rubbish which may arise from the work to be done under this agreement is to be removed by the party of the second part from time to time, or as the Superintendent of the Captiol Building and Grounds may direct; and upon the completion of this contract the party of the second part must promptly remove from the site all tools, machinery, and appliances used by him in the prosecution of the work.

20. It is further agreed that the party of the second part will comply with the requirements of law limiting the duration of work for each laborer and mechanic upon public works of the United States to eight (8) hours in any calendar day.

21. It is further agreed by the party of the second part that no person undergoing sentence of imprisonment at hard labor, imposed by a court of the United States, or of any State, Territory, or municipality, shall be employed upon the work to be done under this agreement, and no material shall be furnished hereunder which is the result of convict labor or in the manufacture and construction of which convict labor has in any way been employed.

22. It is further agreed by the party of the second part that he shall make good at his own expense any defects of material or workmanship that may arise or be discovered in the work provided for under this agreement within two years after final payment is made.

23. It is further agreed by and between the parties to this agreement that the said party of the second part shall, promptly and without delay, commence the work hereby contracted for, and shall prosecute the same with all due diligence so as to insure the completion thereof within the time limited by this contract; and it is further stipulated and agreed that in the event that the said party of the second part shall fail to commence the work promptly as herein provided, or shall fail, in the judgment of said parties of the first part, to diligently prosecute the same as hereinbefore provided, or in any way or for any cause shall fail to prosecute the same according to the specifications and requirements of this contract, then and in either case the said parties of the first part shall have the power to annul this contract by giving notice in writing to that effect to the party of the second part or his legal representative, and, upon giving of such notice, all moneys unpaid on account of this contract to the said party of the second part by the said parties of the first part shall be and become forfeited to the United States, and the parties of the first part shall thereupon be authorized to proceed to provide for the completion, construction, and erection of said marble sculptured group, wholly free and discharged from any and all obligations to the party of the second part in respect of the matters and things in this contract contemplated to be performed by the said party of the second part, with the right in the parties of the first part, on behalf of the United States, or the right on the part of the United States, to compensation from the party of the second part for such damages as may result from the failure of

the party of the second part to faithfully keep and perform this agreement.

24. And it is further stipulated and agreed by and between the said parties to this contract, that, if at any time during the prosecution of the work herein provided for, it shall be deemed by the parties of the first part advantageous or necessary, or desirable to make any change or modification in respect of the work provided for in this contract, which would involve any change in the character of the work, the quantity and quality, or labor and material, and such as would either increase or diminish the cost of the work, such change or modification may be made, but the same must be agreed upon, in writing by the parties of the first part and the party of the second part before the change is made,

25. No member of or Delegate to Congress, nor any person belonging to, or employed in, the military service of the United States, is or shall be admitted to any share or part of this contract, or to any benefit which may arise therefrom.

26. All erasures, interlineations and corrections made and noted before signing.

In Witness whereof the said parties have hereunto severally set their hands this *sixteenth* day of February, A.D. 1909.

[Bartlett's Modified Contract, 12 May 1914, Records of the Architect of the Capitol.]

No. 1 WHEREAS, by an Act of Congress approved April 16, 1908, entitled "An Act for completing the pediment of the House Wing of the Capitol," it was provided that an expenditure of seventy-five thousand dollars or so much thereof as may be necessary, be authorized, to be expended under the direction of the Speaker of the House of Representatives, the Joint Committee on the Library, and the Superintendent of the Capitol; and by subsequent legislation contained in the Sundry Civil Bill approved May 27, 1908, an appropriation of fifteen thousand dollars was made toward procuring statuary for the pediment of the House Wing of the Capitol; and subsequently on the 16th day of February 1909, the said Speaker of the

House of Representatives, the Joint Committee on the Library, and the Superintendent of the Capitol, entered into a contract with Paul Wayland Bartlett to furnish for the sum of seventy four thousand dollars the sculpture for the House wing of the Capitol, said sculpture to be completed within three years from the date of the contract, and said seventy four thousand dollars to become due and payable upon the completion, erection in place, and acceptance of said sculpture;

No. 2 AND WHEREAS, on the 25th day of July 1912, the commission for completing the Pediment of the House wing of the Capitol, consisting of the Speaker of the House of Representatives, the Joint Committee on the Library, and the Superintendent of the Capitol, acting upon the written request for an extension of time for the period of two years, made by the sculptor, Paul Wayland Bartlett the contractor under the contract of February 16, 1909, did by an instrument in writing extend the time of said contract for the period of two years, or so much thereof as might be necessary, from February 16, 1912, said date being the date of expiration of the original contract.

No. 3 AND WHEREAS, on the 10th day of April, 1914, the said Commission for completing the pediment of the House wing of the Capitol did by an instrument in writing grant to the Superintendent of the Capitol Building and Grounds (a member of said Commission) the right and authority to act for the said Commission in certain matters between said Commission and the said Paul Wayland Bartlett, and for and in behalf of the said Commission to extend the time of completion of said contract for the period of three years from the date of the expired extension, viz: February 16th, 1914, and further to so modify the payment clause of said original contract made and entered into on February 16, 1909, the same being clause twelve of said contract, so that the right would accrue to the said Superintendent of the U.S. Capitol Building and Grounds, to make partial payments to

the said Paul Wayland Bartlett, as the work progresses of furnishing sculpture for the pediment of the House wing of the Capitol; the said extension of time, and the modification of the payment clause being based upon a written request of the said Paul Wayland Bartlett, bearing date of January 25, 1914.

No. 4 NOW THEREFORE IT IS MUTUALLY AGREED between the said Superintendent of the U.S. Capitol Building and Grounds, Elliott Woods, acting for and in behalf of the Commission for completing the Pediment of the House wing of the Capitol, and Paul Wayland Bartlett, the contractor for furnishing the sculpture for the House wing of the Capitol, (the consent of the bondsmen of the said Paul Wayland Bartlett, Edwin Baldwin and Samuel C. Van Dusen being first obtained, and their concurrence in writing attached) as follows, viz:

1st. That the time for completion of the original contract is hereby extended to February 16, 1917.

2nd. That the payment clause of said original contract is hereby modified so that instead of the entire contract sum, $74,000.00 being made payable on the completion, erection and acceptance of said sculpture, that the following method may be followed. At such periods of time as may be deemed just and proper, the said Superintendent will cause an estimate to be made as to the value of the work actually done and put in place at the date of the estimate. Thereupon the Superintendent will issue a payment voucher equivalent to 90 per cent of the amount of the estimate. Such method of approximate partial payments will be continued during the progress of the work and until the completion thereof, after which the payment of the retained 10 per cent will be made in the discretion of the Superintendent.

In testimony whereof we have hereunto set our hands and seals at Washington, D.C., this twelfth day of May, one thousand nine hundred and fourteen.

Notes

Chapter 1. Prelude to a Commission, 1851–1908

1. Glenn Brown, *History of the United States Capitol*, 2 vols. (Washington, D.C.: U.S. Government Printing Office, 1900–1903), 2:120. For a discussion of the presumed location of this cornerstone, see Charles E. Fairman, *Art and Artists of the Capitol of the United States of America* (Washington, D.C.: U.S. Government Printing Office, 1927), 129 n. 1. For the 1851 cornerstone ceremony, see Duncan S. Walker, ed., *Celebration of the One Hundredth Anniversary of the Laying of the Corner Stone of the Capitol of the United States, with Accounts of the Laying of the Original Corner Stone, in 1793, and the Corner Stone of the Extension, in 1851* (Washington, D.C.: U.S. Government Printing Office, 1896); and Frederick D. Schwengel, "The Masons and the Capitol of the United States," *New Age* 73 (March 1965): 40.

2. The Architects of the Capitol and their respective tenures are as follows: William Thornton (1759–1828), 1793–94; Benjamin Henry Latrobe (1764–1820), 1803–11, 1815–17; Charles Bulfinch (1763–1844), 1818–29; Thomas Ustick Walter (1804–87), 1851–65; Edward Clark (1822–1902), 1865–1902; Elliott Woods (1865–1923), 1902–23; David Lynn (1873–1961), 1923–54; J. George Stewart (1890–1970), 1954–70; George Malcolm White (b. 1920), 1971–present.

3. Brown, *United States Capitol*, 2:119. See also Architect of the Capitol, "Report of the Architect of the Capitol on the Extension of the East Front of the United States Capitol" (Office of the Architect of the Capitol, Washington, D.C., 1966), 30.

4. For a detailed description of Walter's plans, see Brown, *United States Capitol*, 2:119–20.

5. As an engineer/architect, Captain Meigs made significant contributions to the architecture of Washington, D.C. Besides his responsibilities in connection with the Capitol Extension, he supervised the building of the Washington Aqueduct System and designed the Pension Office Building, 1882–86. For more information on Meigs, see Adolf K. Placzek, ed., *Macmillan Encyclopedia of Architects*, 4 vols. (New York: The Free Press, 1982), 3:154; and Russel F. Weigley, *Quartermaster General of the Union Army, A Biography of M. C. Meigs* (New York: Columbia University Press, 1959). For a discussion of the controversy surrounding the transfer of control over construction of the Capitol Extension from civilian to military authority, see Lillian B. Miller, *Patrons and Patriotism, The Encouragement of the Fine Arts in the United States 1790–1860* (Chicago: The University of Chicago Press, 1966), 68–69.

6. Brown, *United States Capitol*, 2:126–27.

7. Ibid., 2:124–27.

8. MCM to Edward Everett, 7 July 1853, copy, Records of the Architect of the Capitol (hereafter cited as R.A.C.).

9. Miller, *Patrons and Patriotism*, 71.

10. Edward Everett to MCM, 12 July 1853, R.A.C.

11. MCM to Hiram Powers, 18 August 1853, R.A.C. (Published in Fairman, *Art and Artists*, 143.) In each letter Meigs enclosed a small engraved view of the entire building representing "the Entablature of the Porticos as crowned with a horizontal balustrade;"

but, Meigs explained, "I propose to substitute a Pediment as more beautiful and affording in its tympanum space for sculpture." Meigs also enclosed a tracing of the pediment over the eastern portico as well as "a tracing of a group designed by [Karl Frederick] Schinkel [1781–1841] for some European Building." Apparently, Powers never received his set of tracings. See Hiram Powers to MCM, 22 September 1853, R.A.C. (Published in Fairman, *Art and Artists*, 144.)

12. Fairman, *Art and Artists*, 143; MCM to TC, 23 August 1853, R.A.C.; MCM to TC, 29 November 1853, R.A.C.

13. MCM to TC, 30 November 1853, R.A.C. For more information on Crawford's pediment, see Vivien Green Fryd, *Art & Empire: The Politics of Ethnicity in the United States Capitol, 1815–1860* (New Haven and London: Yale University Press, 1992), 109–24.

14. Hiram Powers to MCM, 22 September 1853, R.A.C. See also Fairman, *Art and Artists*, 144.

15. See Fairman, *Art and Artists*, 215–16; and Sylvia E. Crane, *White Silence: Greenough, Powers, and Crawford; American Sculptors in Nineteenth-Century Italy* (Coral Gables, Fla.: University of Miami Press, 1972), 358–59. Reporting to Davis in July 1855, on the status of sculpture at the Capitol, Meigs wrote:

Surely no objection can be made by Mr. Powers or by his friends to the request that he would submit designs and estimates for the approval of the President in so great and important a work. It would not be proper to request any artist to fill a pediment with sculpture leaving to him the design and the price without any understanding in regard to it before the execution of the work. No individual, no country is rich enough to give such an order.
(MCM to Jefferson Davis, 27 July 1855, R.A.C. [Published in Fairman, *Art and Artists*, 158].)

16. Vivien Green Fryd, "Hiram Powers' *America*: 'Triumphant as Liberty and in Unity,'" *American Art Journal* 18 (Summer 1986): 67.

17. Crane, *White Silence*, 359.

18. Peter Fusco and H. W. Janson, eds., *The Romantics to Rodin* (Los Angeles: Los Angeles County Museum of Art, 1980), 250–51.

19. "Notes and Clippings," *American Architect and Building News* 23 (4 February 1888): 60.

20. Jefferson Davis to E. Etex [Antoine Etex], 10 August 1855, copy, R.A.C. The Records of the Architect of the Capitol also contain a rough draft of this letter by Meigs dated 6 August 1855 to which editorial changes and additions have been made by Davis.

21. Crane, *White Silence*, 364.

22. TC to MCM, 17 January 1854, R.A.C. See also Fairman, *Art and Artists*, 145. Meigs's specific remarks were as follows:

I shall expect to call on you for many things as they arrive, but I do not feel at liberty yet to recommend to the President to give you a second commission of this magnitude. . . . Yourself and Mr. Powers were selected from your known reputations, and I think that as he declines, the second should be left open for a while. . . .

When you complete or are well-advanced upon the present work, it will be time to consider the other, and if no other artist by evidence of work accomplished achieves the reputation giving him the right to share in the embellishment of the Capitol, the commission will not fail to be awarded to you as the worthiest. I am not insensible to the advantage of having the unity and harmony of design resulting from one mind directing the whole of these works, but I think that if we have the artists, they should share in the glory. (MCM to TC, 4 April 1854, R.A.C. [Published in Crane, *White Silence*, 366].) In reply to Meigs's letter, Crawford wrote:

I leave the affair to take whatever course your guidance may direct, hoping however that no *drawing* will be received, and that the sketches in the round will be required, or photographs from them. This is the only practical way of deciding the matter. Therefore, if we have the artists, by all means, "let them share the glory." (TC to MCM, 15 May 1854, copy, R.A.C.)

23. MCM to Jefferson Davis, 27 July 1855, R.A.C. (Published in Fairman, *Art and Artists*, 158.)

24. See Samuel Yorke Atlea to MCM, 10 January 1854, R.A.C. See also Fairman, *Art and Artists*, 158.

25. On 3 March 1855, Congress passed an act appropriating a sum not to exceed $25,000 enabling the president to contract with Powers for a work of art suitable to decorate the Capitol. But the appropriation did not identify a specific work to be commissioned, and, in any case, Powers would have preferred that the government use the funds to purchase a marble version of *America*. Not until 1859 was Powers eventually commissioned to do two life-size portrait statues to be placed in the Capitol Building, one of *Benjamin Franklin*, and the other of *Thomas Jefferson*. See Fryd, "Hiram Powers' *America*," 67, 74 n. 52, 53. See also Miller, *Patrons and Patriotism*, 253–54 n. 26.

26. Meigs's annual report dated 14 October 1855 states the following in reference to the sculpture for the Senate pediment:

The original models of several of the figures designed by Mr. Crawford for the eastern pediment have been received and workmen are now engaged in carving in marble the figures of the mechanic and the groups of Commerce and Instruction. . . . We have received the models of the mechanic, the groups of Instruction, Youth, Commerce, and War. I am informed by Mr. Crawford that he has completed the models of America for the center of the pediment and the figures of the woodman and Indian boy and is now engaged upon that of the Indian.
(Published in Fairman, *Art and Artists*, 159.)

27. For an account of Brown's years in Italy, see Wayne Craven, "Henry Kirke Brown in Italy, 1842–1846," *American Art Journal* 1 (1969): 65–77. For Brown's commitment to a distinctly American art form, see Wayne Craven, "Henry Kirke Brown: His Search for an American Art in the 1840's," *American Art Journal* 4 (1972): 44–58; and Michael Edward Shapiro, *Bronze Casting and American Sculpture 1850–1900* (Newark: University of Delaware Press, 1985), 44–50.

28. Craven, "Search for an American Art," 54–55.

29. HKB to Mrs. HKB, 7 November 1855, Henry Kirke Bush-Brown Papers, Manuscripts Division, Library of Congress (hereafter cited as Brown Papers).

30. MCM to Jefferson Davis, 20 March 1856. (Published in Fairman, *Art and Artists*, 192.)

31. HKB to Mrs. HKB, 7 November 1855, Brown Papers.

32. HKB to MCM, 7 December 1855, R.A.C. Brown also thanked Meigs for his recent letter enclosing tracings of the Capitol door as well as the keystones for the Post Office Building then under construction. Regarding the keystones, Brown replied:

I like your idea of those Masks [to decorate the keystones] very much. They will offer a fine opportunity for expression and it seems to me they are very appropriate subjects for the keystones. I should be willing to model them for three hundred dollars each, which is my price for a life sized Bust, and the castings in Bronze will not be expensive. I do not however like to set a price for the Founder, but should you see fit to have them executed by my Founder I will see that they do not cost you more than a fair price.

33. HKB to MCM, 15 December 1855, R.A.C.

34. In mythological terms both figures represent the "Suffering Hero." Other ancient examples of this type include the Hellenistic *Seated Boxer*, mid-first century, B.C., Rome, Museo delle Terme, and *Fallen Warrior* from the east pediment of the Temple of Aphaia at Aegina, ca. 490 B.C., Munich, Glyptothek.

35. William Morris Davis to HKB, 9 May 1855, Brown Papers.

36. Notes, HKB, undated, Brown Papers. See also Fryd, *Art & Empire*, 202–3. Brown recorded Meigs's initial response to his design as follows:

The Capt[ain] on looking at my design . . . placed his finger on the figure of the slave. I felt its significance at once and saw that my hope of introducing him into the composition was vain. After long and careful looking he said: "I do not think it would do to represent a slave in the pediment, it is a sore subject and upon which there is a good deal of feeling and I think no southerner would consent to it"—but I interposed that it is an institution of the country. How else can it be represented? He said the South talked of it as the greatest blessing both for slave and master, but they did not like to have it alluded to, and I was advised to avoid so fruitful a subject of contention, and yet he could not see how else the south could be represented.

37. Wayne Craven, "H. K. Brown and the Black Man in the Pediments" (Paper delivered at the annual Meeting of the College Art Association, Chicago, February 1976), 11.

38. Ibid., 18.

39. Ibid., 14.

40. William Morris Davis to HKB, "Heroism in Art," Brown Papers, 5:1370. (Quoted in Craven, "Black Man," 16.)

41. HKB to MCM, 21 January 1856, R.A.C. Still hoping to offer a design for the Capitol door, Brown also asked Meigs whether or not the door in question was to have reliefs on both sides.

42. HKB to William Morris Davis, 27 January 1856, Brown Papers. Brown wrote:

I attached no blame to him [Meigs], but could not fail to see what restraint rests upon all who desire success in our governmental affairs. They have to skulk and dodge in many ways, which must be repulsive to them. The friends of slavery and their opponents are more numerically even now than formerly and we trust that the day is not far distant when the gag may be taken from the mouths of all men, and that without outrage we may put these outrageous habits by, as worn out garments.

43. For Brown's association with Ames, see Shapiro, *Bronze Casting*, 50–60.

44. HKB to MCM, 12 February 1856, R.A.C. (Published in Fairman, *Art and Artists*, 191–92.)

45. Ibid.

46. For more information on related themes in mid-nineteenth-century American genre and history painting, see Linda S. Ferber, "Themes in American Genre Painting: 1840–80," *Apollo* 115 (April 1982): 250–59; William H. Truettner, "The Art of History: American Exploration and Discovery Scenes, 1840–1860," *American Art Journal* 14 (Winter 1982): 4–31; and William H. Truettner, ed., *The West as America: Reinterpreting Images of the Frontier, 1820–1920* (Washington, D.C.: Smithsonian Institution Press, 1991).

47. Fairman, *Art and Artists*, 160–61.

48. Fairman, *Art and Artists*, 161. For illustrations of the entire fresco cycle, see The Architect of the Capitol, *Art in the United States Capitol* (Washington, D.C.: U.S. Government Printing Office, 1976), 314–17.

49. HKB to Mrs. HKB, 7 November 1855, Brown Papers; Annual Report, MCM to Jefferson Davis, 14 October 1855, R.A.C. (Published in Fairman, *Art and Artists*, 159.)

50. For a contemporary account of the life of Israel Putnam, see William Cutter, *The Life of Israel Putnam* (New York, 1850; reprint, Port Washington, N.Y. and London: Kennikat Press, 1970).

51. "The Capitol Extension," *The Crayon*, October 1856, 311. The writer continued:

This profession [designing bank notes] demands a knowledge of every description of material agency and implement used in the country. Its designer is acquainted with, and draws every object that has reference to the sea or the land, to commerce, to agriculture, or to manufacture. He is thoroughly acquainted with the ship

on the stocks or afloat; he knows "the plow, the loom, and the anvil,"—the factory, canal, and railroad; he knows the farmer and the planter. . . . Familiarity with the implements of labor, as well as the character of the farmers, mechanics, etc., who use them; also the occupations and interests which the people in general are devoted to, renders the artist who has studied such material, the most suitable man of the time to make designs for the decoration of a national building.

52. The standard paper money reference is Grover C. Criswell, Jr., *North American Currency* (Iola, Wis.: Krause Publications, 1965). See also James A. Haxby, *Standard Catalog of United States Obsolete Bank Notes 1782–1866* (Iola, Wis.: Krause Publications, 1988).

53. MCM to Jefferson Davis, 20 March 1856, R.A.C. (Published in Fairman, *Art and Artists*, 192.) Meigs's recommendation to Davis to reject Brown's design read as follows:

I regret to say that I do not think it is of such pre-eminent merit that I can advise its execution in marble, but in fulfillment of the promise made to Mr. Brown I respectfully submit it to you and ask your instructions as to the answer to be given to his letter.

54. HKB to Brownley Brown, March 1856, Brown Papers.

55. A similar problem with creating imagery that was both uniquely American and sufficiently monumental in character is reflected in notable nineteenth-century American history paintings such as Charles Willson Peale's *The Exhumation of the Mastodon*, 1806, and George Caleb Bingham's *The Emigration of Daniel Boone*, 1857. See Lillian B. Miller, "Charles Willson Peale as History Painter: *The Exhumation of the Mastodon*," *American Art Journal* 13 (Winter 1981): 47–68.

56. MCM to TC, 2 May 1856. (Quoted in Robert L. Gale. *Thomas Crawford* [University of Pittsburgh Press, 1964], 224 n. 277.) Meigs framed his request as follows:

I have received lately a design for the second pediment which I have not been able to recommend for adoption. I think it is time to begin the work on this pediment and without being able to promise that it will be adopted, should be pleased to receive from you a sketch for it.

57. TC to MCM, 23 July 1856, R.A.C.

58. Ball's remarks were delivered in Congress on 26 March 1856. (Quoted in Fairman, *Art and Artists*, 165.)

59. TC to Louisa Crawford, 16 August 1856. (Quoted in Gale, *Crawford*, 165.)

60. On 17 September 1856, Crawford wrote Meigs:

I shall not hesitate to occupy myself with a design for the 2d Pediment without reference to the acceptance by the President but simply for the purpose of showing what I think might be done for such a place.
(TC to MCM, 17 September 1856, R.A.C.)

61. Gale, *Crawford*, 172.

62. In early April 1857, Captain Meigs wrote the ailing sculptor:

I have read with great concern the accounts which have appeared from time to time in the newspapers of the severe attacks under which you are laboring. I hope that you will be able to resume your labor in the world of art at an early period, but if the affliction of the eye should make that impossible, I at least rejoice that you have had health and strength to complete for the Capitol so great a work as no other American sculptor has yet ever attempted. When the complete set of statues for the pediment are once in their places, I believe that we will have in the United States one work that is worthy [of] the strength and wealth of this young but vigorous republic.
(MCM to TC, 10 April 1857. [Quoted in Gale, *Crawford*, 183].)

63. James Clinton Hooker to MCM, 22 August 1857, R.A.C.

64. After Crawford's death, his wife assumed responsibility for seeing that his most important projects were completed including his works at the Capitol. The dome figure, *Armed Freedom*, was shipped to America in April 1858 and cast by Clark Mills (1815–83);

it was erected on 2 December 1863. The figures of *Justice* and *History* were carved in Rome and arrived in Washington during the winter of 1859. The last figure for the Senate pediment, the colossal figure of *America*, was completed in marble in 1860; the entire pediment was installed by the fall of 1863. The plaster models for the bronze doors of the Senate and House wings were completed in Rome by William Henry Rinehart (1825–74) and shipped to the United States. Those for the Senate wing were cast by the Ames Foundry, Chicopee, Massachusetts, and set in place in 1868; the doors for the House wing were not cast until 1904—also at Chicopee—and were installed the following year. See Crane, *White Silence*, 402–7.

65. J. Carson Webster, *Erastus D. Palmer* (Newark: University of Delaware Press, 1983), 20.

66. In February 1857, a writer for *The Crayon* announced that Palmer was one of several artists who had "received invitations, directly or indirectly," to furnish a design for the east pediment of the Capitol Extension in Washington. However, the writer went on to explain, Palmer had so far declined to prepare a design for the proposed work because he preferred not to enter into a competition. See "Competition in Art," *The Crayon* (February 1857): 56. Webster believes that Palmer was invited to submit a design. See Webster, *Palmer*, 28. Fairman states the following:

It seems, although the facts have not been fully proved by the records and correspondence examined, that through a personal conference with Mr. Palmer some promise had been held out to him of the possiblity of the acceptance of his works for the remaining pediment.
(Fairman, *Art and Artists*, 193.)

67. Hamilton Fish to MCM, 10 April 1857, R.A.C. Edwin B. Morgan to MCM, 13 April 1857, R.A.C. (Published in Fairman, *Art and Artists*, 193.) In his letter, Morgan wrote:

A friend well qualified to judge who visited Palmer's studio a few days since, informs me that he never saw a man who more truly appeared inspired. His whole soul is in the work scarcely leaving it day or night.

68. "Palmer's Landing of the Pilgrims," *Albany Evening Journal*, 10 April 1857. (Reprinted in Fairman, *Art and Artists*, 193, 195.)

69. MCM to EDP, 28 April 1857, R.A.C. (See Appendix.)

70. "Exhibitions," *The Crayon* 5 (April 1858): 115. See also Webster, *Palmer*, 156.

71. Webster states that Mather must have gotten the names of the figures and their respective virtues from Palmer. Webster also provides more information on Mather's article and its relationship to Palmer's design. See Webster, *Palmer*, 155–56.

72. Joseph Willson to MCM, 16 May 1857, copy, R.A.C.

73. Ibid. On 19 May 1857, Meigs wrote Willson:

Mr. Palmer's design for the Pediment is not free from the objection about which you make that it is in a measure local in character. At the same time of all single events in the history of the country except the Declaration of Independence it probably is the one which has most extensively influenced that history in its results. Mr. Palmer is now engaged in working out in the round a small sized design for the pediment somewhat modified from the sketch which you now described. The final decision upon this matter is likely to be made by the President. Any designs that may be sent to me which I may think worthy of presentation to the President will be carefully considered but I cannot take the responsibility of making one contract not well established by reputation.
(MCM to Joseph Willson, 19 May 1857, R.A.C.)

74. For the notion that the sectional nature of Palmer's design figured significantly in its rejection, see Webster, *Palmer*, 28, 155; Fairman, *Art and Artists*, 197; Lorado Taft, *The History of American Sculpture*, new and rev. ed. (New York: The Macmillan Company, 1924), 36; and "Old Paper Reveals North-South Jealousy Delayed Capitol Sculpture for 70 Years," *Washington Post*, 6 February 1939.

75. Palmer's figures seem to be based on the kneeling warriors from the east and west pediments of the Temple of Aphaia at Aegina, ca. 490 B.C. See Furtwängler's reconstructions of the two pediments in Gisela M. A. Richter, *The Sculpture and Sculptors of*

the Greeks, 4th ed., new and rev. (New Haven and London: Yale University Press, 1970), figs. 415 and 416.

76. For a recent discussion of this tradition, see Vivien Green Fryd, "Two Sculptures for the Capitol: Horatio Greenough's *Rescue* and Luigi Persico's *Discovery of America*," *American Art Journal* 19 (Spring 1987): 16–39.

77. There is no record of when the photographs of Palmer's modified design actually were submitted to Meigs, but based on the captain's letter to Joseph Willson written on 19 May 1857, it is probably safe to assume that the photographs arrived in Washington that June or July. In June 1857, a notice in *The Crayon* announced that Palmer had won the pedimental commission. The statement had no basis in fact, however, and could have been inspired simply by the recent submission of Palmer's design to Washington. See *The Crayon* 4 (June 1857): 186. Webster states that Palmer or the editor for *The Crayon* may have mistaken the order for the model as the commission. See Webster, *Palmer*, 156.

78. Buchanan was inaugurated on 4 March 1857; the established date for the official ceremony was not moved up to 20 January until Franklin Delano Roosevelt's first inauguration in 1933.

79. For more on Meigs's involvement in this conflict, see I. T. Frary, *They Built the Capitol* (Richmond, Va.: Garrett and Massie, Inc., 1940), 187; and Miller, *Patrons and Patriotism*, 68–69.

80. Miller, *Patrons and Patriotism*, 69. See also Weigley, *Quartermaster General*, 78–79.

81. MCM to John B. Floyd, 11 July 1857, R.A.C.

82. Thomas W. Olcott to MCM, 26 August 1857, R.A.C. The four letters delivered to Buchanan are also located in the Office of the Architect of the Capitol; they were written by Olcott, Governor Seymour, and two other prominent New Yorkers, Senator Dickinson and Judge Greene C. Bronson. Fairman published the letters of Olcott, Seymour, and Bronson. See Fairman, *Art and Artists*, 195–96. On the cover of Olcott's letter to Meigs, Meigs wrote, "Enclosures sent to Sec[retary] of War 28th Aug[ust]." Buchanan's referral of the four letters back to the War Department is noted on the cover of Olcott's letter to the president.

83. Palmer had gone to Washington to lobby on his own behalf concerning the commission, and, upon his return to Albany, he received the following notification from a clerk in the War Department:

On returning from Cabinet Meeting today the Secretary of War directed me to inform you that your matter was before Cabinet, and it was decided to examine the law closely and if it did not specifically authorize the purchase of *ornaments* such as you propose (if, indeed, they are regarded by law as ornaments) that nothing could be done until the meeting of Congress.
(Quoted by Palmer in a letter to Meigs, 12 November 1857, R.A.C.)

84. EDP to MCM, 12 November 1857, R.A.C. (Published with some errors in Fairman, *Art and Artists*, 196–97.) ; Order, 17 November 1857, R.A.C. The order is signed by Meigs and acknowledged by Palmer. Webster gives an incorrect date of 14 November 1857 for the order. See Webster, *Palmer*, 155. A month after receiving his payment, Palmer would still confide to Morgan, "I had decided to make no further effort to secure the commission, but at the same time, shall be ready and glad to execute the work if by any means it may be required of me." (EDP to Edwin B. Morgan, 14 December 1857, Wells College Library, Aurora, New York. [Published in Webster, *Palmer*, 276–77].)

85. James G. Wilson and John Fiske, eds., *Appleton's Cyclopaedia of American Biography*, 7 vols. (New York: Appleton and Co., 1888), 4:637–38. See also "Old Paper Reveals North-South Jealousy," previously cited.

86. G. W. Sewell to MCM, 11 February 1858, R.A.C.

87. Wayne Craven, *Sculpture in America*, new and rev. ed. (Newark: University of Delaware Press, 1984), 179, 200–203.

88. TDJ to Lewis Cass, 22 October 1857, copy, R.A.C.; Lewis Cass to MCM, 28 October 1857, copy, R.A.C.

89. TDJ to MCM, 17 November 1857, copy, R.A.C.

90. Craven, *Sculpture in America*, 192–96. For a more extensive treatment of Dexter's life and work, see John Albee, *Henry Dexter, Sculptor* (Cambridge, Massachusetts, 1898).

91. HD to MCM, 24 February 1859, R.A.C.; HD to MCM, 4 November 1858, R.A.C.

92. HD to MCM, 13 January 1859, R.A.C. Regarding his models, Dexter wrote:

I wish now to say, I shall have the models for the Pediment design heretofore refered [*sic*] to, completed and photographed and ready to forward to Washington in about ten days: and I wish to ask you the favor to inform me, as early as convenient, to whom I shall consign them in Washington, that they may receive attention.

93. HD to MCM, 10 February 1859, R.A.C.

94. HD to MCM, 24 February 1859, R.A.C.

95. HD to MCM, 16 March 1859, R.A.C. Some of Dexter's remarks read as follows:

That I may not loose [*sic*] an opportunity, in presenting my design for the pediment . . . I very much desire you would inform me what the prospect is of the work going forward . . . I do not know to whom I can write, or through whom the work can be accomplished other than yourself. . . . At the time I was in W[ashington] and since my return, I have seen many Washington people, and I have not heard a single reason . . . why you should not exercise the same control as you have done heretofore.

96. Francis S. Grabar, *William Randolph Barbee & Herbert Barbee, Two Virginia Sculptors Rediscovered*, exh. cat. (Washington, D.C.: George Washington University, The Dimock Gallery, 1977), 3.

97. John B. Blake to William Pennington, 15 February 1860, R.A.C. See also "Barbee, The Sculptor," *Intelligencer*, 26 December 1859. (Quoted in Grabar, *Virginia Sculptors*, 4.) A note from Meigs to Barbee dated 20 January 1859 refuses the sculptor's request to have his stone-cutting tools repaired at the Capitol Extension shops because "the regulations prohibit the doing of any private work in a government shop." See MCM to WRB, 20 January 1859, R.A.C. Meigs's note places Barbee at the Capitol early in 1859 but clearly precludes an official commission for the sculptor.

98. Herbert Barbee to David Lynn, Architect of the Capitol, 21 October 1977, R.A.C. See also Mrs. Henry Dockery Brown, Jr. to Mario E. Campiolo, Acting Architect of the Capitol, 1 November 1970, R.A.C. Referring to her own research on Barbee, Mrs. Brown wrote:

He was a sculptor and the unconfirmed tradition (appearing many times in print) is that he was commissioned to help finish the work on our National Capitol. This commission was supposedly issued in the year 1859/60 and he was assigned a studio in the basement of the Capitol Bldg. . . . Barbee continued at his work until the outbreak of the Civil War where he was given so many hours to get through the lines—he was a Virginian & therefore a "rebel." He fled to his home near Sperryville, Va., where he died a few years later of cancer. He never resumed the work in Washington.

99. I am indebted to Professor Francis S. Grabar of George Washington University for this suggestion.

100. The letter was published in the *Page News and Courrier* (Luray, Virginia), 28 October 1927. It had been made known to the paper by its then owner, Nena Barbee Lane, of South Wilton, Connecticut. A photocopy of the article is in the Records of the Architect of the Capitol.

101. James Dabney McCabe [Edwar Winslow Martin, pseud.], *Behind the Scenes in Washington* (New York: The Continental Publishing Company, and National Publishing Co., 1873), 93. One would like to know where McCabe got his information, since his book was published five years after Barbee's death. See also Charles E. Fairman, Acting Architect of the Capitol, to Herbert Barbee, 22 Ocobert 1927, R.A.C.

102. Herbert Barbee to David Lynn and Charles Fairman, 24 October 1927, R.A.C. Referring to his father's work at the Capitol, Herbert Barbee wrote:

My father's designs for the pediment—"Discovery of America by Columbus"—was most fitting & appropriate & told the story faithfully & gracefully, & I would love to see the plan fully carried out—which I would do with pleasure if commissioned—since I still have his original designs.

103. Fairman, *Art and Artists*, 70, 162–64.

104. Ibid., 162–64. See also Andrew J. Cosentino and Henry H. Glassie, *The Capitol Image, Painters in Washington, 1800–1915* (Washington, D.C.: Smithsonian Institution Press, 1983), 78–80.

105. For the text of the memorandum, see "Documentary History of Art Commissions 1858–1911" (Compiled for the Office of the Superintendent of the U.S. Capitol), 733, R.A.C.

106. The act is published in Fairman, *Art and Artists*, 179.

107. For Buchanan's official statement making the appointment, see Fairman, *Art and Artists*, 187. Not everyone in Washington felt that the art commission would improve the situation or that it was even feasible. President Buchanan may have shared these misgivings; in any case, he delayed appointing the committee for nearly a year. In March 1859, however, the matter once again came before Congress. Back in June 1858, the original memorial from the Washington Art Association had been referred to a select committee of five Congressmen who were appointed by the Speaker of the House "with instructions to report on the expediency of granting the petition." On 3 March 1859 the committee, after deliberate and thoughtful study, presented an extremely favorable report regarding the artists' request. The report, which undoubtedly helped to precipitate the president's action in this matter, reads in part as follows:

The erection and embellishment of the nation's Capitol affords the opportunity for Congress to encourage American art and to develop American genius in the department of art. At the risk of unfriendly criticism, this committee ventures the suggestion that the field of competition should be confined to citizens of the United States, because art, to be living, must be projected from the life of a people; to be appreciated, it must be familiar, must partake of the nature and habits of the people for whom it is intended, and must reflect their life, history, hopes, and aspirations. The committee regret to be compelled to observe the deficiency in this particular, so far as the decorative work in the Capitol extension has progressed. . . . At all events, enough has been said to prove that there is a propriety in changing the present system and of establishing a new mode of conducting the work. The committee are of the opinion that, in the adoption of such new mode, the establishment of an Art Commission which shall suggest a general plan of decoration and embellishment is the first step to be taken.
(*American Artists, H. R. Report No. 198*, 35th Congress, 2d sess., 3 March 1859, compiled in "Documentary History of Art Commissions 1858–1911," 732.)

108. MCM to Randolph Rogers, 23 July 1859. (Quoted in Fairman, *Art and Artists*, 185–86.)

109. On 20 September 1860, Meigs was relieved of his duties related to the Aqueduct and sent to Florida where he was given charge over the construction of Fort Jefferson. With the eventual resignation of Floyd from Buchanan's cabinet on 29 December 1860, and the subsequent appointment of Joseph Holt, of Kentucky, as the new secretary of war, Meigs was brought back to Washington and reinstated as superintendent in charge of the Aqueduct and, ultimately, the Capitol, on 13 and 20 February 1861. See Weigley, *Quartermaster General*, 94–112, 126–30.

110. "Report of the United States Art Commission," 22 February 1860, compiled in "Documentary History of Art Commissions 1858–1911," 747–48.

111. "Documentary History of Art Commissions 1858–1911," 749. See also Fairman, *Art and Artists*, 189.

112. *Congressional Globe*, 36th Congress, 1st sess., 3199. (Quoted in Fairman, *Art and Artists*, 189.)

113. Quoted in Fairman, *Art and Artists*, 201.

114. 16 April 1862, *Stats. L.*, 12:617. (Quoted in Fairman, *Art and Artists*, 208.)

115. Brown, *United States Capitol*, 2:137. See also Frary, *They Built the Capitol*, 304.

116. Fairman, *Art and Artists*, 175, 201, 219, 222. See also Frary, *They Built the Capitol*, 220, 304; and Craven *Sculpture in America*, 173. For biographical information on Clark Mills, see Craven, *Sculpture in America*, 166–74; Anna Wells Rutledge, "Cogdell and Mills, Charleston Sculptors," *Antiques Magazine* 41 (March 1942): 192–93, 205–7; and Shapiro, *Bronze Casting*, 34–44.

117. Fairman, *Art and Artists*, 243–44. After Walter's retirement, President Andrew Johnson appointed Clark as the fifth architect of the Capitol. He held the position until his death on 6 January

1902. See Architect of the Capitol, "Report on the Extension of the East Front of the Capitol," 47.

118. *Joint Resolution*, 41st Cong., 2d sess., H.R. 89, 16 December 1869.

119. Webster, *Palmer*, 25. For biographical information on Thompson, see Craven, *Sculpture in America*, 237–40.

120. EC to Captain F. C. Adams, 7 February 1870, R.A.C. Clark concluded his letter to Adams with the following advice for Thompson: "The sculptor will be at liberty to choose his own subject, but the general arrangement should be similar to the groups of the North Pediment."

121. EC to LT, 16 April 1870, copy, R.A.C. (Published in Fairman, *Art and Artists*, 295.)

122. LT to EC, 25 April 1870, R.A.C.

123. For Roosevelt's involvement with the arts, see Glenn Brown, *1860–1930, Memories: A Winning Crusade to Revive George Washington's Vision of a Capital City* (Washington, D.C.: Press of W. F. Roberts Company, 1931), 138–77.

124. Smithsonian Institution, *The Federal City: Plans & Realities* (Washington, D.C.: Smithsonian Institution Press, 1981), 32. For more general background on the development of Washington, D.C. at the turn of the century, see Dennis Robert Montagna, "Henry Merwin Shrady's Ulysses S. Grant Memorial in Washington, D.C.: A Study in Iconography, Content and Patronage" (Ph.D. diss., University of Delaware, 1987).

125. Joint Commission, *Extension and Completion of the Capitol Building*, 58th Cong., 3d sess., 1905, H. Doc. 385, 5–6. See also Architect of the Capitol, "Report on the Extension of the East Front of the Capitol," 55–56.

126. Architect of the Capitol, "Report on the Extension of the East Front of the Capitol," 56; Joint Commission, *Extension and Completion of the Capitol*, 1. After the death of Edward Clark in January 1902, Elliott Woods, who had served for seventeen years as Clark's chief clerk, assumed the duties of the architect of the Capitol. Woods received his appointment from President Theodore Roosevelt and held the position until his death in 1923. See Architect of the Capitol, "Report on the Extension of the East Front of the Capitol," 49.

127. Joint Commission, *Extension and Completion of the Capitol*, 1–2. The other members of the commission were Senators Russell A. Alger of Michigan, and Arthur P. Gorman of Maryland, and Representatives Joseph G. Cannon of Illinois, William P. Hepburn of Iowa, and James D. Richardson of Tennessee.

128. They further recommended the addition of a column on each side of the central pediment, thereby broadening the pediment so that it would dominate those of the two side wings. In their initial report to the commission dated 27 December 1904, Carrère and Hastings also presented a second scheme for the extension of the central east portico more in line with Walter's original plans; this second scheme called for an extension of thirty-two feet six inches and would have provided additional interior accommodations. See Joint Commission, *Extension and Completion of the Capitol*, 6–7.

129. Joint Commission, *Extension and Completion of the Capitol*, 8–9.

130. Ibid., 3.

131. For further information on Niehaus, see Craven, *Sculpture in America*, 450–55; Regina Armstrong, *The Sculpture of Charles Henry Niehaus* (New York: De Vinne Press, 1901) ; and "Charles Henry Niehaus, American Sculptor," *International Studio* 29 (1906): 104–11.

132. CHN to EW, 16 December 1907, 16 March 1904, and 12 December 1904, R.A.C.

133. For further information on Borglum, see Craven, *Sculpture in America*, 488–92; Gutzon Borglum, "Art that is Real and American," *World's Work* 28 (1914): 200–217; and Robert J. Casey and Mary Borglum, *Give the Man Room: The Story of Gutzon Borglum* (Indianapolis, Ind.: Bobbs-Merrill, 1952).

134. See G. L. Heins to EW, 2 September 1904, and EW to Auguste Rodin, 3 October 1904, copy, R.A.C.

135. GB to EW, 13 January 1905, R.A.C.; Note, GB to EW, undated, R.A.C.

136. GB to EW, 25 January 1905, R.A.C.

137. Ibid. Borglum gave a breakdown of his figures as follows:

For the sculptor's work $60,000.00

The marble and the cutting of the figures in the marble $34,000.00

Placing groups in pediment,
scaffolding, hoisting,
machinery, and preparing
pediment for sculptor $10,000.00

I have no precise way of determining the cost of this last item, but I believe I am considerably below what I should spend in delivering and placing the work. I must also prepare to have some of the large blocks let into the wall at the back, in order to protect the overhanging cornice against the great strain that would otherwise be placed upon it.

138. CHN to EW, 23 January 1905, R.A.C.
139. Typewritten manuscript, CHN to EW, undated, R.A.C. (For Niehaus's descriptions of *The Mother Republic* and *The Flight of the Eagle*, see Appendix.)
140. CHN to EW, 13 December 1907, R.A.C.
141. EW to CHN, 14 December 1907, R.A.C.; CHN to EW, 16 December 1907, R.A.C. Niehaus concluded this letter with an expression of his desire to win the commission:

The execution of this work by me would be the realization of one of my most cherished ambitions, for ever since your predecessor, Mr. Clarke [*sic*], asked me to make the designs which I subsequently made for you, I have steadily indulged the hope of some day blending my art with the architectural beauty of the Nation's Capitol.

142. In an act approved by Congress on 10 June 1872 jurisdiction over all works of art intended for the Capitol had been invested in the Joint Committee on the Library. The relevant provision reads as follows:

The Joint Committee on the Library, whenever, in their judgment, it is expedient, are authorized to accept any work of the fine arts, on behalf of Congress, which may be offered, and to assign the same such place in the Capitol as they may deem suitable, and shall have the supervision of all works of art that may be placed in the Capitol.
(See *Revised Statutes*, Section 1831 [40 U.S.C. 188].)

143. EW to Samuel W. McCall, 10 March 1908, copy, R.A.C.
144. 16 April 1908, H. Doc. 17983, *Stats. L.*, 35:63.
145. CHN to EW, 9 March 1908, R.A.C.
146. CHN to EW, 27 April 1908, R.A.C. Niehaus had learned of McCall's reaction to his design through Senator Wetmore's secretary, Harry Vale, with whom the sculptor had met at Woods's suggestion. An earlier pediment executed by Niehaus for the New York Appellate Courthouse, *The Triumph of the Law*, 1900, had come under similar criticism from Charles DeKay, one of the founders of the NSS, who found Niehaus's style "stiff" and "archaic" and his figures lacking in sufficient relationship to the other sculptures on the building. See Charles DeKay, "The Appellate Division Court in New York City," *Independent*, 1 August 1901, 1795–1802; and Charles DeKay, "Organization among Artists," *International Monthly* 1 (1900): 91–92. See also, Michele H. Bogart, *Public Sculpture and the Civic Ideal: 1890–1930* (Chicago: University of Chicago Press, 1989), 93–96, fig. 4.3.
147. CHN to EW, 27 April 1908, R.A.C. On 18 April 1908, just two days after Congress approved the act to complete the House pediment, Henry Kirke Bush-Brown (1857–1935), the adopted son of Henry Kirke Brown, applied to Woods for his consideration when the time came to select a sculptor for the commission. See EW to Henry Kirke Bush-Brown, 21 April 1908, R.A.C. However, Bush-Brown does not appear in the record any further, and it is improbable that he was ever seriously considered for the assignment.
148. Minutes of the Commission, 7 May 1908, R.A.C. The other original members of the commission along with Wetmore and McCall were Senators Henry C. Hansbrough, Frank O. Briggs, John W. Daniel, and Francis G. Newlands, and Representatives James P. Conner, Edward L. Hamilton, William M. Howard, and Charles R. Thomas.
149. In order not to disrupt any plans that Woods already

might have formed concerning the project (he had been of great assistance to the two architects during their 1905 report on the Capitol Extension), Carrère and Hastings wrote the superintendent in confidence regarding Wetmore's inquiry:

The names which naturally occur to us at once are Daniel [Chester] French [1850–1931], Karl Bitter [1857–1915] and Herbert Adams [1858–1945], as the best and safest men, but we do not want to suggest anybody without consulting you first. Both Hastings and I are under the impression that Niehaus has been doing a lot of this work for you and most satisfactorily too. Perhaps you would like to have him continue and would like to have us suggest him and anyone else, or at least if we do suggest anyone else to urge the continuation of the employment of the same sculptor whom you have had heretofore.
(John M. Carrère to EW, 8 May 1908, R.A.C.)

In reply, Woods asked the architects to add two names to the list of sculptors they would recommend to Wetmore—Niehaus and Louis Amateis (1855–1913). Four years earlier Amateis had modeled a bronze door for the main central entrance of the west front of the Capitol. (The door eventually was cast in New York and delivered to Washington in July 1910, but it was never placed in its intended setting.) Woods had been impressed with Amateis's modeling skills and wished him to be considered in connection with the House pediment. But Carrère and Hastings disagreed feeling that Amateis's large figural work was not monumental enough in character to adorn the Capitol Building. See *Compilation of Works of Art and Other Objects in the United States Capitol*. Prepared by the architect of the Capitol under the direction of the Joint Committee on the Library (Washington, D.C.: U.S. Government Printing Office, 1965), 376–77; and Thomas Hastings to EW, 11 May 1908, R.A.C.
150. John M. Carrère and Thomas Hastings to Senator Wetmore, 11 May 1908, copy, R.A.C.
151. CHN to EW, 25 May 1908, R.A.C.
152. Minutes of the Commission, 26 May 1908, R.A.C.

Chapter 2. The Commission, 1908–1916

1. JQAW to Charles Thomas, 8 March 1908, incomplete, Paul Wayland Bartlett Papers, Manuscripts Division, Library of Congress (hereafter cited as Bartlett Papers).
2. JQAW to MCM, 12 May 1857, R.A.C. Ward wrote Meigs anxious to submit models for any of the statuary contemplated for the new extension buildings. He concluded, "Will you please inform me if it is too late to prepare a model for the second pediment? If not I should like to do so."
3. JQAW to Charles Thomas, 8 March 1908, incomplete, Bartlett Papers.
4. The pediment is entitled *Integrity Protecting the Works of Man*. Bartlett modeled the figures based on Ward's designs. See Taft, *History of American Sculpture*, 384. For more information on the commission, see Lewis I. Sharp, *John Quincy Adams Ward: Dean of American Sculpture* (Newark: University of Delaware Press, 1985), 89, 263–64; Montgomery Schuyler, "The New York Exchange," *Architectural Record* 12 (September 1902): 4, 13–20; and Russell Sturgis, "Façade of the New York Stock Exchange," *Architectural Record* 16 (November 1904): 464–82.
5. Minutes of a Special Meeting of the Council of the NSS, 25 May 1908, NSS Minutes Book for 10 October 1904 to December 1909, Office of the NSS, New York (hereafter cited as NSS Minutes Book 1904–1909).
6. The eight additional sculptors placed in nomination by Bartlett, MacNeil, and Bitter were Daniel Chester French (1850–1931), Frederick MacMonnies (1863–1937), George Grey Barnard (1863–1938), Andrew O'Connor (1874–1941), James E. Fraser (1876–1953), Lorado Taft (1860–1936), Evelyn B. Longman (1874–1954), and John Flanagan (1865–1952). See Minutes of a Special Meeting of the Sculptor Members of the NSS, 25 May 1908, NSS Minutes Book 1904–1909. The ten names sent to Washington are listed in the order in which they appear in the NSS minutes. The order reflects the number of votes received; in other words, Bartlett received the most votes and Jaegers the fewest.

7. Minutes, Commission Meeting, 26 May 1908, R.A.C.

8. Ibid.

9. See Original Contract for the completion of the House pediment, 16 February 1909, R.A.C. (See Appendix.)

10. Bartlett received his formal training in France as a pupil of Pierre-Jules Cavelier (1814–96) and Emmanuel Frémiet (1824–1910), and as an assistant in the studio of Auguste Rodin (1840–1917). For a recent study of Bartlett's first major statues, see Thomas P. Somma, "The Myth of Bohemia and the Savage Other: Paul Wayland Bartlett's *Bear Tamer* and *Indian Ghost Dancer*," *American Art* 6, no. 3 (Summer 1992): 15–35.

11. Truman Howe Bartlett was a minor neoclassical sculptor. He studied with Robert E. Launitz (1806–73) in New York and Emmanuel Frémiet in Paris. He settled in Boston in 1879 and for the next twenty-three years taught modeling at the Massachusetts Institute of Technology. See George Gurney, "Olin Levi Warner (1844–1896): A Catalogue Raisonné of His Sculpture and Graphic Works" (Ph.D. diss., University of Delaware, 1978), 1 : 306–10. As an art historian, Truman wrote extensively on French and American sculpture. His most significant publications include *The Art Life of William Rimmer, Sculptor, Painter, and Physician* (Boston: James R. Osgood and Company, 1882; Boston and New York: Houghton, Mifflin and Company, and Cambridge: The Riverside Press, 1890); and an article published in series in the *American Architect and Building News* entitled "Auguste Rodin, Sculptor" (19 January 1889 to 15 June 1889). The article on Rodin, one of the earliest appreciations of the French sculptor to be published in America, is reprinted in Albert Elsen, *Auguste Rodin, Readings on His Life and Work* (Englewood Cliffs, N.J.: Prentice Hall, 1965).

12. At the time of the announcement of the competition, the NSS considered the proposed Sherman Monument to be a test case of major significance. One of the main purposes of the creation of the NSS only two years earlier had been to establish a competent jurisdiction in national art matters such as existed in European countries. Thus, the invitation from the Sherman Monument Committee to provide a professional art jury seemed to be cause for genuine encouragement.

13. The general assumption among artists and the public was that personal favoritism and sectional rivalry rather than artistic excellence had motivated the Monument Committee's selection. For the NSS and the nation's sculptors, in general, the legacy of the Sherman Monument competition was an enduring distrust of open competitions, especially those controlled by committees made up of nonartists.

14. According to Eugene F. Aucaigne, president of Henry-Bonnard at the time, Bartlett's *Columbus* was the first statue ever modeled in Europe but cast in America. See "Heroic Statue of Columbus," unidentified newspaper clipping, Bartlett Papers. For contemporary assessments of Bartlett's *Michelangelo*, see Charles DeKay, *The New York Times Illustrated Magazine Supplement*, 15 January 1899; and Z. Z. and R[ussell] S[turgis], "The Statue of Michelangelo in the Washington Congressional Library," *Scribner's Magazine* 25 (March 1899): [381]–84.

15. Bartlett's *McClellan* and a corresponding equestrian statue of General Winfield Scott Hancock by Ward were to be the principal statuary on the monument, but neither sculptor ever completed his commission. After Ward's death in 1910, the *Hancock* was finished by French, and Bartlett's commission was given eventually to Edward C. Potter (1857–1923). For more information on *The Smith Memorial*, see Sharp, *Dean of American Sculpture*, 87–89, 271–75.

16. The *Lafayette* remained at its original site until 23 July 1984 when it was removed to allow for the archaeological excavations that preceded the construction of I. M. Pei's glass pyramid. The statue was reerected soon after in the Cours la Reine along the banks of the Seine near the Grand Palais. See Geneviève Bresc-Bautier and Ann Pingeot, *Sculptures des jardins du Louvre, du Carrousel et des Tuileries (II)* (Paris: Ministère de la Culture, Editions de la Réunion des Musées Nationaux, 1986), 28.

17. The ambitious program called for four marble statues in niches and five marble tympanum reliefs. See "The Sculpture Commission's Work," *The Hartford Daily Courant*, 12 June 1909.

18. The figures are allegorical representations of the various categories of human knowledge. Bartlett conceived them in terms of three separate but related subgroups: a pair of male figures representing *Philosophy* and *History*, at the extreme left (south) and right (north) ends of the façade, respectively; and two pairs of female figures depicting, to the left of center, *Romance* and *Religion*, and to the right, *Poetry* and *Drama*. For more information on the construction of the library and its sculptural program, see Bogart, *Public Sculpture and the Civic Ideal*, 177–84.

19. Harry A. Vale to PWB, 13 June 1908, R.A.C.; PWB to THB, 15 August 1908, Bartlett Papers; and PWB to THB, 21 September 1908, Bartlett Papers.

20. Sharp, *Dean of American Sculpture*, 273; and PWB to SE, 22 November 1908, Bartlett Papers.

21. PWB to SE, 3 December 1908, Bartlett Papers.

22. PWB to SE, 14 January 1909, Bartlett Papers.

23. Apparently, McCall was quite anxious that the contract between Bartlett and the commission be entered into before Congress adjourned on March 4th. See Harry A. Vale to PWB, 9 February 1909, copy, Bartlett Papers.

24. Minutes, Commission Meeting, 16 February 1909, R.A.C.

25. Original Contract, 16 February 1909, R.A.C.

26. EW to J. P. Tumulty, 22 January 1914, R.A.C.

27. On 22 April 1909, Jesse E. Wilson, assistant secretary, Department of the Interior, responded to Baldwin's letter. He told the attorney that under "An Act for the protection of persons furnishing materials and labor for the construction of public works," approved on 24 February 1905, any person entering into a formal contract with the United States for public work was required before commencing work to "execute a penal bond with good and sufficient sureties with the additional obligation that the contractor shall promptly make payments to all persons supplying him with labor and materials in the prosecution of the work covered by the contract." Wilson enclosed "a form of bond suitable for the faithful performance of the conditions of the contract entered into with Mr. Bartlett," and instructed Baldwin that it "should be executed in accordance with the accompanying instructions and returned to the Department." See Jesse E. Wilson to Edwin Baldwin, 22 April 1909, R.A.C. Two days later, Baldwin wrote to Bartlett in Paris notifying him of the conditions of the bond required by the Interior Department. See Edwin Baldwin to PWB, 24 April 1909, Bartlett Papers.

28. Edwin Baldwin to secretary of the Interior, 8 June 1909, R.A.C.

29. "Exercises Attending the Unveiling of the Statuary of the Pediment of the House Wing of the United States Capitol Building," 4 August 1916, *Congressional Record*, 14012. See also Paul Wayland Bartlett, "Unveiling of the Pediment Group of the House Wing of the National Capitol," *Art & Archaeology* 4 (September 1916): 179.

30. *The New York Herald* (New Jersey Edition), 22 December 1909.

31. The model in the background of fig. 33 is the only one of Bartlett's preliminary plaster sketch models for the pediment to have survived completely intact. Presently, it is on temporary loan to Tudor Place in Washington, D.C. (see Cat. No. 4.)

32. See William Walton, "Mr. Bartlett's Pediment for the House of Representatives, Washington, D.C.," *Scribner's Magazine* 48 (July 1910): 125–[28].

33. Ibid., 127.

34. Ibid.

35. Ibid., 127–28.

36. "Exercises Attending the Unveiling," 14013.

37. Walton, "Mr. Bartlett's Pediment," 125.

38. PWB to EW, 8 July 1910, R.A.C. On 22 February 1911, Bartlett wrote Suzanne that he had been working on "the biggest piece of the pediment," presumably the central figure. See PWB to SE, 22 February 1911, Bartlett Papers. In late July he wrote his father that half of the pediment was well advanced but that "it is all a tough job, particularly with feeble funds." See PWB to THB, 30 July 1911, Bartlett Papers.

39. PWB to SE, 25 October 1911, Bartlett Papers.

40. PWB to SE, 24 November and 8 December 1911, Bartlett Papers.

41. PWB to SE, 8 December 1911, Bartlett Papers.

42. PWB to EW, 1 January 1912, Bartlett Papers.

43. Ibid.

44. EW to PWB, 3 February 1912, copy, R.A.C.; and PWB to SE, 2 March 1912, Bartlett Papers. In an apparent lack of hindsight, Bartlett seemed to hold the officials in Washington at least partly responsible for his financial difficulties. He wrote Suzanne:

The idea of trying to do a big work like *this* without any money anyway is stupid—and I am disgusted with myself—and America does not deserve to have any good work until they can treat their artists reasonably.
(PWB to SE, 2 March 1912, Bartlett Papers.)

45. EW to Champ Clark, 25 July 1912, copy, R.A.C.; and Harry A. Vale to PWB, 25 July 1912, Bartlett Papers.

46. At this time he was also working on a seated *Benjamin Franklin* for Waterbury, Connecticut, a commission he had accepted the previous May.

47. PWB to SE, 2 March 1912, Bartlett Papers.

48. PWB to SE, 3 April 1912, Bartlett Papers.

49. In early September Bartlett wrote Suzanne, who was vacationing in Dinard, France, describing for her what his days were like just then:

Going home every evening dead tired . . . never saying a word for hours and hours, sometimes discouraged about his work, always worried about his rent, and trying to do his best work with his heart in his boots. If that is not a form of long drawn out despair, I should like to know what is. And you can be quite sure it requires a certain amount of courage to keep it up.
(PWB to SE, [4 September 1912], Bartlett Papers.)

50. Originally one of ten papers presented to the Comité France-Amérique over the winter of 1912–13, Bartlett's speech was first given on 22 January 1913 at the Théâtre Michel in Paris. See "La Sculpture aux Etats-Unis et la France," Bartlett Papers. See also Paul Wayland Bartlett, "La sculpture américaine et la France," in E. Boutroux et al., *Les Etats-Unis et la France* (Paris: Librairie Felix Alcan, 1914), 89–110. Bartlett gave his lecture at Colarossi's on 6 March 1913.

51. PWB to SE, 2 April 1913, Bartlett Papers.

52. PWB to SE, 4 April 1913, Bartlett Papers.

53. William Walton, "Recent Work by Paul W. Bartlett," *Scribner's Magazine* 54 (October 1913): 530.

54. PWB to THB, 21 May 1913, Bartlett Papers.

55. Michele H. Bogart, "Four Sculpture Sketches by Paul W. Bartlett for the New York Public Library," *Georgia Museum of Art Bulletin* 7 (1982): 13.

56. PWB to THB, 24 May 1913, Bartlett Papers.

57. Walton, "Recent Work by Paul W. Bartlett," 527–30.

58. PWB to EW, 31 December 1913, R.A.C.

59. PWB to EW, 23 January 1914, copy, R.A.C.

60. EW to Champ Clark, 24 January 1914, copy, R.A.C.

61. Form of Approval, 10 April 1914, copy, R.A.C.

62. Modified Contract, 12 May 1914, R.A.C. (See Appendix.)

63. Lewis C. Laylin, assistant secretary of the Interior, to EW, 15 May 1914, R.A.C.

64. Voucher for Approximate Payment No. 1, 19 May 1914, R.A.C.

65. Bogart, "Four Sculpture Sketches by Bartlett," 13.

66. For more information on the Piccirillis, see Josef V. Lombardo, *Attilio Piccirilli; Life of an American Sculptor* (New York: Pitman Publishing Company, 1944); and Janis Conner and Joel Rosenkranz, *Rediscoveries in American Sculpture, Studio Works, 1893–1939* (Austin: University of Texas Press, 1989), 144–50.

67. The exercise was the subject of a short news item released by the Associated Press and picked up by various local newspapers around the nation:

High above the towering steps of the east portico on the House wing of the Capitol today was hung the figure of a woman with a rope around her neck, while far below on the plaza the sculptor, Paul Bartlett, shouted directions. A sightseer asked what the figure typified. "A suffragette barred out of the Capitol," replied Bartlett, and as the questioner turned away he saw she wore a suffragist badge.
("Suffragette Suspended by Rope at Capitol; Only Sculptor's Joke," *Newark, N.J. Evening Star*, 15 July 1914.)

68. The figures could be seen there everyday between eleven A.M. and seven P.M. from July 16th through the 25th. See Invitation, Bartlett Papers.

69. "Paul Bartlett's New Sculpture for the Capitol," *Vanity Fair* 3 (November 1914): 32.

70. PWB to THB, 15 June 1914, Bartlett Papers. Archduke Ferdinand was assassinated on 20 June 1914; Germany declared war on Russia on 1 August 1914 and on France two days later. The following day Great Britain declared war on Germany.

71. PWB to [SB], 20 September 1914, Bartlett Papers.

72. Mitchell Carroll, "Paul Bartlett's Pediment Group for the House Wing of the National Capitol," *Art & Archaeology* 1 (January 1915): 163–73.

73. Ibid., 167.

74. Getulio Piccirilli to PWB, 3 January 1915, Bartlett Papers.

75. EW to Champ Clark, 5 January 1915, copy, R.A.C.

76. Bartlett's discouragement was evident at an informal address on his pedimental statuary that he delivered in mid-January 1915, before the Archaeological Society in Washington. See *Washington Wife: Journal of Ellen Maury Slayden from 1897–1919* (New York and London: Harper & Row, Publishers, 1962), 256–57.

77. EW to S. W. Stratton, director, Bureau of Standards, 31 March 1915, copy, R.A.C.

78. E. P. Rosa, acting director, Bureau of Standards, to EW, 8 April 1915, R.A.C.

79. GP to PWB, 14 April 1915, Bartlett Papers.

80. Unsigned note, 16 April 1915, R.A.C.; V. H. Manning, acting director, Bureau of Mines, Department of the Interior, to EW, 20 April 1915, R.A.C.; and unsigned memorandum, 21 April 1915, R.A.C. Getulio Piccirilli made known his opinion of Alabama marble in a letter he wrote to Bartlett in late April:

The only thing I know about Alabama marble is that it will never do for your pediment. It is a slate formation and absolutely intollerable [*sic*] for sculpture. It is dangerous to use it or recommend it. I sincerely hope that the Georgia will be used for it is the only material on the market that has proven its durability and we can look back to for years and years.
(GP to PWB, 23 April 1915, Bartlett Papers.)

81. GP to PWB, 1 May 1915, Bartlett Papers.

82. PWB to John A. Martin, 4 July 1916, R.A.C.; and Charles Fairman, Clerk, Woods's office, to PWB, 10 April 1915, Bartlett Papers. Years later, Martin, who during his career eventually became supervising engineer for the Supreme Court Building, talked about his experience as Bartlett's model, and the following account was placed in the files of the architect of the Capitol:

Mr. Bartlett said he had looked over the United States for a man with good muscles and a strong arm and found them in Mr. Martin. Mr. Martin was sent up to the studio not knowing what was wanted and when Mr. Bartlett saw him, Bartlett was delighted and asked him to take off his shirt. As a lady (Mrs. Admiral Dewey) was present, he was a little abashed but Mr. Bartlett assured him she had worked on sculpture and not [to] mind, so he took off his shirt and was told to pose for the figures, and he started right in at the rate of $1.00 per hour.
(Typewritten notes, 11 January 1960, R.A.C.)

83. PWB to THB, 7 March 1915, Bartlett Papers.

84. PWB to SB, 26 August 1915, Bartlett Papers; PWB to THB, 27 September 1915, Bartlett Papers; and Receipt, Adams Express Company to PWB, 23 October 1915, Bartlett Papers.

85. By the end of June the figure had been all pointed and the Piccirillis were ready to begin finishing it. By late July the figure was completed. See GP to PWB, 30 June and 22 July 1915, Bartlett Papers. "Pointing" is an intricate and methodical process that allows for the accurate translation in marble of an original plaster model. With the aid of a delicately adjusted pointing machine, a stone carver can remove the excess material to within an eighth of an inch or less of the finished surface, at which point the sculptor generally reassumes control of the work giving the piece its final surface characteristics. For a detailed discussion of pointing and enlarging in marble, see Malvina Hoffman, *Sculpture Inside and Out* (New York: W. W. Norton and Company, 1939), 158–60, 170–75.

86. The piece reflects the high-relief nature of Bartlett's pedimental sculpture: the broad area of marble to the boy's right corresponds to the posterior portion of the body of the ox, which intrudes from the neighboring farmer group.

87. An article in *The Christian Science Monitor* suggests that the marble figure had been placed onto the building to check its

suitability, but this is unlikely. See "Commissions for National Capitol Engage Sculptor," *The Christian Science Monitor,* 18 September 1915.

88. PWB to SB, 21, 22, 23, and 28 December 1915, and 18 January 1916, Bartlett Papers. See also Bogart, "Four Sculpture Sketches by Bartlett," 16–18.

89. Rodman Wanamaker to PWB, 2 February 1916, Bartlett Papers. The American Art Association of Paris had been formally organized in May 1890, in support of the many American artists studying in France. In 1906, as acting president, Bartlett was influential in soliciting the funds necessary to improve and expand the group's facilities. See *The American Art Association of Paris* (Paris, 1906), Paul Wayland Bartlett Papers, Tudor Place, Washington, D.C.

90. "Bartlett's Latest Work a Triumph of American Art," *The Philadelphia Evening Telegraph,* 19 February 1916.

91. John J. Klaber, "Paul W. Bartlett's Latest Sculpture," *Architectural Record* 39 (March 1916): 278.

92. GP to PWB, 1 March 1916, Bartlett Papers.

93. GP to PWB, 7 March 1916, Bartlett Papers. Bartlett had received two partial payments up to this point. Approximate Payment No. 2 was made to the sculptor on 17 August 1915; the estimated amount due was $33,300 less 10 percent ($3,300) less payment of 19 May 1914 ($13,500) left the amount $16,470. See Voucher for Approximate Payment No. 2, R.A.C.

94. GP to PWB, 14 March and 8 April 1916, Bartlett Papers. Approximate Payment No. 3 was made to Bartlett on 21 March 1916; the estimated amount due was $50,000 less 10 percent ($5,000) less the first two payments ($29,970) left the amount $15,030. See Voucher for Approximate Payment No. 3, R.A.C.

95. GP to PWB, 28 March 1916, Bartlett Papers.

96. 27 July 1916, *Congressional Record,* 13523.

97. EW to secretary of the Navy, 28 July 1916, R.A.C.

98. "Exercises Attending the Unveiling," 14012. The wife of Representative Slayden later gave this personal account of the unveiling:

The air was cool, the wind fresh, and as the big flag rose on its staff above the House it seemed almost to exult in spreading itself against the dazzling sky. No flag could be found large enough, so the pediment was draped with immense white sail, and the figures seemed to be emerging one by one from the marble itself as the canvas fell in splendid folds down on the columns of the portico. The strains of "The Star-Spangled Banner" broke through the shining air, and the crowd watched in breathless silence. (*Washington Wife,* 286.)

99. "Exercises Attending the Unveiling," 14012–13.

100. Ibid., 14014–15.

101. On 26 July 1916 the estimated amount due was $65,000 less 10 percent ($6,500) less the first three paymants ($45,000) left the amount $13,500. See Voucher, Approximate Payment No. 4, 26 July 1916, R.A.C. For Bartlett's final payment the amount due was $74,000 less the amounts from the previous four payments ($58,500), which left the amount of $15,500. See Voucher, Final Payment, 10 August 1916, R.A.C. Soon thereafter, Bartlett asked for and received written notification from Woods that the work provided for in his contract had been satisfactorily completed. The letter was necessary to obtain a release for Bartlett and his sureties from the bond that had accompanied the original contract. See EW to PWB, 22 August 1916; and EB to the secretary of the Interior, 6 September 1916, R.A.C.

102. GP to PWB, 9 August, 19 September, and 19 October 1916, Bartlett Papers. In early November 1916, Getulio Piccirilli sent Bartlett the freight bills for the plaster models together with a bill in the amount of $2,370.44 from the construction company for the installation of the pediment. On 29 November the Fuller Company wrote Bartlett in Washington to confirm receipt of his payment. This was the last transaction related to the commission. See GP to PWB, 4 November 1916, Bartlett Papers; Statement of Disbursement, George A. Fuller Company to Piccirilli Brothers, 30 September 1916, Bartlett Papers; and James Baird, vice-president, George A. Fuller Company, 29 November 1916, Bartlett Papers.

Chapter 3. The Pediment: Design, Style, and Iconography

1. In 1908 Bartlett was promoted to officer of the Legion of Honor—he had been made chevalier of the Legion in 1895—and, in 1911, he was elected corresponding member of the Institut de France. He also became a member of the American Academy of Arts and Letters (1911) and an associate member of the Royal Academy of Belgium (1912). The only other American member of the Institut de France at the time was Augustus Saint-Gaudens; the only other American belonging to the Royal Academy of Belgium was John Singer Sargent (1856–1925).

2. See George Gurney, "The Beginnings of Architectural Sculpture in the United States," in *Sculpture and the Federal Triangle* (Washington, D.C.: Smithsonian Institution Press, 1985), 28–41.

3. See Michele H. Bogart, "In Search of a United Front: American Architectural Sculpture at the Turn of the Century," *Winterthur Portfolio* 19 (Summer/Autumn 1984): 151–76.

4. The west pediment at Olympia is the earliest example in Greek pedimental sculpture of the use of interlocking figures to help unify the composition; this increases the likelihood that the design served as one the models for Bartlett's pediment. See Etienne Lapalus, *Le fronton sculpté en Grèce, des origines à la fin du IVe siècle* (Paris: E. de Bocard, 1947), 179–81.

5. See Bo Wennberg, *French and Scandinavian Sculpture in the Nineteenth Century* (Atlantic Highlands, N.J.: Humanities Press, 1978), 76–81.

6. The total length of the House pediment is eighty feet with approximately sixty feet available for the placement of sculpture. The depth of the pediment is three feet; its height at center eleven feet. The horizontal cornice of the pediment is sixty feet from the ground and about forty-two feet from the top of the steps leading up to the main entrance of the wing.

7. Bartlett, "Unveiling," 184.

8. This was not merely a design problem; serious flaws discovered in the marble used to carve the original statuary for the Stock Exchange pediment exposed the real danger that the stone would crack or split and that a piece, or even an entire figure, might break off and fall to the ground. In late 1903 steel supports were devised to help secure the sculpture within the pediment and the statues were in place by the spring of 1904. Nonetheless, the marble's flaws together with the excessive weight of the statues were finally deemed too hazardous, and in 1936 the original figures were replaced by hollow copper replicas. See Sharp, *Dean of American Sculpture,* 264.

9. Glenn Brown, "Bartlett's Sculpture for the House Wing of the Federal Capitol," *The Art World,* October 1916, 42.

10. Ibid., 43.

11. Bartlett, "Unveiling," 184. For a useful discussion of allegory, contemporaneity, and the real and ideal in American public sculpture, see Bogart, *Public Sculpture and the Civic Ideal,* 221–31.

12. Brown, "Bartlett's Sculpture," 41. See also Klaber, "Bartlett's Latest Sculpture," 265–70.

13. Sturgis, "Façade of the New York Stock Exchange," 481–82. See also Craven, *Sculpture in America,* 432–33.

14. Charles M. Shean, "The Decoration of Public Buildings: A Plea for Americanism in Subject and Ornamental Detail," *Municipal Affairs* 5 (1901): 712.

15. Klaber, "Bartlett's Latest Sculpture," 278.

16. *The Philadelphia Evening Telegraph,* 19 February 1916, Bartlett Papers.

17. Carroll, "Bartlett's Pediment Group," 167.

18. *The Philadelphia Evening Telegraph,* 19 February 1916, Bartlett Papers; and Carroll, "Bartlett's Pediment Group," 167.

19. See François Souchal, *French Sculptors of the 17th and 18th Centuries,* 3 vols. (Oxford: Bruno Cassirer Publishers, Ltd., 1977), 2:190. For the influence and appeal of this statue during the seventeenth and eighteenth centuries, especially in America, see Ellwood C. Parry III, "Some Distant Relatives and American Cousins of Thomas Eakins' Children at Play," *American Art Journal* 18, no. 1 (1986): 21–41.

20. Ancient Greeks could receive the honor while still alive following the example of Herakles. In the nineteenth century the apotheosized individual entered a canon similar to that of a Christian saint.

21. See Pamela Berger, *The Goddess Obscured: Transformation of the Grain Protectress from Goddess to Saint* (Boston: Beacon Press, 1985), 16–23; and James Hall, *Dictionary of Subjects & Symbols in Art*, rev. ed. (New York: Harper & Row, Publishers, 1979), 276.

22. Bartlett's immediate precedent for this division of labor was Ward's pediment in New York.

23. June Hargrove, "The Public Monument," in *The Romantics to Rodin*, ed. Peter Fusco and H. W. Janson (Los Angeles: Los Angeles County Museum of Art, 1980), 21, 29.

24. See Hargrove, "The Public Monument," 30. See also Albert Boime, *Hollow Icons: The Politics of Sculpture in Nineteenth-Century France* (Kent, Ohio: The Kent State University Press, 1987), 105–6. For a complete study of Dalou's monument, see J. Hunisak, *The Sculptor Dalou: Studies in His Style and Imagery* (New York: Garland Publishing, Inc., 1977), 207–29.

25. See Miriam R. Levin, *Republican Art and Ideology in Late Nineteenth-Century France* (Ann Arbor, Mich.: UMI Research Press, 1986), 1–7.

26. Ibid., 176–77, 191–95.

27. Ibid., 21, 26.

28. Ibid., 179, 188–90. The fusion of form and content characterizes Bartlett's oeuvre in general and reflects in large part the seminal influence of his master, Rodin. For a general discussion of the symbolistic qualities of Rodin's sculpture, see Robert Goldwater, *Symbolism* (New York: Harper & Row, Publishers, 1979), 162–77.

29. Paul Boyer, *Urban Masses and Moral Order in America, 1820–1920* (Cambridge: Harvard University Press, 1978), 224–27. See also John Dewey, *The Influence of Darwin on Philosophy* (New York: Henry Holt and Company, 1910); Herbert Croly, *The Promise of America* (New York: The Macmillan Company, 1909); and Edward A. Ross, *Social Control: A Survey of the Foundations of Order* (New York: The Macmillan Company, 1901; reprint, Norwood, Mass.: Norwood Press, 1915).

30. Ross, *Social Control*, 199, 259.

31. All references are to the 1937 reprint of *The Wealth of Nations* edited by Edwin Canaan. See Adam Smith, *An Inquiry into the Nature and Causes of The Wealth of Nations*, ed. Edwin Canaan (New York: The Modern Library, 1937).

32. Ibid., lvii.

33. Ibid., lviii.

34. Ibid., 358-59.

35. Max Lerner, Introduction to Smith, *An Inquiry*, ed. Canaan, viii–ix.

36. Florence E. Yoder, "Paul Bartlett is now Ready to Carve New Statues for Vacant House Gable," *Washington, D.C. Times*, 23 July 1914.

37. Merle Curti, *The Growth of American Thought*, 3d ed. (New York: Harper & Row, Publishers, 1964), 588–89.

38. Ibid., 589–93.

39. Arthur S. Link, *Woodrow Wilson and the Progressive Era 1910–1917* (New York: Harper & Brothers, Publishers, 1954), 20–21.

40. Woodrow Wilson, *The New Freedom, A Call for the Emancipation of the Generous Energies of a People* (1913; reprint, Englewood Cliffs, N.J.: Prentice-Hall, Inc., 1961), 59–61.

41. Peter Kropotkin, *Fields, Factories and Workshops, or Industry Combined with Agriculture and Brain Work with Manual Work* (1898; reprint, New York: Greenwood Press, Publishers, 1968), 1–3.

42. Ibid., iv–v, 5.

43. For the most comprehensive treatment of the period to date, see Richard Guy Wilson et al., *The American Renaissance 1876–1917* (Brooklyn: Brooklyn Museum of Art, 1979).

44. Irving G. Wyllie, *The Self-Made Man in America, The Myth of Rags to Riches* (New Brunswick, N.J.: Rutgers University Press, 1954), 154. The best known popularizer of the rags-to-riches myth was Horatio Alger (1832–99), whose stories inspired countless young men during the late nineteenth century to migrate to the American city in search of their fortunes.

45. Ibid., 161–63.

46. Harriet H. Robinson, *Loom and Spindle, or Life Among the Early Mill Girls* (Boston: Thomas Y. Crowell & Company, 1898). Reprinted in *Women of Lowell, From Colonial Times to the 20th Century* (New York: Arno Press, 1974), 94; Carroll D. Wright, "Introduction," v.

47. Brown, "Bartlett's Sculpture," 42.

48. Wyllie, *The Self-Made Man*, 154–55, 161.

49. Bartlett, "Unveiling," 179.

50. For more information on Kephisodotos the elder's group, see Gisela M. A. Richter, *A Handbook of Greek Art*, 9th ed. (Oxford: Phaidon Press Limited, 1987), 140–41; and *The Sculpture and Sculptors of the Greeks*, 4th ed., new and rev. (New Haven: Yale University Press, 1970), 197–98.

51. David Kinsley, *The Goddesses' Mirror: Visions of the Divine from East and West* (Albany: State University of New York Press, 1989), 150. See also Hall, *Dictionary*, 209–10.

52. The thematic complexities of Bartlett's figure were partly the result of the lack of an established iconography for a peaceful Athena.

53. For a discussion of Vedder's mural, see Regina Soria et al., *Perceptions and Evocations: The Art of Elihu Vedder* (Washington, D.C.: Smithsonian Institution Press, 1979), 225–26.

54. Arnold defined culture as "a pursuit of our total perfection by means of getting to know, on all matters which most concern us, the best which has been thought and said in the world." See Matthew Arnold, *Culture and Anarchy* (1869; reprint, London: Cambridge University Press, 1932), 6; and Wilson, *American Renaissance*, 29 n. 3.

55. Marina Warner, *Monuments & Maidens, The Allegory of the Female Form* (London: Weidenfeld and Nicolson, 1985), 107, 348 n. 10.

56. Wennberg, *French and Scandinavian Sculpture*, 84.

57. See Marc Sandoz, *Théodore Chassériau, 1819–1856. Catalogue raisonné des peintures et estampes* (Paris: Arts et Métiers Graphiques, 1974), 39, 226–36, 241.

58. Maurice Agulhon, *Marianne into Battle: Republican Imagery and Symbolism in France, 1789–1880*, trans. Janet Lloyd (Cambridge: Cambridge University Press, 1981), 103–4.

59. "Paul Bartlett's New Sculpture for the Capitol," 32. See also *Christian Science Monitor*, 18 September 1915, Bartlett Papers.

60. "Placing the Figures of Sculptured Group on the House Wing of Capitol," unidentified newspaper clipping, Bartlett Papers.

61. For the response of the press to Clark's speech, see "Unveiling Rites Held at Capitol," unidentified newspaper article, 2 August 1916, Bartlett Papers; and "Sees Greater Monroe Doctrine," *The New York Times*, 3 August 1916.

62. "Exercises Attending the Unveiling," 14015.

63. Link, *Woodrow Wilson*, 82.

64. See Link, *Woodrow Wilson*, 82. The treaties were intended to prevent any disputes between the nations of the world from ever escalating into a declaration of war.

65. Ibid., 94.

66. Ibid., 104.

67. Frederick L. Paxson, *American Democracy and the World War*, 3 vols. (New York: Cooper Square Publishers, Inc., 1966), 1 : 32; and John Patrick Finnegan, *Against the Specter of a Dragon: The Campaign for American Military Preparedness, 1914–1917* (Westport, Conn.: Greenwood Press, 1974), 7–8.

68. Paxson, *American Democracy and the World War*, 1 : 32; and Finnegan, *Against the Specter of a Dragon*, 8.

69. Urs Schwarz, "The Conduct of War: American and European Practice," in *Diverging Parallels: A Comparison of American and European Thought and Action*, ed. A.N.J. Den Hollander (Leiden: E. J. Brill, 1971), 31–32, 34. See also Urs Schwarz, *Confrontation and Intervention in the Modern World* (Dobbs Ferry, N.Y.: Oceana Publications, 1970).

70. Schwarz, "The Conduct of War," 33–34.

71. The preparedness movement had been maturing some months prior to the submarine crisis of 1915 especially following Theodore Roosevelt's assuming leadership of the movement in November 1914. See Link, *Woodrow Wilson*, 145–48, 164, 177–79.

72. Ibid., 179.

73. THB to PWB, 29 May 191 [5?], Bartlett Papers.

74. See PWB to SB, 30 July 1915, Bartlett Papers; and pamphlet entitled "American Praises Work of the Secours National," Bartlett Papers.

75. Unidentitified correspondence, 22 June 1916, Bartlett Papers.

76. *Catalogue of Memorial Exhibition of the Works of Paul Wayland Bartlett* (New York: American Academy of Arts and Letters, 1931), 28. The eagle was a commercial success for Bartlett, who throughout the early months of 1916 received numerous orders for

bronze casts of the work. See PWB to THB, 11 April 1916, Bartlett Papers.

77. Bogart, "In Search of a United Front," 176.

78. Gurney, *Federal Triangle*, 151–52.

79. Ibid., 150.

80. Wanda M. Corn, *Grant Wood, The Regionalist Vision* (New Haven and London: Yale University Press, 1983), 17–18.

81. Conner and Rosenkranz, *Rediscoveries in American Sculpture*, 88. See also A. W. Newman, "Art and the Workers, Max Kalish, Sculptor of Labor Types," *The Railway Clerk* 26 (January 1927): 19.

82. See Belisario R. Contreras, *Tradition and Innovation in New Deal Art* (London and Toronto: Associated University Presses, 1983); and Marlene Park and Gerald E. Markowitz, *Democratic Vistas: Post Offices and Public Art in the New Deal* (Philadelphia: Temple University Press, 1984).

83. Park and Markowitz, *Democratic Vistas*, 39–43, 55–56.

84. Ibid., 4–5. See also Marlene Park and Gerald E. Markowitz, "New Deal for Public Art," in *Critical Issues in Public Art*, ed. Harriet F. Senie and Sally Webster (New York: HarperCollins Publishers, Inc., 1992), 131.

Bibliography

Manuscript Collections

Library of Congress Archives. Manuscripts Division, Library of Congress, Washington, D.C.

Minutes of the National Sculpture Society. Office of the National Sculpture Society, New York.

Paul Wayland Bartlett Papers. Manuscripts Division, Library of Congress, Washington, D.C.

Paul Wayland Bartlett Papers. Prints and Photographs Division, Library of Congress, Washington, D.C.

Paul Wayland Bartlett Papers. Tudor Place, Georgetown, Washington, D.C.

Henry Kirke Bush-Brown Papers. Manuscripts Division, Library of Congress, Washington, D.C.

Records of the Architect of the Capitol. Office of the Architect of the Capitol, United States Capitol, Washington, D.C.

Records of the Library of Congress. Manuscripts Division, Library of Congress, Washington, D.C.

Records of the Library of Congress. Prints and Photographs Division, Library of Congress, Washington, D.C.

Other Unpublished Works

Architect of the Capitol. "Report of the Architect of the Capitol on the Extension of the East Front of the United States Capitol." Office of the Architect of the Capitol, Washington, D.C., 1966.

Craven, Wayne. "H. K. Brown and the Black Man in the Pediments." Paper delivered at the annual meeting of the College Art Association, Chicago, February 1976.

"Documentary History of Art Commissions, 1858–1911." Compiled for the Office of the Superintendent of the U.S. Capitol. Office of the Architect of the Capitol, Washington, D.C.

Gurney, George. "Olin Levi Warner (1844–1896): A Catalogue Raisonné of His Sculpture and Graphic Works." (Ph.D. diss., University of Delaware, 1978).

Montagna, Dennis Robert. "Henry Merwin Shrady's Ulysses S. Grant Memorial in Washington, D.C.: A Study in Iconography, Content and Patronage." (Ph.D. diss., University of Delaware, 1987).

Government Documents

Congressional Globe. 46 vols. Washington, D.C., 1834–73.

Congressional Record. Washington, D.C., 1873–.

Revised Statutes. Sec. 1831. (40 U.S.C. 188).

Statutes at Large of the United States of America, 1789–1873. 17 vols. Washington, D.C., 1850–73.

U.S. Congress. House. *American Artists H. Rept. 198.* 35th Cong., 2d sess., 3 March 1859.

———. *Extension and Completion of the Capitol Building.* 58th Cong., 3d sess., 1905. H. Doc. 385.

———. *Joint Resolution H.R. 89.* 41st Cong., 2d sess., 16 December 1869.

United States Statutes at Large. 1874–.

Books

Agulhon, Maurice. *Marianne into Battle: Republican Imagery and Symbolism in France, 1789–1880.* Translated by Janet Lloyd. Cambridge: Cambridge University Press, 1981.

Albee, John. *Henry Dexter, Sculptor.* Cambridge, Mass., 1898.

The American Art Association of Paris. Paris, 1906.

Archdeacon, Thomas J. *Becoming American, An Ethnic History.* New York: The Free Press, 1983.

Architect of the Capitol. *Art in the United States Capitol.* Washington, D.C.: U.S. Government Printing Office, 1976.

Armstrong, Regina. *The Sculpture of Charles Henry Niehaus.* New York: De Vinne Press, 1901.

Arnold, Matthew. *Culture and Anarchy.* 1869. Reprint. London: Cambridge University Press, 1932.

Bartlett, Paul Wayland. "La sculpture américaine et la France." In *Les Etats-Unis et la France.* E. Boutroux et al., 89–110. Paris: Librairie Felix Alcan, 1914.

Bartlett, Truman H. *The Art Life of William Rimmer, Sculptor, Painter, and Physician.* Boston: James R. Osgood and Company, 1882; Boston and New York: Houghton, Mifflin and Company; Cambridge, Mass.: The Riverside Press, 1890.

Berger, Pamela. *The Goddess Obscured: Transformation of the Grain Protectress from Goddess to Saint.* Boston: Beacon Press, 1985.

Bieber, M. *The Sculpture of the Hellenistic Age.* Rev. ed. New York: Columbia University Press, 1961.

Bogart, Michele H. *Public Sculpture and the Civic Ideal: 1890–1930.* Chicago: University of Chicago Press, 1989.

Boime, Albert. *Hollow Icons: The Politics of Sculpture in Nineteenth-Century France.* Kent, Ohio: The Kent State University Press, 1987.

Boyer, Paul. *Urban Masses and Moral Order in America, 1820–1920.* Cambridge: Harvard University Press, 1978.

Bresc-Bautier, Geneviève, and Anne Pingeot. *Sculptures des jardins du Louvre, du Carrousel et des Tuileries (II).* Paris: Ministère de la Culture, Editions de la Réunion des Musées Nationaux, 1986.

Brown, Glenn. *History of the United States Capitol.* 2 vols. Washington, D.C.: U.S. Government Printing Office, 1900–1903.

———. *Memories, 1860–1930.* Washington, D.C.: Press of W. F. Roberts Company, 1931.

Casey, Robert J., and Mary Borglum. *Give the Man Room: The Story of Gutzon Borglum.* Indianapolis, Ind.: Bobbs-Merrill, 1952.

Catalogue of Memorial Exhibition of the Works of Paul Wayland Bartlett. New York: American Academy of Arts and Letters, 1931.

Chew, Paul A., ed. *The Permanent Collection.* Greensburg, Penn.: Westmoreland Museum of Art, 1978.

Compilation of Works of Art and Other Objects in the United States Capitol. Prepared by the Architect of the Capitol under the Direction of the Joint Committee on the Library. Washington, D.C.: U.S. Government Printing Office, 1965.

Conner, Janis, and Joel Rosenkranz. *Rediscoveries in American Sculpture. Studio Works, 1893–1939.* Austin: University of Texas Press, 1989.

Contreras, Belisario R. *Tradition and Innovation in New Deal Art.* London and Toronto: Associated University Presses, 1983.

Corn, Wanda M. *Grant Wood, The Regionalist Vision.* New Haven and London: Yale University Press, 1983.

Cosentino, Andrew J., and Henry H. Glassie. *The Capitol Image, Painters in Washington, 1800–1915.* Washington, D.C.: Smithsonian Institution Press, 1983.

Crane, Sylvia E. *White Silence: Greenough, Powers, and Crawford; American Sculptors in Nineteenth-Century Italy.* Coral Gables, Fla.: University of Miami Press, 1972.

Craven, Wayne. *Sculpture in America.* New and rev. ed. Newark: University of Delaware Press, 1984.

Criswell, Grover C., Jr. *North American Currency.* Iola, Wis.: Krause Publications, 1965.

Croly, Herbert. *The Promise of American Life.* New York: The Macmillan Company, 1909.

Curti, Merle. *The Growth of American Thought.* 3d ed. New York: Harper & Row, Publishers, 1964.

Cutter, William. *The Life of Israel Putnam.* New York, 1850. Reprint. Port Washington, N.Y. and London: Kennikat Press, 1970.

Dewey, John. *The Influence of Darwin on Philosophy.* New York: Henry Holt and Company, 1910.

Elsen, Albert. *Auguste Rodin. Readings on His Life and Work.* Englewood Cliffs, N.J.: Prentice-Hall, 1965.

Fairman, Charles E. *Art and Artists of the Capitol of the United States of America.* Washington, D.C.: U.S. Government Printing Office, 1927.

Finnegan, John Patrick. *Against the Specter of a Dragon: The Campaign for Military Preparedness, 1914–1917.* Westport, Conn.: Greenwood Press, 1974.

Frary, I. T. *They Built the Capitol.* Richmond, Va.: Garrett and Massie, Inc., 1940.

Fryd, Vivien Green. *Art & Empire: The Politics of Ethnicity in the United States Capitol, 1815–1860.* New Haven and London: Yale University Press, 1992.

Fusco, Peter, and H. W. Janson, eds. *The Romantics to Rodin.* Los Angeles: Los Angeles County Museum of Art, 1980.

Gale, Robert L. *Thomas Crawford.* Pittsburgh, Penn.: University of Pittsburgh Press, 1964.

Goldwater, Robert. *Symbolism.* New York: Harper & Row, Publishers, 1979.

Goode, James M. *The Outdoor Sculpture of Washington, D.C.* Washington, D.C.: Smithsonian Institution Press, 1974.

Grabar, Francis S. *William Randolph Barbee & Herbert Barbee: Two Virginia Sculptors Rediscovered.* Washington, D.C.: George Washington University, The Dimock Gallery, 1977.

Gurney, George. *Sculpture and the Federal Triangle.* Washington, D.C.: Smithsonian Institution Press, 1985.

Hall, James. *Dictionary of Subjects & Symbols in Art.* Rev. ed. New York: Harper & Row, Publishers, 1979.

Hamilton, Edith. *Mythology.* Boston: Little, Brown and Company, 1942.

Hanotelle, Micheline. *Paris/bruxelles, rodin et meunier: relations des sculpteurs français et belges à la fin du XIXe siècle.* Paris: Editions du Temps, 1982.

Hargrove, June. "The Public Monument." In *The Romantics to Rodin,* edited by Peter Fusco and H. W. Janson, 21–35. Los Angeles: Los Angeles County Museum of Art, 1980.

Haskell, Francis, and Nicholas Penny. *Taste and the Antique.* New Haven and London: Yale University Press, 1981.

Haxby, James A. *Standard Catalog of United States Obsolete Bank Notes 1782–1866.* Iola, Wis.: Krause Publications, 1988.

Higham, John. *Strangers in the Land: Patterns of American Nativism, 1860–1925.* New York: Atheneum Publishers, 1969.

Hoffman, Malvina. *Sculpture Inside and Out.* New York: W. W. Norton and Company, 1939.

Hunisak, J. *The Sculptor Dalou: Studies in His Style and Imagery.* New York: Garland Publishing, Inc., 1977.

Huntington, David C. *The Quest for Unity: American Art Between the Fairs 1876–1893.* Detroit: The Detroit Institute of Arts, 1983.

Jenkins, Arthur Hugh. *Adam Smith Today.* New York: Richard R. Smith, 1948.

Kinsley, David. *The Goddesses' Mirror: Visions of the Divine from East and West.* Albany: State University of New York Press, 1989.

Kropotkin, Peter. *Fields, Factories and Workshops, or Industry Combined with Agriculture and Brain Work with Manual Work.* 1898. Reprint. New York: Greenwood Press, Publishers, 1968.

Levin, Miriam R. *Republican Art and Ideology in Late Nineteenth-Century France.* Ann Arbor, Mich.: UMI Research Press, 1986.

Link, Arthur S. *Woodrow Wilson and the Progressive Era 1910–1917.* New York: Harper & Brothers, Publishers, 1954.

Lombardo, Josef V. *Attilio Piccirilli; Life of an American Sculptor.* New York: Pitman Publishing Company, 1944.

McCabe, James Dabney [Edward Winslow Martin, pseud.]. *Behind the Scenes in Washington.* New York: The Continental Publishing Company and National Publishing Company, 1873.

Mechlin, Leila. "The Year in Art—Washington." In *American Art Annual,* vol. 13, edited by Florence N. Levy. Washington, D.C.: The American Federation of Arts, 1916.

Miller, Lillian B. *Patrons and Patriotism, The Encouragement of the Fine Arts in the United States 1790–1860.* Chicago: The University of Chicago Press, 1966.

Park, Marlene, and Gerald E. Markowitz. *Democratic Vistas: Post Offices and Public Art in the New Deal.* Philadelphia: Temple University Press, 1984.

———. "New Deal for Public Art." In *Critical Issues in Public Art,* edited by Harriet F. Senie and Sally Webster, 128–41. New York: HarperCollins Publishers, Inc., 1992.

Paul Wayland Bartlett, 1865–1925. New York: Ferargil Galleries, 1927.

Paul Wayland Bartlett, 1865–1925, Sculptures. Paris: Musée de l'Orangerie (Jardin des Tuileries), 1929.

Paxson, Frederic L. *American Democracy and the World War.* Vol. 1: *Pre-War Years, 1913–1917.* New York: Houghton Mifflin Company, 1936. Reprint. New York: Cooper Square Publishers, Inc., 1966.

Pingeot, Anne et al. *La sculpture française au XIXe siècle.* Paris: Editions de la Réunion des Musées Nationaux, 1986.

Placzek, Adolf K., ed. *Macmillan Encyclopedia of Architects.* 4 vols. New York: The Free Press, 1982.

The Reminiscences of Augustus Saint-Gaudens. 2 vols. New York: The Century Company, 1913.

Richter, Gisela M. A. *A Handbook of Greek Art.* 9th ed. Oxford: Phaidon Press Limited, 1987.

————. *The Sculpture and Sculptors of the Greeks.* 4th ed., new and rev. New Haven: Yale University Press, 1970.

Robinson, Harriet H. *Loom and Spindle, or Life Among the Early Mill Girls.* Boston: Thomas Y. Crowell and Company, 1898. Reprinted in *Women of Lowell, From Colonial Times to the 20th Century.* New York: Arno Press, 1974.

Ross, Edward A. *Social Control: A Survey of the Foundations of Order.* New York: The Macmillan Company, 1901. Reprint. Norwood, Mass.: Norwood Press, 1915.

Sandoz, Marc. *Théodore Chassériau 1819–1856: Catalogue raisonné des peintures et estampes.* Paris: Arts et Métiers Graphiques, 1974.

Scharnhorst, Gary. *Horatio Alger, Jr.* Boston: Twayne Publishers, 1980.

Schwarz, Urs, "The Conduct of War: American and European Practice." In *Diverging Parallels: A Comparison of American and European Thought and Action,* edited by A. N. J. Den Hollander, 29–56. Leiden: E. J. Brill, 1971.

Shapiro, Michael Edward. *Bronze Casting and American Sculpture 1850–1900.* Newark: University of Delaware Press, 1985.

Sharp, Lewis I. *John Quincy Adams Ward: Dean of American Sculpture.* Newark: University of Delaware Press, 1985.

Smith, Adam. *An Inquiry into the Nature and Causes of The Wealth of Nations.* Edited by Edwin Canaan. New York: The Modern Library, 1937.

Smithsonian Institution. *The Federal City: Plans & Realities.* Washington, D.C.: Smithsonian Institution Press, 1981.

Soria, Regina et al. *Perceptions and Evocations: The Art of Elihu Vedder.* Washington, D.C.: Smithsonian Institution Press, 1979.

Souchal, François. *French Sculptors of the 17th and 18th Centuries.* 3 vols. Oxford: Bruno Cassirer Publishers, Ltd., 1977.

Taft, Lorado. *The History of American Sculpture.* New and rev. ed. New York: The Macmillan Company, 1924.

Truettner, William H., ed. *The West as America: Reinterpreting Images of the Frontier, 1820–1920.* Washington, D.C.: Smithsonian Institution Press, 1991.

Vaughn, Stephen. *Holding Fast the Inner Lines: Democracy, Nationalism, and the Committee on Public Information.* Chapel Hill: The University of North Carolina Press, 1980.

Wainwright, N. B., ed. *Sculpture of a City: Philadelphia's Treasures in Bronze and Stone.* New York: Walker Publishing Company, 1974.

Walker, Duncan S. *Celebration of the One Hundredth Anniversary of the Laying of the Corner Stone of the Capitol of the United States, with Accounts of the Laying of the Original Corner Stone, in 1793, and the Corner Stone of the Extension, in 1851.* Washington, D.C.: U.S. Government Printing Office, 1896.

Warner, Marina. *Monuments & Maidens: The Allegory of the Female Form.* London: Weidenfeld and Nicolson, 1985.

Washington Wife: Journal of Ellen Maury Slayden from 1897–1919. New York and London: Harper & Row, Publishers, 1962.

Webster, J. Carson. *Erastus D. Palmer.* Newark: University of Delaware Press, 1983.

Weigley, Russel F. *Quartermaster General of the Union Army, A Biography of M. C. Meigs.* New York: Columbia University Press, 1959.

Wennberg, Bo. *French and Scandinavian Sculpture in the Nineteenth Century, A Study of Trends and Innovations.* Atlantic Highlands, N.J.: Humanities Press, 1978.

Wilson, Richard Guy et al. *The American Renaissance, 1876–1917.* Brooklyn: Brooklyn Museum of Art, 1979.

Wilson, Woodrow. *The New Freedom, A Call for the Emancipation of the Generous Energies of a People.* 1913. Reprint. Englewood Cliffs, N.J.: Prentice-Hall, Inc., 1961.

Wyllie, Irving G. *The Self-Made Man in America, The Myth of Rags to Riches.* New Brunswick, N.J.: Rutgers University Press, 1954.

Periodicals

Bartlett, Ellen Strong. "Paul Bartlett: An American Sculptor." *New England Magazine* 33 (December 1905): 368–82.

Bartlett, Paul Wayland. "Statues in Washington and Power Plant vs. Art Commission." *Art & Archaeology* 3 (June 1916): 353–58.

———. "Unveiling of the Pediment Group of the House Wing of the National Capitol." *Art & Archaeology* 4 (September 1916): 178–84.

Bartlett, Truman H. "Auguste Rodin, Sculptor." *American Architect and Building News* (19 January 1889 to 15 June 1889).

Bogart, Michele H. "Four Sculpture Sketches by Paul W. Bartlett for the New York Public Library." *Georgia Museum of Art Bulletin* 7 (1982): 5–24.

———. "In Search of a United Front: American Architectural Sculpture at the Turn of the Century." *Winterthur Portfolio* 19 (Summer/Autumn 1984): 151–76.

Borglum, Gutzon. "Art that is Real and American." *World's Work* 28 (1914): 200–217.

Brooks, Van Wyck. "On Creating a Usable Past." *Dial* 64, no. 3 (11 April 1918): 337–41.

Brown, Glenn. "Bartlett's Sculpture for the House Wing of the Federal Capitol." *The Art World* (October 1916): 41–43.

Carroll, Mitchell. "Paul Bartlett's Pediment Group for the House Wing of the National Capitol." *Art & Archaeology* 1 (January 1915): 163–73.

The Crayon 4 (June 1857): 186.

"The Capitol Extension." *The Crayon* 3 (October 1856): 311.

"Charles Henry Niehaus, American Sculptor." *International Studio* 29 (1906): 104–11.

"Competition in Art." *The Crayon* 4 (February 1857): 56.

Craven, Wayne. "Henry Kirke Brown: His Search for an American Art in the 1840's." *American Art Journal* 4 (1972): 44–58.

———. "Henry Kirke Brown in Italy, 1842–1846." *American Art Journal* 1 (1969): 65–77.

DeKay, Charles. "The Apellate Division Court in New York City." *Independent,* 1 August 1901, 1795–1802.

———. "Organization among Artists." *International Monthly* 1 (1900): 91–92.

"Exhibitions." *The Crayon* 5 (April 1858): 115.

Ferber, Linda S. "Themes in American Genre Painting: 1840–80." *Apollo* 115 (April 1982): 250–59.

Fryd, Vivien Green. "Hiram Powers' *America:* 'Triumphant as Liberty and in Unity.'" *American Art Journal* 18 (Summer 1986): 55–75.

———. "Two Sculptures for the Capitol: Horatio Greenough's *Rescue* and Luigi Persico's *Discovery of America.*" *American Art Journal* 19 (Spring 1987): 16–39.

Jones, Alfred Haworth. "The Search for a Usable Past in the New Deal Era." *American Quarterly* 23, no. 4 (December 1971): 710–24.

Klaber, John J. "Paul W. Bartlett's Latest Sculpture." *Architectural Record* 39 (March 1916): 265–78.

Newman, A. W. "Art and the Workers, Max Kalish, Sculptor of Labor Types." *The Railway Clerk* 26 (January 1927): 19.

"Notes and Clippings." *American Architect and Building News* 23 (4 February 1888): 60.

"Paul Bartlett's New Sculpture for the Capitol." *Vanity Fair* 3 (November 1914): 32.

Rutledge, Anna Wells. "Cogdell and Mills, Charleston Sculptors." *Antiques Magazine* 41 (March 1942): 192–93, 205–7.

Schuyler, Montgomery. "The New York Exchange." *Architectural Record* 12 (September 1902): 4, 13–20.

Schwengel, Frederic D. "The Masons and the Capitol of the United States." *New Age* 73 (March 1965): 40–43.

Shean, Charles M. "The Decoration of Public Buildings: A Plea for Americanism in Subject and Ornamental Detail." *Municipal Affairs* 5 (1901): 716–19.

———. "Mural Painting from the American Point of View." *The Craftsman* 7 (October 1905): 18–27.

Somma, Thomas P. "The Myth of Bohemia and the Savage Other: Paul Wayland Bartlett's *Bear Tamer* and *Indian Ghost Dancer.*" *American Art* 6, no. 3 (Summer 1992): 15–35.

Sturgis, Russell. "Façade of the New York Stock Exchange." *Architectural Record* 16 (November 1904): 464–82.

Truettner, William H. "The Art of History: American Exploration and Discovery Scenes, 1840–1860." *American Art Journal* 14 (Winter 1982): 4–31.

Walton, William. "Mr. Bartlett's Pediment for the House of Representatives, Washington, D.C." *Scribner's Magazine* 48 (July 1910): 125–28.

———. "Recent Work by Paul W. Bartlett." *Scribner's Magazine* 54 (October 1913): 527–30.

Wheeler, Charles V. "Bartlett (1865–1925)." *The American Magazine of Art* 16 (November 1925): 573–85.

Z. Z., and R[ussell] S[turgis]. "The Statue of Michelangelo in the Washington Congressional Library." *Scribner's Magazine* 25 (March 1899): 381–84.

Newspaper Articles

"Barbee, the Sculptor." *Daily National Intelligencer* (Washington, D.C.), 26 December 1859.

"Bartlett's Latest Work a Triumph of American Art." *The Philadelphia Evening Telegraph,* 19 February 1916.

The Christian Science Monitor, 18 September 1915.

"Commissions for National Capitol Engage Sculptor." *The Christian Science Monitor,* 18 September 1915.

"The General Born at Luray." *Page News and Currier* (Luray, Va.), 28 October 1927.

"Hands Off America is Clark's Warning." *The Washington Times,* 3 August 1916.

Jewell, Edward Alden. "A Season Dominantly American." *The New York Times,* 29 May 1932.

Mather, Frederick G. "History of a Pediment." *Philadelphia Evening Herald,*" 11 October 1889.

The New York Herald (New Jersey Edition), 22 December 1909.

"Old Paper Reveals North-South Jealousy Delayed Capitol Sculpture for 70 Years." *Washington Post,* 6 February 1939.

"Palmer's Landing of the Pilgrims." *Albany Evening Journal,* 10 April 1857.

The Philadelphia Evening Telegraph, 19 February 1916.

"The Sculpture Commission's Work." *The Hartford Daily Courant,* 12 June 1909.

"Sees Greater Monroe Doctrine." *The New York Times,* 3 August 1916.

"Suffragette Suspended by Rope at Capitol; Only Sculptor's Joke." *Newark, NJ. Evening Star,* 15 July 1914.

"Three Statues Arrive for Public Library." *The Sun* (New York), 23 December 1915.

Yoder, Florence E. "Paul Bartlett is now Ready to Carve New Statues for Vacant House Gable." *Washington, D.C. Times,* 23 July 1914.

Index

Page numbers in boldface type denote illustrations. The figures referred to can be found in the color section.